THE
LOVE
LIAR

A Memoir of Codependency,
Narcissism, and the Pursuit of Self-Love

CARIN M. LACOUNT

Capucia LLC
211 Pauline Drive #513
York, PA 17402
capuciapublishing.com
Send questions to: support@capuciapublishing.com

Paperback ISBN: 978-1-954920-36-1
eBook ISBN: 978-1-954920-37-8
Library of Congress Control Number: 2022914066

Cover Design: Ranilo Cabo
Layout: Ranilo Cabo
Editor and Proofreader: Janis Hunt Johnson, Ask Janis LLC
Book Midwife: Karen Everitt

Printed in the United States of America

Capucia LLC is proud to be a part of the Tree Neutral® program. Tree Neutral offsets the number of trees consumed in the production and printing of this book by taking proactive steps such as planting trees in direct proportion to the number of trees used to print books. To learn more about Tree Neutral, please visit treeneutral.com.

I would never have had this book to write, this journey to discover, or these lessons to have learned without my former husband. He has played a large and integral part in my becoming the woman and mother that I am. If it weren't for him, I can't imagine how I would have learned the lessons on love I was put on this earth to learn.

If it were not for my kids, I have no idea how I would have found the strength to live. They are my everything. Without them I wouldn't have discovered the importance of loving myself, and I wouldn't have shown them the same.

CONTENTS

AUTHOR'S NOTE

My dad always told me I had a good memory. My husband always told me I had a knack for remembering every "goddamn little thing." Despite my good recall skills, in the spirit of artistic license, not everything in this book is exactly how it went—but it has the essence of what it meant in my journey. I realize that many will object to my story—to the depiction of their son or brother or cousin or friend in these pages. Yet it is my hope that they will see the potential for greater good that the telling of this story has for my kids and—should he allow himself to see it—for my ex-husband, as well as for anyone else who reads this book.

It is not my intention to vilify narcissism, or diagnose my former husband as a narcissist, but instead to see how, no matter what label you give it, chronic emotional dysfunction in any form can destroy relationships, families, and individuals. Once we can gain an awareness of what's happening, take responsibility for our part, and learn to love ourselves and others without conditions, real emotional growth can happen. Lives can be healed.

PROLOGUE

Lying is one of the quickest ways to ruin a beautiful relationship.
—Anonymous

It was August 8, 2015. My husband of twenty years, Marty, was sitting on "his" side of the bed with his back against the pillows. His mouth was screwed up in that manner I came to loathe. It was a telltale sign he'd intended to coerce me with whatever lie necessary to get his way. Since I'd first asked for a divorce eighteen months earlier, I'd finally recognized it for what it was. Insincerity, disguised as caring, concern. It was now so obvious to me, like a warning light on the road telling me the bridge was out. Seeing his face, I knew that if I didn't take precautions I'd fall into the abyss of his gaslighting.

He'd been sleeping on the futon in the guest room for a week since I'd told him I wanted a divorce, again. He was smug in his belief that he could once again spin my head and drop my ridiculous notion of living without him. I looked at him, owning his side of the bed, leaning against the pillows with his hands behind his head and his legs splayed, with that face, that mouth.

Be strong, be wary, heed the warning that you aren't safe, I reminded myself. I knew he wouldn't physically hurt me, but I also knew, if I stayed in this marriage, I'd die.

I sat across the room on the hard, wooden chair by the window, one foot on the seat, my shoulders curled over my knees, my arms wrapped

around my legs. I was in a position of protection, a way to brace myself against whatever he was going to throw at me. To anyone else, he looked like a picture of sweetness and calm, a completely different person from the bawling, wicked martyr he'd been just a few days prior, and most days throughout our twenty-seven-year relationship. I didn't look at him. I didn't need to; I'd been in this place before. He had me where he wanted me—cornered, ready to do what he wanted me to do—or so he thought. He looked at me hard, trying to soften his edges as he shaped those lips into words to begin the conversation he wanted so badly to have.

"I think you really need to reconsider this. I mean, why do you think you need to be divorced?" He spoke with a practiced calculation, a patient tone, lightly sprinkled with condescension to give me a taste, but not overpower the dish. It's worked on me before, so I couldn't blame him for trying, but this time it wouldn't work. This time I saw the sheer selfishness his words tried to cover, the slight-of-hand maneuver he used to steal more years of my life. This time, I had the strength to stop him.

"I'm just not happy," I said. It's the same thing I'd said for the last eighteen months. I'd tried so hard, so many times to give him reasons for my unhappiness, to explain how deeply his behavior hurt, but he would shoot all of them down with his twisted version of things.

He'd repeatedly told me, "You've got a real knack for fucking with reality."

"But Carin, you've been unhappy your whole life, certainly this whole marriage. It seems to me, you just can't be happy. So why break up this family for happiness you just can't have?"

I stared at the carpet for a long time. I knew it made him uncomfortable, something that before would have bothered me enough not to do it to

him. I *hated* dealing with his wrath. But this time, I didn't care if he got angry. I didn't revel in my new liberation of not giving a fuck about his feelings. I had too many of my own to deal with.

"Because, Marty, I deserve to be happy, I deserve to be loved and I believe I will have happiness—but not with you," I said, lifting my head to look him directly in the eye. "I will be loved, but not by you."

I released my knees, stood tall, turned, and slowly walked out of the room.

PART ONE

THE LIE BEGINS:
THE INNOCENT LOSS
OF SELF-LOVE

CHAPTER 1

Mommy

There is nothing as sincere as a mother's kiss.
—Saleem Sharma

I knew love. When I was little, love was untainted, honest, and pure. Love surrounded me in the Clovis Grove woods across the street from the house where I lived. Love was the white brick "mansion," with the funky red siding that my dad built for my mom the year I was born. Love was the springtime when the wildflowers bloomed. It was the song in my heart that I'd hum when I walked down the driveway to the woods. Love was the magic of my imagination that wrapped around me to guard me from worry in the world. The sweep of the white "shooting stars"—as my mom called them when she wasn't tending to my younger sister and could join me—was my favorite. Those elegant flowers amongst the thick dark green leaves that accompanied them, made up the carpet of my "living room" in the woods, while the delicate purple-veined wild geraniums were my "bedroom" floor where I cleared branches for a flat comfortable space in the dirt that became my bed under a canopy of dogwood.

I was often by myself but never alone, as the unconditional love of Spirit accompanied me always. All the love I needed was there within my heart, emanating from the flowers and the trees, and from the ducks finding respite in the ponds of melted snow. This love in the woods was an extension of the white brick house across the street. The house of love my father, who loved my mother, built for her. But like the pond water the ducks rested and swam upon, that unconditional love soon evaporated, and I was left with a barren counterfeit love that almost killed me.

When I'm six years old, my mom asks me a question I cannot answer. She sits down next to me on my bed, kisses my cheek, and then leans over to kiss each of my stuffed animal friends gathered around me. It's our nightly bedtime ritual. First, she kisses big orange bear, Marius, who shares my pillow, then Bean's Bear, Chimper the monkey, and the twin doggies that lined up the edge of my bed as a protective army defending against the imaginary trolls that lived underneath. She laughs at herself as she puts her lips on each one, and then gives up before she gets to the brown leather mouse and violet snake that make up the security team at the bottom of the bed.

"What would you ever do if I died?" she asks me as she stands up to leave. Her question startles and confuses me.

"I-I don't k-know," I stutter.

"Well, who will kiss all these animals for you every night?" she says with a laugh. I look at her as I try to process her words. She's laughing, so I smile, but it doesn't feel like anything to smile about.

"Good night, sweet girl," she says as she flips off the light and walks out. I lie in the dark wondering if a mother *can* even die.

Five nights later my mother died of a brain aneurysm and was gone from my life forever.

It was so obvious—my answer to my mother's question once she was gone: I would become a dark pond of tears unable to ever completely swim out of the idea that I messed up and lost her love. She wanted to know, but I didn't tell her that the woods would lose their magic, that the flowers would become mere echoes of her love. That I would lose all sense of what love truly is because her death would take away all of it. With her love ripped away from me, I'd begin to tell myself lies about love to try to understand what I lost.

If I had answered her question, would she have been able to tell me I could never be without her love? Would she have told me that no matter what I do or say I will always be loved? Would she have assured me that I never have to please her or make her proud or give her reason to feel good about herself in order to get her love and feel good about myself? Would she have understood unconditional love and taught me that love for myself is all I need—and if anyone ever makes me doubt myself or doesn't love me for who I am, or only loves me for what I give them, then they have no right to my love?

I'll never know.

At the wake, standing at the casket holding my dad's hand, I tried to fathom the impossibility of my mother's lifeless body. I looked at her hands holding the rosary beads and had an idea. "How do I pray?" I asked my dad. I thought I could tell her, through prayer, what I would do if she died. "Oh hon—" was all my dad could say. He picked me up and squeezed me so hard I couldn't breathe. His pain of being widowed and charged with raising five kids on his own became all-consuming. There

was no room in his heart for whatever my small mind was conjuring. He never answered my question.

My mother left without knowing that I'd be unable to see love without a veil of assumption that I had to earn it. She left without knowing that for years my tears would come without warning, that when my friends' mothers would say something endearing and light-hearted to their daughters, I'd long to be their daughter, too. She left without knowing that I would never stop looking for her in the faces of complete strangers. She left without knowing that in her absence, with no adult in my life capable of showing me otherwise, I would develop an intense need to please people—so much so, that all they had to do was look my way long enough for me to give them everything I possibly could. I told myself the lie that if I loved others enough, gave them everything they wanted, then I'd be loved and never again abandoned.

When my mother died the truth about love died with her. Love became a chore. Conditions for love became the norm. And so began the lies to myself about what love was.

Discussion Questions

- As children we make sense of events in our lives from an unreasonable logic that adults wouldn't even consider. It can shape our thinking in ways that our adult brain is blind to, creating the foundation of how we manage our adult life. What unreasonable logic has the child in you used to make sense of your childhood events, and how might that have driven decisions as you grew into adulthood?

- Parenting is never easy. It's a long-standing joke that therapy in adulthood is all about blaming our parents, because all of us have been screwed up by them in one way or another. However, blame never facilitates healing because we then give up our control. We can't control others and we can't change events; we can only control ourselves and change the way in which we think. What have you blamed your parents for and how can you take back control? Is there any compassion you can find for why they did what they did or behaved the way they behaved?

CHAPTER 2

Conditional Love

That was the problem with conditional love.
It never happened on your terms; it happened on theirs.
—Shannon L. Alder

My father had five kids from his first marriage—children he was already woefully unavailable to—and then he had the five of us who'd just lost our mother. I won't speak for my siblings, but I know he simply could not fathom the deeply toxic mindset my mother's death instigated in my impressionable brain. When he married another woman before the second anniversary of my mother's death, there was no way he could imagine how damaging she would be to my already tender psyche.

I learned early on how to spin the world to make it more bearable, starting with my dad's engagement to the woman who would replace my mother. Riding in the car one evening with my dad in the driver's seat, Ginny, my soon-to-be-stepmother, in the passenger seat and me in the back seat behind her, I leaned up and poked my head over the front seat of the car between my father and his bride-to-be. I turned my head to the right and asked, "When is the *exact* moment that I can call you 'Mom'?"

"Oh, honey," she laughed, "are you sure you want me to be your mom? Aren't you worried I might be an *evil* stepmother?"

"No way!" I said, "You're beautiful and so nice. You're going to be a perfect mom!"

All I wanted was to be loved and be part of a loving family, and in my mind a family needed a mom and a dad. I had no idea how confused my ideas about love had become. I had no doubt that my father loved me, but that's because I worked hard to meet his conditions for that love. He made it very clear when his kids were not being who he wanted them to be. If you accomplished something to make him proud, you were automatically loved because then he could brag, which he did immensely. If you didn't make him proud, you were forgotten. If you challenged or embarrassed him, you were shunned.

He worked in a mill, but in his mind he was never a mill rat. He ran for Alderman and won, and he read a lot. He often quizzed us kids on facts or vocabulary under the guise of "teaching," but we all knew it was just to impress us with his intelligence. He needed people to know that his job at the mill was important, and that he was very skilled at it. Love for himself had conditions, so naturally his love for others did, too. That's what he taught me about self-love.

I was a good student, always on my best behavior, and always did as he asked. Only one time did I challenge him, and I quickly learned never to do it again.

"I think I want to try diving," I said to my dad at the beginning of the summer I was to turn eleven.

"But honey, that's a bad idea," he said. "All Olympic champions have been training in their sport at a very young age, often since the age of three. You just won the State Championship this year, so now is the

time to push even harder if you want to make it to the Olympics." He was my swim coach, and he was determined I follow in my brother's footsteps. He and my mom had sent my brother, who was nine years older than me, to a prep school in Mercersburg, Pennsylvania to prepare him for the Olympics. In college he began training for the 1980 Olympics, but President Reagan boycotted those games because Russia had invaded Afghanistan.

"I know, but it's just for the summer," I reasoned. "I just want to try it." I'd been asking him for the past few years to try anything other than swimming. I loved gymnastics the most, but I also asked to do ice skating or dance as well. I just wanted to do something pretty, and to me that was not swimming.

He wouldn't discuss it with me further or give his consent—but the first day of swim practice I got into my suit, walked out on the pool deck, and past the meter pool to the diving well with the other divers. Diving wasn't really what I wanted to do, but I thought I had the best chance to get my dad's approval with a sport other than swimming since I'd still be at the pool. My dad didn't try to stop me. He allowed me that one practice. But he refused to talk to me on the way home—that evening, and the next day. His silent treatment became unbearable, so I relented and went back to the meter pool after one day of diving.

I would probably never be any good at diving anyway and end up cracking my head on the board, I told myself. I never again considered diving and immersed myself in my dad's dream of one day becoming an Olympic champion. The incongruence between my head and my heart about the Olympic dream and what I really wanted eventually drove me to having back problems, which gave my dad an excuse he could

tell others as my swimming career began to tank. Never again was I as much a champion swimmer as I was at the age of ten."

My stepmother, Ginny, was very hard to please and I believed she would leave me in some way if I didn't make her happy. I worked hard to do that; I picked up after myself, kept my room clean, did my chores and made sure not to do what my older sister did. My sister Carol, who's five years older than me, was more severely broken from our mother's death. She acted out with drinking, drugs, and regular insubordination. She'd been forced into my mother's tasks after she died, like laundry and dishes. She too did her best—until she couldn't take it any longer. She was chronically in trouble, as no one had the sense or empathy to try to understand her pain.

Ginny was obsessed with my sister's bad behavior and convinced I would do the same—which in her mind was the worst thing I could do to her. I needed to show her I wouldn't be anything like Carol. It turned out, it didn't matter if I didn't do what my sister did, because I got accused of it anyway. She would ignore the truth and the clear evidence that I just wasn't doing those things and be angry at me, slamming cupboard doors and giving me the silent treatment.

In the stairwell, one evening, as I'd headed to my bedroom, Ginny confronted me: "I know what you do during the day when I'm not home." It was 1979, the summer of my twelfth birthday. I was up every weekday morning for 7:00 AM swim practice, then rode my bike around with my teammate Debbie until our 4:30 PM swim practice in the afternoon. "I know you're in the park smoking pot."

"No I'm not!" was all I could say.

"You can't hide it from me," she said as she spun on her heel, went back to her bedroom, and slammed the door.

I stood there completely flabbergasted, wondering what "pot" was and having a pretty good idea it was something my sister did. Out of the blue she would accuse me of doing things I had no knowledge of nor intention of doing—including, eventually, sex with boys.

She constantly harangued me for the attention I paid to boys. She had conditioned me to believe that my behavior toward them was too forward because I had the nerve to call them or pursue them in some manner. She took every opportunity to let me know I would be considered "easy" and never be respected by the opposite sex.

One night when I was seventeen, I came home thirty minutes past my strict 11:00 PM curfew. "Of course you were out with a boy," Ginny sneered when she met me in the hallway to my bedroom.

I had been out with a friend, and we were with boys whom we had made out with. I hadn't had sex—I was still a virgin—but I had tried marijuana for the first time. After years of unfair accusations for doing what I was now doing, it seemed pointless to argue anything, so I said nothing as I waited for more.

"You know you're just going to get a reputation for being a whore if you keep this up," she said, so certain she was of what I'd been doing.

By the eighth grade I'd convinced myself I wasn't lovable to the opposite sex. I was rather plain looking, and I accepted that if I wanted a boyfriend, I'd need to give everything I had to get one. Ginny and my dad withheld their love if I didn't do enough, if I didn't make them happy. And Ginny further complicated my perception by twisting what I was doing into something I wasn't doing. The confusion that set in

devastated my thinking around getting love from others. I assumed that if I didn't get love from boys—or at least a reciprocation of my attention— it was because I didn't do enough for them.

Yet Ginny said it was because I did too much.

In my mind, Ginny was a second chance at having a mother who might stick around if I made sure I always gave her the answers she wanted—if I were the person she needed me to be. Then I could have a mother and no longer feel like a freak to my classmates whose mothers loved them enough not to leave.

Eventually, though, I ignored her and defiantly did everything she accused me of doing. I smoked pot, I drank alcohol, and I had sex with boys. Only I had no one to guide me and my thought patterns around the very complicated terrain of sexual intimacy and what a healthy relationship might look like. As hormones and my sexual curiosities began to take a deeper hold when I entered womanhood, they further perverted my assumptions that I wasn't loveable and my belief in how attractive I was to men. I was primed for wicked and confusing relationships as my low self-esteem formulated the lies I told myself about love.

Discussion Questions

- Does your love have conditions? Do your kids need to make you proud, or not embarrass you before they are loved? Do you confuse conditional love with wise parenting to keep your kids in line? It's harsh, but we've all done it because we do it to ourselves first. We withhold love for ourselves if we are not perfect, not making the income we want to make or have the friends we want to have.

- Can you see how removing your love conditions can bring more peace to you, to your family? Can you love others even if they don't accept your unconditional love?

CHAPTER 3

Dysfunction Incarnate

A people pleaser can only attract takers.
—Kyle Cease

I could hear him outside the door before he knocked. *Damn it!*

I'd finished my homework for the night, my roommate, Jenna, was out with her boyfriend, and I had the room to myself to watch my favorite sitcom, *The Cosby Show,* on Jenna's tiny five-inch TV. I contemplated ignoring his knock, but I didn't know how to lie and pretend I was asleep. I knew he could hear me, so I opened the door.

It was late September 1985, my freshman year of college. Jenna, also a freshman, lived with me in a two-bedroom student housing apartment on campus with two other girls who were sophomores. I guessed my other roommate, Lynn, who lived in the bedroom next to ours, had let Jeff in the apartment. He lived across the hall with two other guys, all of whom were juniors. Jenna and I had partied with them a few times. The day we moved in, Jeff was immediately smitten with Jenna and not the least bit shy about saying so. It was clear the guys were not at

all interested in me. I thought Jeff's roommate, Scott, was really cute, and he was nice to me, but when I sat next to him during our drinking game, Quarters, he avoided eye contact and was careful not to bump me. It hurt that Scott didn't seem to reciprocate my attraction, but I let it go. I had absolutely zero interest in the tall, dopey Jeff with the dark hair and perpetually crooked brown plastic glasses, or in their other roommate, Louis, a large, hairy man who bossed others around to hide his own insecurities. Jenna ate up Jeff's attention and flirted with him despite the fact that she had a boyfriend whom she'd followed from across the state. They had been dating for three years. When he decided he wanted to go to a technical college she applied to the state university in the same town, and, as fate would have it, became my roommate.

"Hi." Jeff's goofy smile had done nothing to make me happy to see him. "Where's Jenna?"

"She's out with Mark," I said.

"I'm sure she'll be home soon," he retorted. "I think she's going to break up with that guy. They've been together forever! She's so damn cute and she's wasting her time with him."

"Yeah, well, I don't know that she has any plans to break up with Mark, and I have no idea when she'll be home. I'll tell her you came by, though," I added, glancing toward the door. I hated to sound rude, but I badly wanted him to leave.

"That's fine. I'll just hang out with you until she gets back."

"I'd rather you didn't. I'm watching TV."

"What are you watching?"

"*The Cosby Show*," I said as I climbed back onto my bed, careful to keep my calf-length flannel nightgown pulled down as far as possible. I sat on my bed, straight-legged, tucked my nightgown far under my

thighs, and put the tiny TV on my lap. I was intent on showing him how my plan did not include him.

"Cool! I like that show," he said, ignoring my gestures, and sat down right next to me on the narrow twin-sized mattress. He moved the TV onto the bed down by my feet and flopped his legs up on the bed next to it. I scooted toward the wall, wishing I could just go right through it.

"The TV is too small to see that far away," I protested. "It's really not a TV for more than one person to watch. Will you *please* leave so I can watch this by myself?"

"I like you, too, you know," he said as he awkwardly tried to put his arm around me. Mid-air he changed his mind and rested his hand on my thigh instead. "You're really cute, too, especially in this nightgown," he said, rubbing his middle finger on the fabric. "I just want to see under it," he said as he began to pull it up. I grabbed the fabric in my fist to keep it in place.

"Come on! It's what college kids do! You can't tell me you haven't done it before."

I knew immediately he was referring to sex—and he was right, I had done it before. I was only eighteen, but I'd had sex a few times in the last year, and I'd had it with a couple different guys. But he didn't know that. His assumption that I was experienced, that I was easy, loosened my resolve. I was a slut. It was true. Ginny had made that clear. "You make it too easy for them, Carin," she'd said as she stood on the landing in her pink curlers and sea-foam robe, hands on her hips.

What reason could I possibly have to stop him?

"Jeff, please don't." *Why did I let him on my damn bed?* I was stupid to trust him, to even let him in the room. Stupid to trust that his attraction to my roommate would keep him from pestering me. But

he said I was cute, and that he liked me, too. I didn't think any of those guys noticed me. I wanted to be noticed, didn't I?

I kept my head down, avoiding his face and those dorky glasses as he continued to fondle my nightgown. I saw his erection through his jeans and started to panic. The Wendy's "Where's the Beef," commercial came on.

"Watch this! It's hilarious!" I laughed. I snapped my head up to look at the TV, hoping he'd hear the panic in my voice.

"Do you have underwear on?" he asked.

"Yes," I answered quickly and loudly.

"It's really no big deal. College students do this all the time!" he said again as he unzipped his jeans and his erect penis popped out from his boxers. I didn't look at him. I kept my eyes fixed on the TV as he pulled down his pants and rolled on top of me, seemingly in one move. The TV thumped to the floor at the foot of my bed as I realized I couldn't find even an inch of room to move away. He grunted as he pulled even harder on my nightgown to lift it up. He was thick through the middle, out of shape.

"Come on! Help me out! Pull down your underwear!" He was already out of breath and sweating, his glasses barely hung on the tip of his nose. "I promise I won't tell Jenna, I won't tell anyone! You're just so damn cute I can't help myself!" He got my nightgown up just far enough to press his naked penis hard into my cotton underwear. "You don't even have to take them off. Just pull them down a little so I can get in."

I'll never escape him. He lives right across the hall. If I try to get out, I'll never live it down. He'll tell everyone I pushed him off me, and they'll all hate me. Jenna would know I was a slut, that I'd let him come on to

me, and she'll hate me. If I fight, it will get ugly. How can I tell people I didn't want this when I let him in my room—let him on my bed? They'll all think I'm a bitch if I don't let him do what he wants. I've done it before, it's just sex. If I just let him, it will be over in a few seconds and I can get my evening back. He's right, it is no big deal. It is just sex, and he won't hate me if I do. He won't tell everyone I'm a bitch if I just pull down my damn underwear.

Without allowing another thought pass through my mind, I pulled down my underwear.

"This isn't Burger King, you can't have it your way," I heard Cliff Huxtable say as Jeff stood and zipped up his jeans. I pulled my nightgown down and turned to face the wall. "Please don't tell Jenna," he said, and then added, "I promise I won't tell anyone."

I said nothing. I lay there facing the wall with the window above me—irrationally thinking about the open curtain when I realized that the apartment was on the second floor, and the window was too high above me. *No one could have seen us. They wouldn't have seen my resistance; they wouldn't have heard me say, "please don't." It would be my word against his—the word of a slut against the word of a man. It is 1985. I've made the right decision.*

The word *violated* showed up first. It was a few days later as I walked home from class trying hard not to think about what I couldn't stop thinking about. I was alone. I preferred it that way. I avoided everyone. Then the word *rape* crashed into my head like a screaming banshee through the fog. I had to face the term, but I stopped my head before the word victim could push through. I wouldn't allow it. I didn't want to be a victim. I didn't tell anyone because no one would believe me—or

they would probably think I deserved it. Could I even call it "rape" if he didn't hurt me? If I didn't fight him?

I told myself for the millionth time that I'd made the right decision to just let him do it. I pushed it all to the back of my mind and I fought hard to let it be forgotten. *Just keep your mouth shut about it and it'll be okay,* I lied to myself.

But I couldn't keep my mouth shut. A year had passed and Jenna and I were roommates again, this time just the two of us in the dorms. We became really close. I decided to tell her about Jeff because I needed someone to know, someone to understand and validate me, someone to give me the love I couldn't give myself.

"I have to tell you about something that I haven't told anyone," I started, frustrated that I was visibly shaking.

Jenna just gave me a look to go on.

"Early last year, when you were out one night with Mark, Jeff came over," I said. She still just looked at me so I continued. "I told him you'd be home any minute, and he insisted on staying until you did. I tried to tell him to leave, but he sat with me on my bed." My body suddenly felt like a robot. I stopped shaking. I should have been crying, but I couldn't feel anything. The intensity of what I was about to say completely choked off all the emotions I had and I told the story like I was reciting a times table.

"He had sex with me even though I told him I didn't want to and tried to get him to leave."

Jenna looked at the floor for a long time until she said, "I don't even know what to say, Carin," without even looking at me. Her saying my name felt like a righteous slap.

I knew she wasn't seeing this as it happened, so I decided to come out and say it. "He raped me, Jenna." I said. "I knew I didn't fight and I had no proof, so I didn't tell anyone, but—"

"Yeah, but I dated Jeff, and he isn't capable of rape," she said forcibly, cutting me off.

"I'm so sorry, Jenna, but I never meant for it to happen, it just did," I said, suddenly losing my resolve.

Her tone drove me to accept full responsibility for my reprehensible behavior. Shaking her head, she said again, "I really just don't even know what to say."

I was devastated. If she didn't believe I was raped, then she believed I was a shitty person who would sleep with a guy who had a crush on her and then try to pass it off as rape—which was even worse. I felt guilty and stupid and I wished I hadn't said a damn thing. *Why do I always feel like I have to tell the truth? I should have stuck to my initial pledge to myself to never tell anyone, especially not Jenna.* It felt logical that telling her would make me feel better. I did sense that something within me didn't think so and seemed to be pushing me to shut up. Given how things went down, I shouldn't have ignored that part of me.

I cherished our friendship like no other friend I'd ever had. I believed we were devoted to each other. So when she proved that she was far from devoted to me, I wouldn't allow myself to see it. We avoided each other for a few days until our routines of school, work, and homework pulled us past my confession as if I'd never said anything at all. I was frightened at how close I believed I'd come to losing my best friend. I told myself to never bring it up again.

It worked. Jenna and I remained friends and became closer than ever because I accepted her judgement of me while I judged myself even

more—a deeply unloving act I committed upon my own heart.

She'd given me another opportunity to tell myself lies about how and why people love me. I suppressed the truth about what real love should look like coming from a friend. It never occurred to me to demand that she understand what I'd been through. I didn't have the self-respect necessary to leave that friendship in the dust, or the confidence that I'd ever deserve another friend.

Discussion Questions

- Have you ever been overpowered and coerced into doing something because of your need to please and not be judged? How deeply did that affect you? How willing are you to look even more deeply into why you allowed it to happen? How can you make sure it never happens again?

- Do you have friends who don't have your back one hundred percent? Can you see how unloving that is to yourself?

CHAPTER 4

Love Intentions

What you see reflects your thinking, and your thinking reflects
the choice of what you want to see.
—*A Course in Miracles*

After the incident with Jeff, I couldn't let go of thinking that it was my fault. I knew I needed to attend to my feelings, to be angry and feel hurt, but I couldn't shake the confusion in my head that told me I didn't have the right to feel anything. Instead, I buried my feelings and questioned myself: *I did what he wanted so why did I feel so wrong?* I knew I liked sex, yet it was unfair that it seemed it was always wrong. I didn't want to have sex with Jeff, so I knew it was wrong that he pressured me, but why couldn't I just let it go? Why did I feel guilty, and why did I care if he wanted me when I certainly didn't want him? I tried to dismiss Ginny's assessment of me because in my heart I knew it was bullshit, yet something within me felt so icky about myself and I hadn't the support of anyone—certainly not Jenna—to tell me otherwise.

As I buried the pain and anger, a bewilderment settled in that became yet another lie I told myself about love: If a man said he loved

me, he couldn't possibly hurt me. I thought I'd found a way to identify a healthy relationship and avoid the unhealthy ones.

I concentrated on school and kept my head down, until I happened upon a guy who lived downstairs from my apartment.

Seth initially impressed me with his gentle, intelligent demeanor and soft-sounding name. He was night-and-day different from Jeff and all the other guys Jenna was hanging around with. He was different from any guy I'd ever been attracted to, and I thought this was a good thing. We talked for hours and I felt like he really listened to me. I didn't think he was my type physically, but I told myself I didn't know a damn thing about what I wanted. Every guy I ever liked never really liked me back, not enough to make me their girlfriend, anyway. This guy was nice to me, so I decided his pudgy physique and Charlie Brown head were endearing.

Seth's attention allowed me to believe that I hadn't been broken by Jeff. After a few weeks of seeing him, he told me he loved me. I'd never been told that by a guy before. His declaration made a huge impression on me because I believed I was not lovable. I wasn't conscious of that belief back then, but it's what had me walk right into Ginny's prophecy. If a boy was going to give me attention, I was going to take it or I might never get it again. I'd surmised that's how I got raped, but I'd learned from that situation. I was never going to let something like that happen again.

Only what I let happen was even worse.

I believed I was safe with Seth because he said he loved me. Those three words, *I love you*, were his ticket to treat me like a demented boy treats his pet. He loved how clever he was and was forever tickled by his ability to manipulate others. He had me perpetually confused with his

early and frequent declarations of love juxtaposed with his tormenting behaviors. Often he'd tease me and try to pass it off as loving, as something any boy would do to a pet he had no real empathy for. Everything he did felt increasingly more like mockery than endearment.

"What the hell did you do?" I said to Seth when I walked into the kitchen of my apartment one evening. He was supposed to be making macaroni and cheese for our dinner, but instead I saw him at the stove, giggling.

"Nothing!" he laughed, "I just put all the knobs on backwards and turned the burners on."

"You can't just do that!" I yelled, trying to reach over the burners and the boiling water to turn the knobs to *off* but getting confused as to which position was *off* and which was *high*. He laughed even harder as I began to cry with frustration and had to keep pulling my arm away to avoid getting burned. I eventually figured it out while he continued to laugh at me and tell me I couldn't take a joke.

I endured countless episodes of this kind of insult, and it progressed to him not taking no for an answer when he wanted sex. Every time he would persuade me with his declarations of love and how much he needed me. I'd relent because I liked sex and because my adolescence taught me that I had no reason to expect to be loved by a man. He used those three magic words that I desperately wanted to believe, and there was no way I was going to mess that up.

I put up with him for six months before I began to sense that I should have been treated better. I didn't want to acknowledge to myself or to anyone else that I was being sexually abused in some subtle way, but I did start to formulate a plan to get out when he came to my apartment one afternoon manic with excitement.

"You'll *never* believe the awesome night I had!" he blurted.

"Really? What happened?" I asked, smiling with his excitement.

"You know that slut cheerleader, Sherri, who fucks all the basketball players?"

"Yeah," I said tentatively. I didn't know Sherri well, and I knew she dated a lot of the players on our Division One team, but I cringed at him calling her a slut because I didn't know her and I knew he didn't either. The name seemed unfair.

"Well, we just *fucked* like four times! She couldn't fucking get *enough*!" He bounced around the room in his excitement, giggling like a creepy, over-sized toddler.

"Jesus Christ, Seth, what the hell?" I glared at him waiting for him to say, *Just kidding*.

"What? It's not like I'm *in love* with her! It was just fucking. Don't make a big fucking deal out of it!"

I walked across the room, giving no comment, being careful not to look at him, and headed to my bedroom in the back of the apartment. He left the apartment with a giant slam of the door. I couldn't help but think that Sherri might have been too drunk to fight him off.

I tried to avoid him after that, but he kept showing up in my face, at the apartment, on my way to or from school, in the school hallway. He was always coming at me, never apologizing, expecting that I should be supportive of his blatant infidelity. And because I was not, I was called out for being "too uptight."

I knew I had to get out, but I didn't know how I could when he was in my face every day. I still had a few more weeks to go before the summer break could get me physically away from him.

The last day of the school year finally came. I was scared. Deep down

I still believed his love was a gift that I should honor, but when he insisted I show my love for him before our summer hiatus by participating in a threesome with his best friend, I knew I'd had enough. I said I couldn't, and he began to rant. I finally walked away, empowered by his friend's insistence that it was my right to say no.

Even then, I struggled to completely break it off. But I took comfort in that fact that he was a hundred miles away from me, so with my heart pounding and my words smothered in tears, I called from home that summer to tell him I would not be his girlfriend our sophomore year.

I knew I'd been abused, but because I'd gotten away from him, I thought he'd made me wiser. *No one will treat me like that again*, I decided.

But I still had no idea of how little love and respect I had for myself, how badly I needed to please others, and how vulnerable that left me.

I dated a few other guys over the next two years. They were decent. However, my confusion over relations with the opposite sex was not resolved. And the concept of self-love was as far from my consciousness as the idea of personal growth. I was steeped in the naive notion that I just needed to be a good, honest, considerate person and I would be supplied all the love necessary to thrive. I never imagined that I didn't need to rely on others to love and respect me; I never imagined that I was capable of giving myself all the love and respect I needed.

When I met the man I was to marry, I told myself I was over whatever insecurities I'd had about dating and relationships. We met several times: at the record store where he worked, at a dance club where he worked as a Video Jockey (VJ) and at a bar where his band played.

I believed that fate had destined us to be together given that we kept running into each other. Then we got to know each other when I got a job at the same nightclub that summer between my junior and senior year to supplement my summer job as a lifeguard and swim instructor.

When we started working together, I was immediately impressed by how responsive he was to me. He never tried to hide his attraction, and when the club was slow, he'd shine the spotlight from the VJ booth at me as I worked behind the bar—letting everyone in the place know he liked me. I loved the attention and soon we were a couple. It was refreshing because I'd never had a guy—other than Seth—whom I was attracted to who clearly reciprocated my attention. Yet he was nothing like Seth. He was handsome, attentive, and respectful regarding sex—and he wasn't so overtly controlling.

We saw each other as much as we could, given that both of us were working two jobs at about sixty hours a week. We went out to dinner often, and he paid almost every time. I went with him to band practices and swooned over his songwriting skills whenever he'd present new material to the band. He was a good songwriter. I loved being "with the band" too, when they played shows around town. They were a really great original music band, only occasionally playing covers. He clearly loved to be up on the stage and playing for people. I tried to ignore the fact that he was more passionate when playing that bass than he was with me.

I certainly matched his music passion on the dance floor. Dancing is always where I find my happiest moments. I don't even care if others like my dancing—as I often close my eyes while I'm on the dance floor. I just let my hips take on the beat as if they're the ones actually hitting the drums, and the rest of my body follows.

I was often complimented on my dancing, but my new boyfriend never did. In fact, he seemed determined never to compliment me. That was okay with me, though, because he was with me and everyone knew it. I told myself that was enough.

Often, in our twenty-seven years together, Marty would recount a scene from that first summer we dated, using it as proof for how much he loved me. He had been out with his friends at the bar we worked at and asked me for a ride home after my shift. He'd been smoking pot in the parking lot and had the inevitable munchies. On our way to his friend Jacob's house—where he was staying that summer—he asked me to pull into the parking lot of a convenience store.

"Will you please, pretty please, go in and buy me some Cool Ranch Doritos and a tub of sour cream?" he asked. "As soon as my face hits those fluorescent lights, my eyes will bug out and everyone will know I'm totally stoned."

I laughed at his paranoia and got out of the car to go and do what he asked. When I got back to the car, he said, "That's why I love you— that you would do that for me."

Something felt off about the comment. I felt embarrassed for him and the slightly unnatural grin on his face. It wasn't the first time he told me he loved me—he'd been saying that two weeks into our dating, which I thought was too soon—but again, I wasn't going to deny the gift horse. That night I knew he was appreciative, and trying to be sweet, but something nagged at me. Was it that it was still too early in the relationship for him to be saying he loved me? Was it that there had to be other reasons why he loved me? *Can it really be love if it's about what someone does for you?*

But that's exactly how I earned love from my parents—because of what I did for them.

I decided I was being ridiculous and chose instead to be happy. I had a man who said he loved me and he didn't mock me or push my sexual boundaries. I compared him to Seth often, and in my mind he always measured up to be a far better guy. I was lucky to have him. If he said he loved me, then I would love him for who he was—or who I thought he was.

After several weeks of dating, we decided it was time for the relationship to be consummated. Neither of us had our own place—I was living at home, and Marty was living in his friend's parent's basement—so we had to get creative about where we were going to "get it on."

It was my idea to sneak the key from my parents' motorhome and have a copy of it made. After dinner and a movie one evening that's where we headed.

We'd made out a few times before and it always bothered me that we didn't seem to have any physical chemistry despite getting along so well. I'd told myself he was just holding back. If we were to have the freedom to go all the way, then the real magic would happen.

But it didn't. It wasn't awkward or rushed, but I really wished we could have had that powerful, sexual intensity I fantasized I'd have someday with the man of my dreams. I was on the bottom, and when I rose up to kiss him, he turned his head like he was worried about breathing in my face and didn't realize what I was doing. Other than our initial foreplay where I initiated the kissing, he didn't kiss me. That seemed weird, but my body was responding to him. All my erogenous zones were firing. I concentrated hard on my body's sensations well enough to feel something close to a climax.

As we lay together after he'd climaxed, he asked, "So, did you get excited?"

I wasn't sure how to answer, as once again, I'd had to work to feel aroused, but I didn't think he meant that. "Are you asking if I climaxed?"

"Yeah," he said.

"That's a really sweet question, but. . .well, no, I didn't," I said, and then immediately added, "But that's okay, I never do the first time. It'll take me awhile, but that doesn't mean it wasn't good!"

I was heartened that he even cared to ask. No guy had ever asked. I clung to the idea of his caring for the sake of making this night memorable. I was still bothered by the lack of sexual intensity or connection, and it was odd that he wouldn't kiss me, but I told myself we had the makings to build up to that.

Thinking I could spark things up, I brought up the night of our first date when we'd jumped the fence at the pool I worked at and had our first make-out session in the shower. "You know, that first date we had in the shower," I said as I got up on my elbow to smile seductively at him, "I might have been willing to go all the way that night if we'd had a more comfortable spot." Before he could say anything I added, "I think that ever since I met you, I've really felt like there is something special about us, like we were destined to be together."

I had confidently bared my soul to him, revealing a spiritual belief about our being together that we hadn't ever talked about, so I felt like a complete fool when he said, "Yeah, but if you had gone all the way, I probably wouldn't have gone out with you again."

I was stunned. I didn't know what to do with that. It felt undeniably insulting and brought on a rush of guilt and memories of Ginny calling me a slut. He didn't say he loved me. He didn't acknowledge my comment about feeling we were destined to be together. He just said this shitty thing.

I said nothing. I allowed the insult to slide somewhere off into the periphery of my mind where all my doubts about our connection were beginning to collect. I focused on what I could say so that he wouldn't feel bad about implying that I would have been too much of a slut for him if we'd gone all the way on our first date. Rather than kick him out of the motorhome, I fought my heart to make room for my justifications of his behavior. I had to. He was the best boyfriend I ever had and I was too afraid I'd never have another opportunity to be loved.

Discussion Questions

- Where in your life have you wanted something so badly that you willingly looked the other way instead of recognizing the evidence that it was not in your best interest? Why did you do that? Can you see how unloving that was to yourself?

CHAPTER 5

The Lie Deepens

Once you give a charlatan power over you, you almost never get it back.
—Carl Sagan

When I went back to school for my senior year to complete my Bachelor of Science degree in Human Biology, I allowed myself to believe that I'd met the man who would marry me and love me forever. I wanted love so badly, no amount of shitty comments or passionless sex would sway me from my happily-ever-after lie. I became entrenched in the habit of blaming myself for whatever was amiss between us. Any problems I saw in our relationship I took it upon myself to find solutions in either my behavior or my thinking.

One of the problems I saw in our relationship was that Marty was shy about giving me compliments or telling me he found me sexy. And weirdly, he still wouldn't kiss me during sex. I was determined to find a connection to him that we could enjoy sexually, so one night after we made love, I began to fish for some kind of understanding for why our lovemaking was so bland.

"What's the best sex you ever had?" I asked, trying to influence a seductive intensity and maybe go for round two. I hesitated to add "with me" on the end of that sentence, but before I could, he was already answering.

"With Marissa," he said, referring to the girl he dated before we got together. "She and I were at her dad's house in the living room. It was soooo hot," he said, "it totally felt like I had an out-of-body experience. It was the only time I can think of that I could do it more than once," he added.

"Were you stoned?" I asked, trying to be cool and hide my hurt.

"No! That was the best part. We weren't, and we weren't drinking. It was just so intense."

"Oh," I said. I didn't know what to say after that. I thought he could have at least been a gentleman and lied, but I got the answer to my question and wondered what the hell was wrong with me that we didn't have that same passion. I felt stupid for asking the question.

I was more confused and frustrated. I began to settle into the idea that I just was not someone like Marissa who inspired powerful sexual excitement in a man. I just wasn't that pretty or sexy. I eventually drummed up the courage to get Marty's permission to use my own fingers, so I was successfully having orgasms during sex, and it was good. He always let me climax first, and I felt like we had settled into a comfortable physical relationship that I could live with. *There don't have to be fireworks for there to be love*, I told myself.

I couldn't see that it was a lack of emotional intimacy that snuffed out the fireworks, indicating a far bigger problem that would eventually suffocate our relationship.

I was content in believing that our souls were meant to be together, so I let go of any need for validation from him. I'd begun to develop

my own spiritual path—having rejected the Catholicism of my parents and any other organized religion because of the hypocrisy I saw. I truly believed that people are destined to be together, but I didn't try to evaluate why we were together other than for love. I pushed aside every feeling of disappointment or hurt because dating was so damn hard and I just wanted to be done looking. I was determined to spend the rest of my life with this man, convinced he was meant for me.

I've never let go of the belief that fate aligned us. To this day I believe he and I were together for a reason. But it took me three decades to fully realize that the real reason was for me to love myself—that his inability to love would facilitate my learning how to do it on my own.

It was Christmas of that year when my sister from my dad's first marriage came to visit. She was going to school for optometry in Chicago, and her timing in my life at that point couldn't have been more perfect. I had been in a significant crisis of spirit over what I wanted to do after I graduated. I'd been striving for medical school, but I struggled with my GPA and I was failing the required Organic Chemistry class so badly that I had to drop it, disqualifying me for med school. But my sister had an answer that I quickly glommed onto—because optometry school didn't require Organic Chemistry and their GPA requirements were not as stringent. By March I had gotten a job with Pearle Vision so I could get a taste of the profession, and I formulated a plan for my career from there. That meant a fifth year of undergrad to obtain the full year of Physics credits I needed for optometry school. I was determined to do it.

When I got accepted to the Illinois College of Optometry, I told Marty how excited I was to be a doctor.

And he said, "Really, now you're going to be a doctor," with a roll of his eyes.

I immediately chastised myself for bragging. I knew he felt insecure about having only gone to one semester of college. I was being an asshole for rubbing it in that I was more educated. So I made a point to remain humble regarding my education.

Those four years in Chicago were not easy on our relationship. Marty stayed in Appleton to keep his job and be with the band, but I was determined to beat the statistics on long-distance relationships and keep us together. I had my man, and I had my career and life plan. We just had to survive four years apart and we would have the loving marriage and family I'd dreamed of. I hardly socialized in school because Marty made frequent comments about his fear of my cheating and I never wanted to give him reason to think I might.

He rarely came to visit, which I justified because he needed to work on the weekends and often his band had gigs, so it would be easier for me to make the three- to four-hour drive home so I could study on Saturday while he worked and then spend time with him when he was off work on Sunday.

I didn't have much contact with Marty between trips home. It was the early 1990s, so it was before cell phones. I quickly realized relying on phone calls to keep us connected was painful. The few times I'd call, I'd have to fight to keep the conversation going using high energy and positivity to downright sickening levels.

One call in particular, during my first year, always stood out to me. I was studying for the first set of finals and I hadn't been home for almost three weeks. The weekend was approaching, and I knew I had to stay in town to study for the last two exams I was going to have the following Monday. When Marty got on the phone, I could tell he was particularly unenthused.

"Hey sweetie, sorry to bother you, but I miss you and I'm sick of studying so I thought I'd take a break and call."

"That's nice," he said.

"You know I'm coming home Monday night, right?"

"Yeah," he said, "you told me that before," which I knew I did, I just couldn't tell if he remembered, and I was hoping I could invoke some comment to indicate that he looked forward to seeing me.

"It's been a few weeks since I've been home. Have you missed me?" I asked. I realized I was being ingratiating and wanted to kick myself for it.

"Of course," he said.

I tried to ignore the eye roll I imagined him doing.

"I'm listening to The Jam CD you loaned me," I said as I turned up the volume just high enough for him to hear Paul Weller sing *Oh baby, I'm dreaming of Monday.* I held the phone to the speaker, and then turned it back down as I got back on the phone and said, "I know, I'm a dork," I laughed.

"Yeah," he said, giving me the impression that he wasn't really even paying attention. He didn't laugh. He wouldn't engage in the conversation.

As we said our goodbyes, I had to work to brush off the heavy feeling I got from him. It wasn't his fault, though, I knew he hated to talk on the phone, and here I was trying to push the conversation for my own peace of mind.

While I was in optometry school we bought some furniture together for his apartment with the idea that it would be ours when I was done with school and we moved in together. We put the queen-size bed, couch, and love seat on my credit card, and I made regular payments, accepting that he would pay his half in one lump sum when he got his Christmas bonus. His bonus was always pretty hefty, so I didn't worry that he'd be able to pay me.

By the time I got home for Christmas break, he had received his bonus. With great excitement and fanfare he showed me the new VCR, the stereo receiver, and several music CDs he'd bought with his bonus money.

"Wow! This is great! I can't believe your bonus was so big that you could afford all this *and* your payment on the furniture!"

Suddenly the energy in the room shifted. He said, "Goddamn it! Of course, you're so fucking uptight you had to bring up that damn credit card before I could show you this," he said, holding open a jewelry box with a small opal pendant.

"My God! How much was that?" I asked.

"I spent two hundred dollars on this *for you*, so get off my fucking back!" he yelled. "I needed this stuff! This old VCR doesn't work for shit!" he screamed as he threw the old one on the living room floor. "And I work my ass off! I should get what I want! Goddamn it!"

I couldn't believe how intense he was. This was our first major argument after over two years of being together, and it scared the hell out of me. He stomped around as he drove home the point that it was his goddamn money and that I should leave him the fuck alone.

I was in shock. I thought we were so solid because we never, ever fought. And I didn't want this fight. I couldn't justify his behavior this time, but I didn't know what else to say or do, so I let it all go to a foggy place in my head where all the confusion I had about him was continuing to accumulate. Several weeks later he did give me some money; but he never fully paid for his half of the furniture he and his roommate got to use while I was in Chicago.

One weekend I came home to find a pair of large, teal-colored hoop earrings on the table next to our bed. "Whose are those?" I asked.

"Oh, yeah, Shelly got really drunk here the other night for the Packer game so I let her sleep in the bed and I slept on the couch," he said.

Something in me was screaming, but I stuffed it down. I didn't want to believe that my boyfriend—who was forever on my case about any guys who gave me attention in school—would cheat on me. Not in the bed that I bought for us, the one he said he'd pay half of and never did. He took every opportunity to remind me of his first major girlfriend who cheated on him, how much that hurt him, and how important it was that he could trust me. And I took every opportunity to prove to him that cheating was the last thing I would ever do to him because I loved him so much.

Then he proposed. I knew he was going to. We had discussed it. I told him that he needed to know that I wanted kids—at least two or three—and I said he'd need to be sure he wanted them, too, before proposing. Because that was non-negotiable.

I really was unhappy in the relationship but I couldn't understand why. I tried to blame it on the stress of graduating. I made an appointment with the psychiatrist my school's Dean of Students recommended after I had confessed to him that I was really scared about starting my career as an optometrist. The Dean validated my fears by telling me it was very common for graduating students to freak out about leaving school and taking on the responsibilities of a doctor—and he told me that they had a psychiatrist who would see me at a discount.

It was my first time seeing a psychiatrist. I was quite intimidated to see him. But he blew me away when he asked me if I believed in reincarnation. He used a hypnosis technique that he said could bring his patients back to incidents in their lives where their fears and issues

had their root. He explained that sometimes that meant going into past lives. I immediately said yes to another appointment where he would attempt the hypnosis—but he was unable to hypnotize me. I could only afford the two sessions with him, and I never fully addressed my fears about my relationship. But he did recommend a book on reincarnation called *Many Lives, Many Masters* by Dr. Brian L. Weiss, who had had great success with the hypnosis technique the psychiatrist used. That book didn't give me the answers I needed regarding my relationship, but it did lead me to find another book called *Why Me? Why This? Why Now?* by Robin Norwood. I found fulfillment in these books; they were deeply inspiring and started me on a spiritual quest to seek a greater understanding of reality. But they actually took my mind off making a decision about marrying Marty.

I believed Marty would break it off when I insisted on kids because I suspected he didn't really want children. Perhaps my heart was trying to convince my head to make a break for it. I should have paid attention to how okay I would have been if he didn't propose. But when he did, I told myself maybe he really did love me. I was so close to my dream life of having a husband, a career, and a family—and I was afraid that I was too old at the age of twenty-six to find another man who would love me and marry me in time for me to have children.

At this point I'd been with Marty for six years. I presumed it would take another six years to get to the point of marriage with another man and I felt I didn't have that kind of time. I'd invested all these years in Marty, so when he agreed to have kids, I decided to marry him and not look back.

The lies I told myself about love were piling high.

Discussion Questions

- What beliefs do you hold about why things happen to you or who is in your life? Are there other possible perspectives you can give yourself? If so, what possibilities might that hold?

- What limitations have you placed on your future based on your beliefs and insecurities? Brainstorm on what's possible if you remove them.

PART TWO

COUNTERFEIT LOVE

CHAPTER 6

Blissful Illusions

The worst of all deceptions is self-deception.
—Plato

The wedding ceremony was in the lovely courtyard of Le Bon Appetite restaurant in Appleton, Wisconsin on August 19th, 1995. My dress was gorgeous. There were three parts to the traditional white ensemble: a simple slim-fitting, mid-thigh length tunic in smooth-as-milk, silk fabric with a wide off-the-shoulder collar and a straight, full-length, lace skirt. The third part was a sheer fabric train that attached under the collar behind my shoulders, gathered at my waist by a belt made of white silk roses, and followed behind me about three feet. My friend Kyle created it. He'd also designed many of the suits and dresses I'd worn to work. His designs always gave me confidence, and my wedding dress was no exception. He made me feel more beautiful on my wedding day than I had ever felt in my life.

I wanted the ceremony to be magical. Given the reservations I'd had about getting married, and the long-distance relationship we endured, I wanted the ceremony to reflect a real and undeniable commitment to each other. Neither of us was religious, so we didn't have someone from

the clergy marry us. In the state of Wisconsin, there is no such thing as a Justice of the Peace. The only other option was to have an attorney perform the ceremony. It bothered me how that didn't feel particularly romantic, so I wanted to put extra effort into our vows. I'd hoped to find words that would reflect the deep and unique love I believed we had for one another. I'd wanted us to each write vows declaring our love and saying why we thought the other was special enough to commit to for the rest of our lives.

I asked Marty if he would help me write them.

"I have no idea what to say. You can just write them," he said, "I really don't care."

I was disappointed, but I understood because I didn't know what to write, either—especially if he didn't care. Since I'd begun to delve into spirituality, studying reincarnation and alternate philosophies about our existence, I wanted to incorporate that into our vows, but I had no idea how. Marty did not get into studying or even discussing spirituality, so I was on my own in finding the words to truly express our love and commitment to each other.

Despite the lack of inspiration from my fiancé, I found some stock vows that kind of aligned with what I wanted for us to say to one another. Yet in the end, our exchange of words had no soul, no heart—and I was frankly embarrassed by them. Still, no one else seemed to notice. As it was a hot August day in Wisconsin, there were plenty of bees attending the wedding who were flitting about the flowers and threatening the guests. I think they captured more attention than our stupid, humdrum vows. In fact, many guests commented on how appreciative they were that the ceremony was so short.

In the receiving line, just after the attorney we'd hired to marry us had said *I now pronounce you husband and wife*, Marty's sister-in-law

was bursting to tell me, "You gave him your right hand! Your ring is on the wrong finger!"

I laughed as I quickly moved the ring to my left ring finger while everyone else around snickered.

"Yeah," Marty said, rolling his eyes, "I noticed that." He was always fond to point out my mistakes.

Then Marty's uncle said, "Maybe that's some kind of omen."

Everyone laughed. I fought hard not to lock my mind on it. I didn't want some kind of omen. I wanted to be happy.

My dad had the perfect idea for where to start our new married life: in the house he built for my mother—my childhood home. He wanted me to buy it. Without involving realtors, the price would come down for us, so it seemed like a good idea. I was in love with the idea of having a house for Marty and me to live in and start a family.

It was too big for a starter home. It was just under 3,000 square feet, with four bedrooms, and it needed some serious updating after my stepmother's tacky decorating assaults had wiped out my mom's decor. But Marty was ecstatic about the house and my dad was happy to sell it to one of his kids. Dad was nostalgic about it being the house he built for my mother, and he hated to see it go to strangers. Yet, I was nervous about buying such a big house. We could afford it, but it was going to be tight with my student-loan payments starting, and I wasn't sure I was going to be able to follow through with my plan to have them paid off in ten years to diminish the relentless interest.

But I let that all go. Marty was far too excited about the house, and my dad was so proud that I was the one to be getting it. Once again, it was more important to me to make others happy and set aside my own needs. And no one questioned me. My old home would now be my new

home with my new husband. I told myself that Marty and I and our future children could make new memories and make this house truly a home of love and happiness. We moved out of the apartment we had been in since I'd moved back from Chicago and moved into our own home. Dad and Ginny, newly retired, took off in their motorhome to roam the country indefinitely.

The night before we moved in, I wandered the house, allowing the memories of my childhood to wash over me. I wanted to connect to the happy times the house had hosted and find compassion for the unhappy times. I thought it best to confront the unhappiest times first, so I went straight to the master bedroom. As I stood in the doorway, I thought back to the morning my dad had told me of my mother's aneurysm. I could see my dad get down on his knees as I stood in front of him with his hands on my shoulders as if I were his support. He paused, looked me in the eyes and said, "Honey, your mother had a really bad headache last night. I took her to the hospital, and the doctors said she had an aneurysm. That's a blood vessel in her brain that burst open."

I could see tears in his eyes, and his hands were shaking. He was using big doctor words to try to mask the unthinkable meaning of what he was saying. I knew he was telling me something big, something life-changing.

Even then, as I stood there in the dark, panic set in as I relived his news.

"She's still in the hospital, but the doctors say she's in a vegetative state and she's not going to make it." I saw my dad like I'd never seen him before. He was still my dad, but I saw a man suffering. My dad was in pain and I wanted to take that pain away. I didn't want to add to it, so I didn't ask any questions. I had very little grasp of what I was being told, but I felt the emotion saturating the air and it scared me into submission. I knew questions would be an intrusion. He needed

my love, so I just let him hug me as I hugged him back. Many years later I'd learned that my dad had to make the decision that day to take my mother off life support.

Standing and trembling in the now empty bedroom that was to become my own, the scene that unfolded in front of me woke up emotions inside that I'd fought to address all these years. Why did she leave me? The logic of my adult brain told me things just happen, but the child inside me crumbled as I fell to the floor. That child felt responsible and stupid that she drove her mother away, stupid that she had no idea how much that would hurt. I lay in the fetal position on the floor and bawled. Waves of anguish threatened to wash all reason—all the lies I had told myself to stay afloat—from my mind. I was going to drown if I didn't grab on to the lies that buoyed my existence.

All I knew to mourn in that moment was my mother's death. It never occurred to me to mourn the innocent child who took it upon herself to take care of her father who was incapable of taking care of her.

I spun the agony of losing my mother to the fear of my future kids losing me—and then refused to allow myself to consider even that. I refused to have that heartache in this room. I sat back up and wiped my eyes. That horror of the kids I desperately wanted and didn't even have yet, losing me, had no place in the cheerful family life I had planned. There was no way I was going to die and leave them.

I neatly tucked back in the pain that consumed six-year-old Carin, while logic took hold and asked, *Why rehash that decades-old drama? Everything is going to be better than the childhood I lived in this house. There will not be dysfunction, there will be nothing but love and joy and days on end of happiness. I will make sure of it!*

I left the bedroom and headed toward the living room with my mind still on my mother. Even twenty-one years after she was gone her presence lingered in the deep rust-orange wool carpet she picked out for that room, still striking after all this time. It reminded me of the dress she was buried in. I could still see her in her richly multi-colored party dress with the long-sleeves and tiny fabric-covered buttons at the wrists. I always thought about how the colors of the dress complemented the carpet in our living room. I'd often wondered if she picked that dress out for when she and my dad entertained because they went together perfectly.

I thought back to the wake, to seeing my mother's body in the casket. I held firmly to the memories with calloused determination to push the emotions aside. I shook my head at little Carin who never understood that her mother was dead. I saw her standing next to the casket holding my dad's hand as she stared at the white vase resting on top of the dark wood to keep from looking at her mother's face. The vase was overflowing with all the wildflowers she'd picked earlier that day. Wildflower picking was something my mom and I had done together—and it was June in Wisconsin, the perfect time for picking wildflowers with her. The white vase held little purple violets, white "shooting stars," pink wild geraniums, and plenty of white Queen Anne's lace. The bouquet was really too wide and short for the tall, white vase. The word *Mommy* was sprawled across it in my handwriting. I'd written it on masking tape with red marker and my dad had stuck it on the vase. I imagine it inspired many tears that day.

My own eyes welled up as I thought about the loneliness I'd felt as I'd picked those flowers alone. I quickly wiped them away.

My dad seldom talked of my mother, presumably out of respect for Ginny, but as I stood in the house, I realized for the first time how

much his not speaking of her compounded the tragedy of her death. The silence was another kind of death. There were a few small anecdotes he would tell me when Ginny wasn't around, such as the time he showed my mother the plans for this house and she said, "You said you were going to build me a house, you didn't tell me you were going to build me a mansion!" And there were some stories my "Aunt" Marilyn—my mom's best friend—told me years later, like the time my proud father had his first meeting as District Alderman, and my mom hired a guy from the sanitation department to pick him up at our house in his garbage truck and drive him to the meeting.

I wanted to do what I could to bring Mom's memory back alive, if not with actual stories—since I had so few—then at least in the sheer joy I wanted to believe she had moving around the rooms of this house when she was alive. I suspected I may have put her up on a pedestal, as my older siblings never talked of this "joy" that my imagination imbued in her memory. As I saw it, that didn't matter because I had the perfect opportunity to bring real, genuine bliss into this big empty house whether or not it had ever been there.

Immediately we made plans to renovate. I wanted to install central air, and the kitchen was still decked out with the avocado appliances my mom had picked out in the sixties. My intention for the kitchen was to update the appliances, cupboards, countertops and flooring, and to get rid of the tired pale-yellow flowered wallpaper Ginny had put in.

Neither Marty nor I was handy, so we went to a kitchen-and-bath design store for help. The designer gave us a quote for the updates, but then he also gave us a design for more than twice the cost for a complete overhaul—which included gutting the kitchen, knocking out the wall

that separated the kitchen from the dining room, adding a central island with a granite counter, putting in brick on the opposing kitchen and dining room walls, and adding a glass block to separate the kitchen from the dining room.

Marty preferred the complete overhaul. In order to do the project, I would definitely have to compromise my student-loan payments, and that gave me serious pause. Having already adjusted my ten-year repayment plan to a fifteen-year plan to afford the house, I was now looking to extend that to twenty years. I tried to talk to Marty about it, but he was blinded by the blueprints. It seemed as though he wasn't the least bit worried about how I would manage it, as he just kept coming up with more ideas for the kitchen, and wouldn't discuss my financial concerns.

I got caught up in Marty's excitement, and I told myself it would be therapeutic to eliminate the kitchen of my childhood. Ginny's sour mood forever infected every family gathering. Her favorite display of her disgruntled existence was to slam cupboard doors. I never wanted to hear the slamming of those doors again. An entirely new kitchen just might root out the Ginny demons.

So, it was decided. I adjusted my student-loan repayment plan and we went for it.

The next project Marty wanted to undertake was finishing the basement to create his man cave, soon to be known to all as *Martyland*. He had a couple of handy buddies come over for several weekends, and before long our basement was sectioned off into a bar area with a black-and-blue vinyl checkered floor. Green indoor/outdoor turf carpeting was added around the pool table my dad left, and there was a lounge/TV area to watch the Packer games.

It became a joke to my staff at LensCrafters whenever Marty would call me at work to ask permission to buy items for Martyland. He'd tell them he was looking through the classifieds and had found yet another item he just had to have.

"Hey Doc," the office manager would say, "your hubby's on the line! He's been looking at those classifieds again!" And she'd snicker. She thought it was cute that he was calling.

I'd pick up the phone and say, "Now what?" not even attempting to hide my irritation.

"I know," he'd say, "but hear me out. This is a classic and whoever is selling it has no idea what it's worth."

It was a pinball machine, a juke box, a Daddy-O arcade game, a beer sign, an air hockey table, a vintage salon or a hair-dryer chair—and it was always "in perfect condition." The argument was always the same: He must buy the thing ASAP or risk losing out because it's an antique but priced at a steal! *And,* he can always resell it for double or triple the asking price. And if he doesn't act now, it will be gone since no one else would be so stupid to pass this by. I was still trying to pay extra on my student loans to get them off my back, but he always had something else he needed for Martyland. I'd try to say no and explain why, but he'd get sullen and wouldn't hear me. Ignoring me, he'd go to saying he was going to "just look at it"—and then he'd end up coming home with it saying, "I really couldn't pass it up." So I'd once again have to pay only the minimum on my loans to keep from racking up credit-card debt.

He also spent hours at antique shops. It was Marty's spending that I knew was going to be our biggest problem as a couple. I had an idea that I thought might offset that: We both got an allowance. I thought

forty dollars a week would be reasonable, but Marty complained bitterly about it and within two weeks I'd jacked it up to sixty. But I knew he would never be satisfied. He was blowing through his allowance on lunch breaks, going out with friends, and buying albums. Since the basement was part of the house, he paid for things he wanted for that with our joint credit card. In no time, the walls of the finished part of the basement were completely covered with music, and beer signs, as well as the Packer and bowling paraphernalia he needed to go with the bowling-alley lanes he'd found and had installed with the expensive service of a wood-flooring specialist. The wood from the bowling lanes became the floor of the lounge/TV area of Martyland, which did turn out really nice; it was actually my favorite part of Martyland.

Really, it was all very impressive. He did a fantastic job putting it together. Any football parties Marty hosted with his friends were a huge hit, as everyone admired his decorating and he soaked up all the compliments. Before every party, while I cooked and cleaned the house, he'd spend hours in Martyland, tweaking and setting it up for the party.

In 1998, three years after we married and moved into my childhood home, I found myself suffering from an inexplicable depression. I wanted to cry. Constantly. I didn't want Marty near me, and anything he wanted to do irritated me. Marty would want to have sex, but I wouldn't be interested. It was just the way that he asked was so juvenile and heartless to me. I didn't feel like I was attractive to him. He never made me feel sexy, never flattered me, never wanted the lights on when we made love. He'd call it *binka*—he never used the phrase *making love*. I'm sure he thought his foreplay was light-hearted, but I thought it was verging on repulsive—such as when he would pretend as though my breasts were

punching bags and mimed knocking them around. And I still never understood why he wouldn't kiss me during sex.

My depression drove me to find a counselor. Marty promised me when we married that if we ran into trouble he would go with me to counseling. I sensed that trouble was upon us and I wanted to make sure we were as strong a couple as possible before we had children. The therapist's name was Ellen, and I asked Marty to go with me after I'd seen her for a couple of appointments. He made it through one session.

When I told him I'd scheduled a second appointment for us, he said, "No, I'm not going. This is your problem, not mine."

"But *I* feel it's our problem. It's *our* marriage, and you promised!" I pleaded.

"But I don't have a problem. I'm in the perfect marriage. If you don't see that, that's your problem and I'm not going to waste my time talking to some shrink about something that's not even my problem!"

Ellen assured me that she ran into this all the time. "Men just have a harder time with therapy, but I'm confident that we can work on this marriage through you," she said. "It takes two to tango, so if you change the dance, Marty will have to go along with it or get out of the dance altogether."

That made a lot of sense to me, since I was pretty sure Marty was right—that I was the messed-up one. After all, I was the one whose mother died when I was six. He only had experienced his parents' divorce when he was eight, which he'd always said was a good thing—that it never affected him in the least.

He didn't have the trauma I'd had. It was my responsibility to fix myself, to fix our marriage. My hope was that I would find a way to help Marty be less moody and more affectionate. Then maybe I wouldn't feel so lonely.

I was never fully convinced of the idea that Marty was happy in our marriage. He was happy with material things—the house, and his Martyland and the ever-growing collection of albums and music CDs. Yet despite his declarations of love, I didn't feel he was happy with me. He often went out without me and I was okay with that. The few times I would go out with him he and his friends seemed to have their own language and I didn't feel like I fit in.

One day, with hardly a moment's forethought, I asked if he was having an affair. I'd noticed an exchange between him and his friend Carly in our kitchen when she stopped by to pick up a CD Marty had for her. In light of his sullen behavior and my depression, on some level I suddenly wondered if it were significant. I couldn't recall what the conversation was, but the look she gave him seemed far too intimate for a friend.

That was the only thing I had to suspect he was having an affair—a look—and the fact that I felt that he and I just didn't connect. His answer to me was, "Why would I risk losing the perfect life? The perfect wife?"

I tried to get him to see how unhappy he looked to me, and how discontented I felt in our marriage. He turned it on me—pointing out how easily I could have an affair at one of the doctors' conferences I attended. It shocked me that he would even suggest such a thing! Questioning his fidelity was all I could think of to let him know that I sensed something was really wrong, as he wouldn't answer any questions about his mood.

He'd just say, "Whatever. I'm not unhappy." His answer made sense. Why would he risk losing the perfect life and wife? And so, I didn't press it. Although I did wonder, *Why didn't he say he loved me too much to cheat on me?* Would that have made as much sense as his pointing out how great his life was—how great his wife was for paying for the life he had?

I'd begun to have digestive issues. I decided it was time to see a gastroenterologist. Before I could get in for that appointment, I'd looked up the intestinal symptoms I had in one of my books from school. I'd had a hunch, and the book confirmed my fears; my symptoms were due to proctitis—an inflammation of the rectum. I took solace in the fact that it did not appear to be the dreaded colitis—which is an inflammation of the colon. When I learned about colitis in school as we studied auto-immune conditions and how they can affect the eye, I had an eerie feeling. There are so many horrifying auto-immune conditions such as ankylosing spondylitis, sarcoidosis, Multiple Sclerosis, or Grave's Disease; but for some reason ulcerative colitis stood out as the most horrifying to me, even though I didn't have any symptoms at the time, and I never knew anyone who'd had it. Given all the other horrors I learned about that the body can inflict upon itself, I remembered reading how the intense pain of ulcerative colitis, the accompanying severe weight loss and the chronic nature of the disease actually caused patients to become suicidal.

A giant weight was lifted from my shoulders when the gastroenterologist confirmed that it was just proctitis. Yes, it could progress to colitis, but that was not an absolute. I was prescribed medication to manage the symptoms. It eventually got better, but it took months for it to completely go away.

Marty and I had somehow formed a great team, which created cognitive dissonance within my mind. I rejected the reality of my highly dysfunctional marriage in favor of the idea of being the mother I never had. It had become such a bright spot in my thoughts, all the shadows of doubt over my husband and my marriage shrank from my perception.

I'd worked with Ellen for six months and experienced fewer heavy moments of melancholy, so I decided I was ready for my babies.

Discussion Questions

- How often do you sacrifice what you want and what you believe in, in order to satisfy others? Where has that taken you?

- When have you ignored your intuition? What were the consequences?

CHAPTER 7

Bringing Up Baby

Desire knows no boundary. It is simply the very nature of the universe itself. Desire is the very root of the universe.
—Darcy Lyon

Once I got a handle on the proctitis, I began the discussion with Marty about getting pregnant. When we were engaged, he said he was worried I'd be asking to have kids too soon. We had been married for five years. I believed I'd respected his wishes, and he didn't object. I decided to shove down inside me all my doubts, to ignore my heart and mush on with the belief that having my babies would outshine any dysfunctions in my marriage that I couldn't articulate.

And then we discovered we had fertility issues.

I don't know why, because I had no facts to support my intuition, but I had worried from the beginning that we might have trouble getting pregnant. After eight months of being off the pill and no positive pregnancy test, I decided it was time to test my theory. I went to see my OB/GYN who recommended I come back for a post-coital test. In that test, it was discovered that Marty's semen was completely void of sperm. Not just a low count, but absolutely no sperm at all.

We were referred to a clinic in Milwaukee where the full scope of our problem was discovered. Marty was born without the vas deferens (the tubes that carry out the sperm, the same ones that are tied in a vasectomy). I expected the problem to be with me—because I always thought I was the problem—but it made sense to me on a cosmic, spiritual level that Marty's body was the hurdle I'd have to jump in order for me to have children. This condition of Marty's was congenital; he didn't cause it. It was fate. Still, the irony of our situation was not lost on me.

Having a child of our own would be impossible without a very expensive in-vitro fertilization procedure. But I didn't care about the cost. Having kids was non-negotiable. I would have been reluctantly okay with a sperm donor—which would have made the whole thing cost a fraction of what we were looking at—but Marty wouldn't hear of it. With his relentless fear of me cheating on him, that made a lot of sense in a twisted sort of way.

I was actually grateful to hear that he wouldn't consider that option because I wanted this to be our child, together. Having a child of our own was the final piece of the loving and happy life I'd always strived for. I wanted the experience of being pregnant and giving birth, and I wasn't going to give up on that dream this close to achieving it.

Despite the lack of tubes to carry them out, Marty did produce sperm. But the doctors would have to extract them surgically and then inject them into my eggs, which were also surgically removed. It would mean I'd have to endure a surgical procedure followed by weeks of painful shots. Marty would also have to have a procedure done, but no shots. I didn't care about what *I* had to do, but I was heartened by Marty's willingness to undergo the minor surgery to fulfill my dream.

I allowed myself the thought that Marty refused all but the most expensive procedure to get pregnant in the hopes that I would decide the price was too high; but I wouldn't dare say it out loud. On the heels of that thought, another one occurred to me: that a true parenting partnership with Marty was unlikely. However, I shoved that one down before it could get any traction in my mind. I wouldn't allow myself even to consider the idea that emotionally and intellectually I'd be raising any children I had on my own even though I had a husband.

Insurance wouldn't cover the procedure. Not only that, we faced a lowly thirty-percent success rate. But I wasn't to be discouraged. I went to a trusted Reiki Master/psychic named Donna Marie who consulted my astrological chart to advise me on the timing of my IVF procedure. I believe it was that decision that allowed us to get pregnant with our son on the first try.

A few weeks prior to getting pregnant, Marty got fired from his job as manager at the record store. They had some "stupid rule" about employees selling their promotional CDs before their official release to the public, and Marty had gotten caught selling a new Dixie Chicks album. I thought it was a legitimate reason for firing him, but there was no way I was going to tell him that. I felt sorry for him. I knew that if I were in his shoes I'd be so embarrassed. I empathized with his pain, which prompted me to immediately say, "Let's just make this an opportunity. Why don't you go back to school?"

"Really?" Marty asked.

"Yes! I think we can do it if we put my student loans into temporary forbearance, and if you get a part-time job." I really didn't want to put those loans in forbearance. Even though I'd not be making payments, the interest would still accrue. But I wanted a family, and I wanted a

happy husband, so I decided my dreams were worth it. I'd figure out another way to get those loans paid.

Within a few weeks of being fired, Marty went back to school full-time to earn an Associate Degree in Pre-Press Graphics. I was forever confused as he kept calling it a *Graphic Arts degree*, which is a four-year degree, and he was going for only two years. I'd suggested he get the four-year degree, but I didn't push it since he finally seemed happy.

During my pregnancy, the proctitis flared up again. It was worse than ever. I didn't even gain any more weight in the last trimester. The gastroenterologist said it could have progressed to colitis. The only way to confirm the diagnosis was to do a colonoscopy, but given my condition it could not be done until after I gave birth. The doctor explained to me the "one-third rule" for any given auto-immune condition and pregnancy: One-third of the conditions worsen, one-third of the conditions remain the same, and one-third get better. I didn't allow myself to consider the first third. I decided it was going to remain stable, and then after I had my baby it would get better.

It didn't go that way. The symptoms worsened. But it was manageable. I wouldn't let myself even *think* about colitis.

I got very good at this point in my life at ignoring my heart and forcing my will to allow only thoughts that supported what I wanted my life to be. I told myself I was being optimistic when what I was really doing was denying my heart. But I had no idea how not to do that.

I stopped all pursuits of personal growth and spiritual study as my painful emotional reality seeped into the cells of my digestive system. Even as my heart tried to speak to me through physical pain, I refused to listen. Like an impudent child I tried to control all outcomes while my body demonstrated how little control I actually had. I had no idea

of how true that was until years later; but at this point, my need to control the love I got from others by people-pleasing set in motion a very dangerous path in my physical health.

On May 2nd, 2001, my son was about to join us in this world. I was in the kitchen making sandwiches to take to the hospital—as our Bradley Method of Natural Childbirth instructor had advised— when I called out to Marty who was upstairs, "I think the contractions are starting!" They were really light and far apart, but I knew it was happening. It was around 7:00 PM. I called Cindy, my doula, who'd also been my regular massage therapist and alternative-health guru.

At the hospital, the contractions got more intense and more frequent. I thought about how, in our birthing classes, our instructor had asked each of us what worried us most about the birth we were expecting. Most of us women were worried that we wouldn't be able to go without drugs or artificial labor induction of some sort. The men were mostly worried about their wife's pain; but Marty joked about how he was worried about all the noise I would make giving birth, disturbing the whole maternity ward. Everyone laughed. They had no idea he was serious.

When the contractions started getting intense, the nurse got me in the jetted tub in my hospital room. I knew the worst of it was coming, but I remained positive that I could handle it. All of a sudden fear grabbed hold of me. My muscles tensed up, my legs, my arms, my hands, my neck, and my back. It was like an electrode was clamped on my neck and the power was turned way up.

My fear was only mildly tempered by the fact that Cindy was very familiar with it. "It's tetany," she said. "You have to yell it out." I looked at her, my eyes wide with confusion and horror.

I had no control over what was happening to me. I wasn't told about this in my birthing class or in anything I'd read about childbirth. I locked eyes with her, holding my breath as I tried to comprehend why she would ask me to do the very thing my husband dreaded most.

"Seriously, I need you to start yelling as loud as you can right now!"

Cindy had some weird ideas sometimes, but damn if she wasn't always right, and I wasn't about to question her now. I started to yell, and my body began to relax immediately. Marty moved in to try to cover my mouth. I kept yelling as Cindy pushed Marty's hand away. Marty could see that she was adamant about the yelling, so he got in closer, feigning concern, to try to muffle my yelling with his head. It would have been comical if I weren't so damned frightened of what was happening.

After a few minutes, I relaxed further and was able to stop yelling. I was eternally grateful for Cindy. I don't think the nurse had any idea of what I experienced or how to deal with it, and it never happened again. I marveled at how things would have been different without Cindy to push my husband away and get me through it.

I had included in my birth plan that I was not to be offered drugs unless absolutely necessary, and that I wasn't going to ask for them. I'd read too much about the potential damage and developmental difficulties epidurals can have on the newborn, so there was no way I was going to subject my son to them. The inflammation in my rectum amped up the pain, but I didn't care, I never once considered pain management. Anyone could imagine the pain I was in, yet my husband never acknowledged it. I didn't care, though, because Aidan and I made it through.

Mother's Day was just around the corner. I looked forward to my first Mother's Day. It would take the pressure off me to be expected to

celebrate my stepmother on that day, which was always so awkward. I didn't think Ginny deserved any recognition as a mother. So I expected a happy celebration with my husband, given that we now had our very first child.

But that didn't happen. Instead, Marty went all out for Mother's Day for *his* mother, spending over a hundred dollars on her. He completely dismissed the fact that his wife had just become a mother for the first time, *less than ten days ago.*

I was deeply hurt, and for the first time I could remember, I said so.

"What the hell, Marty? I seriously just gave birth to your first child, and I don't deserve to be acknowledged on Mother's Day? You've never spent that much on your mom before. Why the hell now?"

"Christ!" he yelled, "I just wanted to get her something nice for once."

"What about *me*, goddamn it?" I cried. "I don't need anything material, I don't need you to spend money, but I'd like to be celebrated! And I'd like for once to not have to be the one figuring it all out!" I screamed.

"Well, what the fuck do you want me to do?"

"Just use your imagination!"

He promptly went out, slamming the door behind him. He showed up a half hour later with a bouquet of flowers and an outdoor glider rocking chair for our sun porch, making sure to spend more than he'd spent on his mother—completely ignoring the fact that I'd said I didn't need anything material. All the while he pouted and sulked, and completely neglected any sort of apology or celebration of my motherhood.

Later that day, I sat in the rocker nursing my son, looking at his sweet-smelling head. *I love this kid with all my heart*, I thought, *and I am not going to fuck up his life. I know I can't control everything. Shit's going to happen, and it's my job to help him be strong and prepared for it.*

But the one thing I can control, the one thing I can keep him from having to suffer, is divorce.

It wasn't until that moment that I realized I'd been entertaining the idea of divorce for some time. The depression I'd suffered shortly after we married and the nagging doubts I chronically suppressed, created a rancorous debate in my head. The only way to control it was to say to myself: *No more talk of divorce.*

The events triggered by Mother's Day positively broke my heart. I struggled to go on, but I did recognize that my dream of having children had come to fruition. (Marty did buy the glider rocking chair, which showed *some* thoughtfulness, at least.) And my baby was right there in my arms. I had to do whatever it would take to give that boy every possible chance for happiness.

For the first three months of Aidan's life, the proctitis symptoms began to improve; but they never went away. By September, I felt increasingly weak and exhausted. I was losing blood, and most frightening of all, I was quickly losing weight. It made caring for a baby more and more difficult. I reminded myself that if I were alone, if I had left Marty, it would be all the more difficult.

It was maddening to have to get Marty's help when it was urgent because I needed to get to the bathroom fast or risk messing my pants. But at least he was there to take the baby if I was in the middle of changing his diapers when the urge to go came upon me. He did throw a mild temper tantrum, though. He'd slap his computer desk whenever I called for help, and stomp down the hall to the baby's room saying, "I can't just drop everything the second you yell," and then he'd pout as he'd take over changing Aidan's diaper, leaving me to swallow my fear

that he might somehow take his irritation out on the baby. Whenever possible, I would take Aidan and a pile of blankets to lay under him on the bathroom floor rather than suffer Marty's wrath.

I knew he was busy doing homework. I told myself this was really hard on him, too, but it would get better. Aidan would get older and be easier to manage, and I wasn't going to be sick forever. I needed to get loud in my head with those positive thoughts to drown out the steady mantra that threatened to topple my resolve: *This is your fault. Your being sick is your fault—you're not eating well, you're stressed and you work too much. You not getting better is your fault, so who could blame Marty for being stressed and yelling once in a while—especially when he never wanted a kid in the first place?*

Unable to ignore my declining health any longer, I went to the gastroenterologist and a colonoscopy was ordered for the day before Thanksgiving. After I recovered from the anesthesia, the doctor gave the undeniable diagnosis: pan-ulcerative colitis. There were ulcerations throughout the entire colon—the very thing I dreaded most the moment I'd learned of the disease's existence. The disease I'd studied in school, which had sounded so harrowing, was now here inside me. I quietly sobbed after the doctor left. My dad was there to console me, but neither of us could fully know the course of pain the diagnosis was going to bring to my life. I was simply grateful my dad was there for me.

The colonoscopy pushed me over the edge. Every symptom worsened and I was hospitalized the next day. My body was attacking itself and no one knew why—aside from the diagnosis of an auto-immune condition. The medical community has no idea what would cause such a horrifying disease.

Aidan was six months old. I was forced to quit nursing him because I was severely dehydrated and couldn't produce any milk. That was

devastating to me. Nursing my son had become more than good nutrition for him. He was my son whom I loved more than anyone in the world and every time I nursed him I felt our bond grow stronger. I'd come to feel that as long as he was in my arms getting sustenance directly from me, we were invincible and we could conquer together anything life threw at us. I realized intellectually that that fact didn't really change if I weren't able to nurse him, but it still felt like something was being taken away from us. It was unfair.

My family was impressed at how Marty stepped up to take care of Aidan, but they didn't see his resentment of me. It was subtle, and for my eyes only. He took no interest in talking with my doctors to understand what I was going through. He seemed to have no compassion for my being diagnosed with this disease that could potentially take my life after months or years of significant pain and torment. Nor would he sit by my side to assure me we could beat this thing.

He was feeling the pain of it, though—in the hassle of having to be a full-time caretaker for an infant. He claimed that because he had to take care of Aidan, that was why he wasn't there with me talking to the doctors. He ignored the fact that many family members offered to take Aidan off his hands for a few hours so Marty could be there to comfort me.

I cried often as I suffered the excruciating physical pain, the emotional pain of not being able to care for my son, and the guilt for putting Marty through all of it. In all the feelings I had, I had none for myself. Any compassion I might have had for myself was rerouted to my stressed-out husband. It was a pattern I'd set in motion from the beginning of our relationship, which had now taken its frighteningly toxic effect.

In March, after four months off, I went back to work, but I managed to stay working for only two months. By Aidan's first birthday in May,

the symptoms that hadn't fully subsided returned in full force. The little weight I had regained fell back off, and then some. At 5'7", I was down to 112 pounds. I was a lean 142 pounds when Marty and I married. I didn't go into the hospital this time, but I was still too weak to care for Aidan, so Marty took him to daycare on weekdays.

Upon this second major flare-up of the colitis, I decided to leave my job at LensCrafters. I began working as a contracted optometrist for an ophthalmologist, and for other optical shops, so that I could have more control over my schedule. This meant that my income would be less consistent. I'd have the potential to make much more, but it would be harder to plan. I had foolishly thought the colitis was a thing of the past, so I didn't even think of how important having disability pay could be. I made a plan to save up from the extra income for the possibility of my having to take time off from work if I had a flare-up, but I wouldn't allow myself to really believe it could.

I had flare-ups now and then, but not as bad as Aidan's first year of life. I managed to work through them, working wherever some clinic needed me. I worked hard to manage the colitis with a gluten-free, dairy-free, meat-free diet, which never fixed the problem as various naturopaths told me it would. I still got sick, but it didn't get bad enough to have to be hospitalized or to have to take any time off from work.

I thrived from the love I shared with my son, practicing what I later came to understand was true unconditional love—and it was enough. I still didn't have the same unconditional love for myself, since I continued to sacrifice myself in an attempt to abolish Marty's chronic discontent. But I had my son.

Discussion Questions

- My desire to have children was non-negotiable. My stubborn will pushed me right past my own cognitive dissonance so that I did not even think to question whether the man I chose to have children with was capable of functional parenting. How strong is your will? How does it serve you? How does it work against you? Does it ever cloud your judgement?

CHAPTER 8

Cognitive Dissonance

It ain't what you don't know that gets you in trouble, it's what
you know for sure that just ain't so.
—Mark Twain

When Aidan was two, something happened with him and his father
that shaped my parenting for years to come. One evening I was
folding a load of laundry in our bedroom while Aidan jumped on the
bed. Marty was down the hall in his office. Aidan was winding up and
getting rambunctious, as he usually did when he got tired, instead of
winding down and getting sleepy.

"Okay Peanutty," I said, "I need you to settle down, so when I'm
done with the laundry we can snuggle in your bed and I'll read you a
book, okay?" I was weary from a long day, but I wasn't getting angry
with him. I let him keep jumping as I reminded him that he was going
to have to stop in a bit. I didn't expect him to settle until I picked him
up to change his diapers and get him into his jammies.

Suddenly, I heard Marty slam his hands on the desk in the office and
stomp down the hall to our room. He walked over to the bed, grabbed

Aidan by his shoulders, picked him up, yelled, "*Fuck!*" with his face inches from Aidan's, and then dropped him on the bed.

I was stunned. I immediately ducked under Marty's arms to sweep around him and pick Aidan up. He was in shock and hadn't yet begun to cry. I wanted to change the scene as quickly as possible in the hopes that Aidan would forget what happened and it wouldn't be imprinted in his memory for life. I quickly carried him to his room as he began to lightly sob.

"Hey, sweetie, it's okay, Mama's here, you're okay," I said, giving him a moment to relax. Once he settled in my arms, I picked him up, swung him around and made airplane noises to get him to laugh. I guided him onto his changing table and lightly tickled him so he was laughing even more. I asked him what book he wanted me to read, and spent half an hour changing him, snuggling with him on his futon and reading the book *Guess How Much I Love You* by Sam McBratney.

Once he was asleep, I quietly left his room and walked down the hall to where Marty was back at his computer. When I walked in the room, he didn't stop what he was doing or acknowledge me in the least.

"What the fuck was that?" I asked, incredulous.

"What?" he said, never turning away from the computer.

"What you just did to Aidan not more than thirty minutes ago," I said. "I was going to take care of it. He was a little wound up, but he's *two*! What do you expect?"

"Whatever," he said, "I didn't do anything." He stared at his computer, deep in whatever he was doing.

"What?!" I said. "The poor kid was in shock!"

He said nothing. He continued to type on the keyboard and stare at the screen as if I weren't even in the room. I stood there for a few

moments waiting to be acknowledged, then spun on my heel muttering, "My God," and left the room.

As I got myself ready for bed, I felt my chest begin to squeeze as thoughts flooded my head and ominous questions I never wanted to consider began firing. Did he think that if he didn't acknowledge what he did, I wouldn't know it happened? *I know he doesn't handle stress well, but that was outright child abuse, wasn't it?* His behavior was so bizarre. I thought back to the weeks I was in the hospital, or too sick to take care of Aidan. I wondered what kind of stress my son would have put him through then, and what Marty might have done to shut him up when no other adult was around to witness it. I wondered about "shaken baby syndrome" and convinced myself that Aidan hadn't suffered anything like that. *But what might have happened, and what could I have done? What can I do now? Can I even have another child with this man?* And then I began to sob. I so desperately wanted another baby. More than absolutely anything in the world I wanted another child. *Marty's just really stressed with his new job and trying to bring in more money doing freelance graphic design,* I told myself. *This was just a one-time thing, and I'm sure Aidan is fine. After all, he was giggling and totally himself by the time I tucked him into bed. It'll all be fine.*

I worked hard to convince myself. I never witnessed Marty do that again, yet I never stopped feeling like I needed to protect my son from his father.

As he grew older, Aidan developed learning problems that were diagnosed as Attention Deficit Disorder. He also developed anxiety and defiance issues that got him into significant legal trouble as a teen. Could that have been simple genetics? Or could there have been psychological or even physical effects on his brain from moments like that one with his father?

Although I'd never again witness Marty's physical abuse of my son, I learned from Aidan many years later that there were other times he'd done the same thing—grabbed him by the shoulders and yelled in his face—up until the time of the divorce. I thought my confronting Marty that night assured he would never do it again, but all it did was assure that he'd never do it again *in front of me.*

By 2003 I had been consistently feeling well. I'd gone almost a year without any colitis symptoms so my thoughts turned toward having a second child. I was determined to have at least one more child. Since I'd not witnessed another incident of abuse, I pushed my fears about Marty's fitness to parent out the window. I consulted with Donna Marie, the Reiki Master/psychic who had helped me with the timing of Aidan's conception, and again on the first try with the IVF procedure I became pregnant for the second time.

I knew we were in for a big tax refund, which we'd have for my maternity leave, plus I managed to get additional savings together for an emergency, in case the furnace died, or I got sick and couldn't work for a while. I had $4,000 saved up in a separate savings account, and I was proud of it. Soon after bragging to Marty about the money I'd saved, he drove down a back road somewhere and saw a jet-ski boat for sale that he had to have.

"And how much is it?" I asked.

"It's $4,000," he replied.

I rolled my eyes. Of course it was the exact amount of money I had saved.

"It's the perfect boat!" he pushed. "It seats four people, it's got its own trailer, and it will go fast enough for water skiing! Didn't you say you had about 4,000 saved up?"

"Well, yeah, but I told you that money is for emergencies. What if I get sick again after this baby like I did with Aidan? Besides, I'm pregnant and shouldn't be riding in this thing, and when our daughter is born, she will be too young to ride in it for at least a year!"

"Christ! This boat is a steal at that price. It's in great shape, and other people are looking at it. Someone's going to buy it and we'll lose out when we even have the money for it!"

"But we don't have this money for a boat," I pleaded. "This money is for *emergencies*. This boat isn't a goddamn emergency!"

Per his usual modus operandi, Marty sulked and pouted, giving me the silent treatment. He kept his distance—not that he was very affectionate anyway, but I had no hope of having my affections reciprocated. I'd say goodnight to him in bed and rub his arm with his back to me, but get barely a grunt in response. He was always angry with me for not spending money on fun stuff, telling me I was "too intense"—and maybe I was.

This went on for two days until I just couldn't stand the guilt. I simply didn't know what to do but to let him have his way. This time, though, I felt my heart sink. Giving in to him, after I'd worked so hard to save that money, made me feel for the first time as if I were actually being played.

Marty, happy once again, hauled the thirty-year-old jet-ski boat to our driveway and before it ever touched the water we discovered it needed another $1,000 in repairs. Then we were informed by the boat mechanic that these particular boats were a "nightmare" of chronic problems.

I couldn't stop thinking I was a chump. Marty wouldn't even consider leaving that money alone. It was like I was dead in the water simply for having told him I had the money saved. I began to wonder if it was the boat he wanted so badly, or if he just had to spend that money because in his mind I was keeping it from him. I was "in charge" of the finances, but I never really got a say in how we spent our money. If I didn't think we should spend money on something he wanted, he relentlessly pressured me and pouted until I gave in. When I'd ask him to help me with the finances so he could see what I was talking about, he'd say I was better at taking care of the bills and managing it all, so I should just do it. That didn't stop him from making fun of my math when I'd write up a deposit slip and add the numbers wrong.

We just never had enough. "Please look at the spread sheet," I would beg him as I'd hold the laptop up for him to see.

"Christ! Warren Buffett wouldn't understand that shit! You've got that so fucking complicated, how could anyone figure it out?" he'd say, walking away. We were always scraping by to pay our bills, and it was my fault if they couldn't get paid. When we married, I never wanted him to be intimidated by how much more money I made than he did. I seemed to be paying some kind of price for my compassion, yet I couldn't fathom how or why my husband would be so vindictive. He'd call me a control freak when I'd try to tell him we didn't have the money for something he wanted, but I didn't feel like I had any control at all. I had no idea how to change our dynamic. I buried my suspicions and frustrations and looked forward to the arrival of my daughter.

Roan was born on August 8, 2004.

As we drove to the hospital, Marty said, "I just know she's going

to come out with a full head of dark hair." My heart swelled with love for him for saying that. I always worried that he didn't want kids, but he genuinely sounded excited for this one. I'd felt deeply connected to both my babies in the womb, but Marty hadn't seemed to have a connection. Not until he said those words did I ever think he even thought about them before they were born. And I believed he really did "see" her dark hair, because Aidan was born with very light-colored hair and not much of it.

It was a special time and I felt close to my husband as together we joyfully anticipated our daughter's arrival. Her birth was a lot more relaxed than Aidan's. It was just Marty and me along with the midwife and nurses.

It was uncanny how much Roan looked like Marty. She did indeed have a mop of dark hair, and a set of eyes that were dark blue like her dad's, only more striking. He'd hold her like a ventriloquist's dummy, facing forward in the crook of his arm, and call her his "Mini-Me" like in *Austin Powers*. He took to her a lot more easily than he did to Aidan, which I figured was because she was the second child. It's not as if she were any less fussy than Aidan, but for some reason he was much more attentive to her.

Aidan was three years old when we brought Roan home. I told him I wanted a picture of him in the glider rocker with his baby sister on his lap.

"Okay! But wait! I gotta put on the shirt Nana got me at the hospital!" he said.

Once he'd climbed on the chair properly attired, and I placed his sister in his arms, I paused for a moment to look at them together. Aidan was in his *I'm the Big Brother* T-shirt and Roan was a lump of

newborn sweetness on his lap, with her head cradled in the crook of her big brother's elbow—just like I showed him. The sudden intensity of emotions I felt made me simultaneously choke, laugh, and cry. Aidan snickered at the noise I made, then looked at me with sweet curiosity.

I smiled as I wiped my tears and shook my head, then bent down to kiss his and Roan's heads. "I love you both so much! Mama has waited and worked really hard for this moment," I said to my son.

"Love you too, Mama!" Aidan said.

My sensitive boy knew my heart was filled and didn't question my twisted face. He got antsy, fidgeted, and then asked me to take Roan from his lap. The moment was fleeting, but there would be many more to come. *I had my babies!* My dream had come true and I felt like I was the luckiest mother on the planet.

I thought about my dad's love for all his kids. I never doubted his love for me, but I always felt like I had to work for it. I was never going to let my children think they had to work for my love. I was only getting started in parenting, but with all the love I had for them, I had no reason to believe I couldn't conquer any obstacles. And with my babies immersed in my love, I had no reason to believe they wouldn't love each other. All the components of my happy life had now come together. I just had to live it.

While I was on maternity leave with Roan, Ginny passed away. She had battled cancer of the mouth for over a year. We thought it was going to spare her after the first round of radiation and chemo, but then the tumor grew so aggressively it took over the right side of her face. I watched it grow in horror as it displaced her right eye to the point where she completely lost vision in it. I'd struggled with her as a child, and

I'd learned to keep my distance from her as an adult, but I did grow to respect the challenges she had in life.

Her younger sister, Marilyn, helped me gain a greater understanding of Ginny's troubled childhood. She was beautiful with her movie-starlet figure, but that came at a price which she paid with unwanted male attention, including molestation by her stepfather, and her first marriage to an abusive alcoholic. Learning of her childhood gave me a deep sense of empathy for her that I couldn't understand as a kid who simply had to suffer through her bad moods. I came to realize her sullen nature was less about me and more about her being a human fraught with trouble early on in life.

I knew my dad loved her, but I also knew he didn't fully respect her or appreciate the painful psychological side effects from her childhood. He never appreciated the effect my tragic childhood had on me, either. He always preferred to sweep all that pain aside and pretend everything was great.

From stories my oldest sister from my dad's first marriage told me of my dad's mother, who passed away before I was born, I understood more about my dad's childhood. His father passed away when he was only twelve, and his mother was cold and controlling. I recalled how he had so many more happy stories of his father, while stories of his mother pertained only to her cooking. She had been in his life twice as long as his father, but he employed the "if you can't say anything nice, then don't say anything at all" rule. It explained to me why his coping mechanism was never to dwell on the negative while accentuating the positive. His wife—the mother of his kids—was dead; but if he didn't talk about her or attempt to help his kids with that tragedy, then he didn't have to concern himself with the negative emotions of all that. If his kids didn't

do anything to make him proud, or embarrassed him in some way, it was far easier to shun and ignore them rather than help them—while the kids who did what he wanted them to he put on a pedestal.

While I was on maternity leave with Roan, I spent every day after Ginny's funeral at my dad's—clearing out and shredding documents that Ginny had been hoarding for years. My dad commented on how much he appreciated me helping him with it. "I'll bet Ginny is rolling over in her grave with you doing all this," he sighed. "She was always so afraid to throw anything out."

"I can see that," I said as I fed the shredder bank statements from 1978. My dad and I smiled at each other as we each thought warmly of Ginny. I knew he missed her dearly, even with all her quirks. Surprisingly, I did, too.

A few days later, I had a dream—a dream more real and intense than anything I'd ever experienced before. In the dream, I was in the office where I'd been shredding Ginny's documents. Roan was sleeping in her battery-operated baby swing just beyond the doorway. I was engrossed in my task when I suddenly felt the room lighten as if someone had opened a door on a warm spring day. I looked up expecting to see my daughter waking from her nap, but instead I saw Ginny. She was absolutely stunning. She was wearing her light-pink crew-neck sweater and jeans, looking like photos of her from her thirties. It wasn't just her appearance that was so striking, though, it was her essence. She was full of light as if she'd actually had a lamp shining through her from within. And she was weightless, almost floating. Instinctively, my chest squeezed with fear as if I were about to get caught doing something wrong and

be yelled at—but the familiar trepidation quickly dissipated. She had an easiness to her, completely untainted by sarcasm or cynicism, something I realized I'd never seen her without in life.

"I don't know what I was thinking, hanging on to all of this crap!" she said, laughing as she swept her arm toward the bags of shredded documents.

I was so in awe of her, I didn't even think to laugh with her. I just watched as she came closer to me, raising her arms as if to embrace me. I sat there, glued to my seat, anticipating the hug. As she got closer to me, she became even more bright. The brightness blurred her form, yet it didn't hurt my eyes. By the time she was in front of me, there was no form to her at all. She was pure light. She was gone, yet she wasn't gone. She was transformed. She *was* the light—and it completely engulfed me in a peace-filled, fearless, guiltless vapor of love more powerful than all the love I'd longed for and craved in my entire life.

It only lasted for a beat or two. When the vision cleared, and the dream faded, I found myself lying in my bed with Roan sleeping soundly next to me in her co-sleeper.

I lay there in the dark and kept my eyes closed in an attempt to hang on to the vision and feeling of contentment as long as I could. I knew I'd just experienced the pure, unconditional love of heaven. I was puzzled, yet delighted that Ginny represented this love.

I didn't fully understand the dream until a few weeks later when I went to see Donna Marie, the psychic I'd been seeing for years. I hadn't told her of my dream, but as she did my reading she saw Ginny on "the other side." She was amazed to see her. She said she was the "most evolved spirit" she'd come across in a long time. She said that the lifetime Ginny had just left was specifically chosen to finish up her

final lessons, particularly regarding vanity. *Wow.* Her lessons included: being molested by her stepfather; suffering abuse from her first husband; becoming nearly paraplegic in a car accident that disfigured her legs; and then finally enduring the excruciating annihilation of her face.

To this day, I still feel humbled by the gift Ginny's spirit gave me. The anger and frustration I felt for her replacing my mother was swapped out for love and gratitude, as I knew she had been in my life to teach me lessons as surely as she'd had hers to learn.

Soon after I went back to work, I dove into books on spirituality to better understand the experience I'd had in that dream. It opened up new ideas about love. I read *The Disappearance of the Universe* by Gary R. Renard, which introduced me to a three-volume book of spiritual philosophy called *A Course in Miracles*. I learned from it that the intense feeling of pure love that I was given in that dream is exactly what is available to each and every one of us. Not only that, but it is also where we all come from.

All my reading started me on the journey to learning to love myself. It was just the beginning of a very long road. Unfortunately, I didn't give it my full attention because I was too distracted by whatever was amiss with my husband and my burgeoning thoughts that I no longer loved him. I even began to have fantasies of becoming a widow.

I was tempted to believe there was something wicked about me—that I would wish for my husband's death—but I wouldn't let myself chase down that rabbit hole. I knew there was a much deeper issue at hand. Again, I went to Donna Marie, confessed my fantasy, and asked if she could find an explanation for my feelings in a reading.

She took my wedding ring and held it in her hands for several minutes, then told me an amazing story.

"I see you and your husband in another lifetime strolling on the deck of the Titanic. I can see you are both older and very well-to-do. Your husband made a lot of money in the railroad business. You are limping and leaning heavily on him. He is very gentle and loving with you. You are dependent on him in every way—physically, mentally, emotionally, and financially. On the Titanic, since the women and children were given the life boats, your husband perished when the ship went down. Months later, completely incapable of taking care of yourself, you died of a broken heart. Your souls then made a pact for your next lifetime that you would learn to take care of yourself, to be independent and not rely on others to give you what you needed."

I was to have many readings with her over the years, but never one this detailed or powerful. I had no doubt that she was exactly right. I stopped chastising myself for my desire that Marty be gone from my life for good and became more pragmatic about my marriage. I still believed Marty and I were together for a deeply spiritual reason—but Donna Marie's past-life reading initiated the first notion of that reason being for my own personal growth, rather than because we were destined to be happy together.

Without judging him, I allowed myself to consider that there might be something psychologically defective about my husband. I'd come across the term *passive-aggression* and it got me thinking that it sounded very much like my husband's behavior, so I Googled it and found that it is a very toxic psychiatric problem. When a man is emotionally incapable of taking care of someone else, passive-aggressiveness is one way that he makes sure that the other person cannot depend on him. A few techniques that people who are passive-aggressive will use are: the silent treatment, subtle insults, sullen behavior, and stubbornness. That sure sounded

like Marty. All the websites, articles, and books I'd read were telling me that it can be very difficult to live with a passive-aggressive person. And if at all possible, it's advised that a relationship with someone like that should be terminated. In my mind, however, I had enough stress to deal with. Leaving my husband just wasn't an option. I thought if I could shift my expectations about his behavior and just take care of myself and my kids, then this marriage would survive—at least until the kids were on their own—and I decided I would be stronger for it.

Then again, knowing your husband isn't going to support you requires letting go of all hope that maybe he will if only you make him happy. Old habits are hard to break. Not even all the books I'd read on what the psychiatric community was just beginning to call *passive-aggressive personality disorder* could help me understand how much of myself I was sacrificing for my husband, and how caustic my lack of self-love was to my health.

Discussion Questions

- Have you ever sacrificed the well-being of your chil-
 dren—purely because you wanted to please someone? Or
 because you didn't want to upset someone? Can you see
 why you did that? What was missing in you that drove
 you to make that misguided decision? Have you been
 able to face your regret, and to accept the path on which
 it's taken you? Have you been able to forgive yourself?

- Have you ever had a profound spiritual experience?
 What did it mean to you? How did it change your life?
 Did you experience an immediate change, or was it a
 transformation that happened over time?

CHAPTER 9

Tipping Point

Just because you've had enough doesn't mean you wanted too much.
—Dean Young

I had longed to have a third child, but I knew it was not a good idea, particularly because of my recurring illness. The stress of another child could finally be too much. I loved being pregnant, but as I thought back to my pregnancies I realized I'd been completely alone in my expectant bliss. Marty was never one of those husbands who raved about how beautiful his pregnant wife was. I regret that I have only one picture of me when I was pregnant, and I wasn't even in the center of the photo. How could I have gone through two pregnancies and it had never occurred to me to have the glory of that miracle photographically documented? And then I realized my husband was never impressed with the miracle of it. He didn't think I was beautiful, and so neither did I. So why would we have taken a photo?

I thought back to a time when I'd begun to feel Aidan kick in my belly and I asked Marty to lay his hand on me to feel the baby move.

"That's just weird," he said.

"No, it's not! It's beautiful! That's your son! Give my belly a kiss and let him know you're here and that you love him," I pleaded.

"Really?" he said with a shrug as I lay on the bed rubbing my belly.

"Yes, really. I think it's important."

"Whatever," he said as he kneeled on the bed, leaned over and kissed my belly at the exact same spot where the baby had kicked. I laughed as Marty pulled away, clearly irritated and not at all dazzled by his first contact with his son.

I knew: No matter how desperately I wanted to, having another child with this man was just plain stupid.

Another thought occurred to me that I'd left in the shadows and told no one: *I might die and leave my children to be raised by their father.* That thought scared the hell out of me. It felt like that would be the ultimate shitty thing to do to these children I'd fought so hard to bring into this world. It was my biggest fear that I wouldn't be able to protect them from having the same dysfunctional childhood that I'd had. My dad didn't handle the tragedy of my mother's death in the best interest of us kids, and I knew Marty would be far worse.

I was seeing more and more how self-absorbed my husband was—how his needs and wants always came first. I thought about how Marty would pout every time he cleaned up when the kids spilled something. Or he'd tell them, "You're wasting my time," when he thought they took too long to do something by themselves.

I sensed Aidan might be afraid of Marty because he'd started lying about things for fear of his dad being angry with him. Marty often yelled at or lectured Aidan. Despite my pleading with him to lighten up, he never would. I knew I needed to be there for my kids and

protect them from their father's passive-aggressive coping mechanism. It would be selfish of me to stress myself out even more with another child—stress that could potentially take my life. The thought of my kids living through their lives without the unconditional love I was there to give them was the ultimate driving force in my decision that two kids were enough.

I was always trying to find creative ways to make more money. In 2005, we bought a rental property. It was twice the size of what the many books I'd read on investing in real estate had recommended, but Marty fell in love with the house and insisted. It became a nightmare—of deadbeat tenants and home repairs we were ill-equipped to do ourselves. I opened my own practice in 2006 in the hopes that I could increase my income, but then the recession hit and I had to work in other offices to pay the bills—which became a recipe for disaster in my own practice. My attempts to better our financial situation kept making things worse while Marty seemed oblivious to it all.

Five years after we bought the rental property, and four years after opening my practice (which still wasn't making a profit), Marty found a mobile home on a permanent lot near Shawano Lake. He had an aunt who'd lived there when he was a boy. He was feeling nostalgic about the many childhood summers he'd spent at the lake.

"My kids could have some great summer memories on this lake like I did," he begged. These were memories he said he had, but ones he'd never shared with me. I wondered how much fun he could have had at a lake in the summers, since he'd told me on our first date that he didn't learn how to swim until he was eighteen.

The mobile home was priced at $10,000. Marty was refusing to take no for an answer and I, once again, found it so damn uncanny that the amount of this lot and trailer was exactly what I'd recently told him was the approximate equity in our home.

"Let's just take the kids there for a day to check it out. It's the least you can do," Marty said. "Then we can take the kids to the beach and make a nice day trip of it," he added.

"Okay, fine," I agreed, "but seriously, the rental is a fucking money pit, and my practice is still not profiting. We are not buying this thing!" I spoke as forcefully as I could. "Besides, it would just be more stress to maintain this property on top of the rental and our own home."

When we got to the lake to see the mobile home, it turned out to be old and unsightly, and farther away from the lake than I had been led to believe. If I stood on my tiptoes, in just the right spot on the tiny deck, I could barely see the lake, which was about a hundred yards away over the neighbor's fence.

The owner stood watching us while we looked around the inside of Marty's summer dream home.

"No, this just isn't going to work out for us," I said as I smiled at the owner.

Marty shot me a nasty look.

"Are you sure?" the owner asked, "Why don't you take a moment to look it over some more?"

"Thanks," Marty said, "we will. Would you mind waiting by your truck so we can talk about it?"

"Sure," he said as Marty walked him over to the door of the mobile home. I was goofing with the kids trying to keep them distracted because I knew it was going to get ugly. There wouldn't be any hitting, but the

energy was going to get really nasty as it always did when Marty didn't get his way.

I made the decision to stand my ground this time. I sent the kids outside to wait by the car, and then I started right in before Marty could say a word. "We simply cannot afford it. And even if we could, I do not need the headache of maintaining this shithole!"

"That's bullshit! You said yourself we have the money in the house! And this place isn't that bad!"

"Goddamn it, Marty! Having equity doesn't mean the money is buried under a floorboard in our house. It means we would have to go to a bank, get an appraisal on the house, and take out another loan, which has fees—to completely drain the tiny bit of value we have in that goddamn house! And after we go through that process, we may find out that we don't even have that much equity in it anyway. We are absolutely not fucking doing this!"

"So, now what do I go tell that guy?" Marty whined.

"I don't fucking care! I'm not telling you anything I didn't already say to you many times this week," I said. "I'm here to have a nice day with the kids at the beach. Whatever you are here for is your own goddamn problem! I don't give a shit what you tell him, I don't even care if you tell him 'we'll take it,' but I assure you, *we will not.*"

Marty left to talk to the owner as I waited for him with the kids at our car. He came back to tell me he'd told the guy that he and I would discuss it and get back to him.

"Whatever," I said, shaking my head.

We took the kids to the beach. The kids and I splashed around and had fun wading and floating in the waist-deep water as Marty stood next to us—sulking, with his head hanging low and not saying a word. The

kids were nine and six at the time. I knew they were picking up on the tension—especially Aidan who I knew to be very sensitive—but they both played along with my attempts to ignore the black cloud that was their father lurking around us like a giant, morose ogre.

He didn't "win" that time. I don't honestly know how I got through that day, but I did. After that, I knew that something had shifted. I don't know if the shift was in me, or him, or us, but it didn't feel good. I knew I was doing the right thing, but I also sensed that I was going to pay for it one way or another. This was the first time I'd said no to Marty and stuck with it.

Soon after that, our financial burdens became too great. I'd been taking out credit cards with "no-interest for one year" promotions in order to pay bills and keep my optometry practice afloat. I'd expected the practice to finally turn around and begin profiting and then I'd be able to pay off that debt, but it never happened. I'd had my student loans in forbearance—a debt that had now become far greater than its original principle. We had no retirement savings and the money I'd had for the kids' education was gone. Every clever attempt I'd made to get ahead had failed miserably.

I had to tell my husband that my business attorney advised that we file for personal bankruptcy in an attempt to save my practice—our last hope for becoming financially sound.

He wasn't as mad as I thought he would be. I think he was just happy to do away with our credit-card debt. But he didn't have a full grasp of how little credit we would then possess. He was a hard worker, but he never understood money. He had his full-time job with a graphics company as a Mac operator, he did freelance work at home, and he

played in a cover band most weekends. Precisely because he worked so hard, he thought that he could have whatever he wanted—an attitude that was not in the least bit curbed by the bankruptcy. He continued to do what he wanted, while I scrambled to make it work.

In 2011, Marty was offered an opportunity to play in the band of a long-time idol of his. The guy offering him the position of bass player in his band had some hits in the eighties and nineties and was making a grand swing at getting back out there. He was his own manager and promoter back then, too, and he remembered Marty from his days in the record store. They'd always kept in touch and that networking had paid off. Playing in this band would mean Marty would be gone for two to three weeks at a time as he went on tours of the West Coast and the Midwest, and then internationally to Australia, Japan, and Germany.

I was in full support of it. Marty was flying high with the news and the planning of these tours, and I was excited that the kids and I would have some space away from him.

Marty's employer was fine with him going on tour, but he had no more vacation days so he wasn't going to get paid while he was gone. He would earn some money from each of the gigs, but it actually wouldn't even be enough to cover his travel expenses and time off work. I ended up *paying* a few hundred dollars for each of the tours as I struggled to get Marty to grasp the concept that his playing in this band actually *cost us money*, not brought in more. He banked on the idea that the bands would generate more income as their popularity climbed and they could demand more per gig. He was hopeful that someday he would be able to quit his day job and tour full-time.

His pouting and bitching had grown worse than ever. So I knew that anytime Marty was away from home, the kids and I were going to be happier. And I was genuinely happy for him. The lack of remorse I felt—for potentially having a husband who might become a full-time music-touring, groupie-loving, absentee dad—was not lost on me. I wouldn't say out loud how happy I was to see him go—not even when his stepdad called me a "goddamn saint" for letting him do it. Tom didn't realize how nice it was going to be for the kids and me to get a reprieve from Eeyore. It was a win-win for all of us.

With Marty on tour, I could focus more on finding peace and joy in my own life—the biggest deterrent to which I thought was our financial situation. I'd come across a CD program in the spring of 2012 given by a guy who called himself an "income acceleration coach." I took full responsibility for our bankruptcy and was determined to make sure it was not in vain. I was going to save my practice and finally live without financial worry.

I realized that my husband was a big part of the problem, but I thought I could control him, or rather convince him to change his ways. So much of what was said in this program was aligned with the philosophy of *A Course In Miracles*, so I believed I had stumbled upon divine intervention.

I was so convinced of what I was learning in the program that I decided to sign up for a two-day intensive in Washington, D.C. in September 2012. It would be an opportunity to get in the room with the creator of the program and fifty other people to dig deep into my money mindset and discover some real answers as to what to do to move forward in my life.

I told Marty after I signed up for it. I should have cleared it with him first, but I decided I deserved to spend money on what I wanted—which wasn't just a material object; it was something that could make a real difference for us.

I suggested we go out to a nice restaurant with a quaint outdoor patio, because in my mind I felt like I had something to celebrate and I was going to show Marty that he did, too. I was on a high from my decision, and feeling a powerful sense of heavenly inspiration in having found the program and signed up for it. I knew the benefit would go way beyond my optometry practice into a very deep spiritual awakening, so I was ecstatic. I believed Marty would truly understand once I explained how I thought this program would catapult our lives out of not only the financial struggles we'd been facing, but also from the rut we seemed to be in. I said it would bring us closer together as a couple.

Marty was not at all impressed. With his face scrunched and twisted he said, "But how do I know you're not just going to go to this thing and meet some guy?"

"What? Didn't you just hear what I was saying? Oh my God! I don't know how else to say that I think this intensive is ultimately going to be the best thing for *us*!"

My eyes welled up with tears as I once again saw how stupidly futile it was to attempt a spiritual conversation with my husband. I tried to explain again, "You know, Marty, I've always believed us to be divinely matched. We are in this life together for a reason. I know I've told you that many times before. And I could never go against that. I swear I've never looked at another man since we met. I've, never even *considered* anyone else, even when I was away at school. I've always felt that we are supposed to be together!"

As we sat on the restaurant's quaint outdoor patio, I poured out my entire soul to this man over my caprese salad and Pinot Grigio.

"People are fucking looking at us. Stop crying for Christ's sake," he hissed.

I looked around the patio and didn't see anyone paying attention to us. I knew I wasn't outwardly bawling, but I didn't argue and dropped the conversation. We finished our meal in silence and walked back to the car. It was the first time I realized that not only did this man not appreciate the very best side of me, he wanted nothing to do with it whatsoever.

A love for myself finally made a tentative debut. I had just begun to confront my own lies about the love I'd thought I had from my husband.

Discussion Questions

- When you met that straw-that-breaks-the-camel's-back moment, how did you stand your ground? Did you get angry? Did you walk away? Were you able to stick with your new intention and direction? Or did you later fall back in line with your old habit of putting up with shit?

- How conscious were you of the need to change? How do you remember your moments of clarity?

CHAPTER 10

Wicked Intentions

I never felt so wicked / As when I willed our love to die.
—Rilo Kiley, *Silver Lining*

The two-day intensive was as transformative as I knew it would be. Shaking from the upset stomach I'd been managing since the day before—when the income acceleration coach had told me to file bankruptcy and close my practice—I filled out his form to declare that I was an official life coach and facilitator of his program.

I got myself home, where I was facing big decisions requiring immensely daring endurance. I knew I had to close my practice, but I would rather have jumped off a hundred-foot cliff.

I called my attorney about a form I'd received just before I went to the intensive. It was from the bank where I had my business loan; they wanted me to sign it and return it immediately. I knew the form was sent in response to my personal bankruptcy, and that signing the form would put me personally on the hook for the loan I had on the practice.

"I strongly advise you shred that form immediately and file bankruptcy," my attorney said. "If you sign it, you'll be stuck with that

debt even if you close the practice. You'll never get out from under it. You've already got over two hundred fifty thousand dollars in student loans crushing you. You've worked very hard on this practice, Doctor LaCount. People will be cruel to you about this decision, but it is the right one. I know you have done everything possible to make this work. The recession hit hard just after you opened your practice in 2006, and that is unlucky, but it's not your fault. It's time to let it go."

Her clarity and reason was the parachute I needed to jump off that cliff.

It was a very scary time. I wanted to do right, and I wanted to maintain my integrity, but at times it was so hard to see that I had made the right choice. I avoided the term *bankruptcy*. To allow continuity for the patients' care and the honoring of their eyeglass warranties, I merged my practice with a colleague's and worked for her two days a week.

I also worked to build my coaching business. It was beginning to pay off, but not enough to quit or even to cut back on optometry. It was going to be a long haul to get to that point. But I was committed to it.

In July of 2013 we planned a family trip to Six Flags Great America near Chicago. Although I was beginning to experience colitis symptoms again, I still thought it was a good idea. I had been relatively free of symptoms for a few years, and I had managed the last flare-up with diet and homeopathic remedies, so I didn't allow myself to worry.

We took a shuttle from our hotel to the park, got there around noon, and commenced a day of fun with our twelve-year-old son and almost-nine-year-old daughter. The kids were having a blast.

I had to rush to the bathroom several times, and often missed out on rides with the kids, but my energy was good.

More than once I said, "If you can all be patient with me, we'll get through the day."

Toward the end of the evening, we were finally on the side of the park where the new Superman ride was. Aidan had been asking all day to ride it. It was near the exit to the park, so it seemed like perfect timing to me—but not to Marty. He was nervous that it was too close to the park's closing time and that we would miss the shuttle back to the hotel.

"The shuttle bus driver said this morning that a shuttle would be at the park until 11:00 PM, but if we missed that, no big deal because they would not leave any of us stranded," I reminded Marty when he started to object to getting in line for Superman. "Remember?" I reassured him. "He said if we miss the last shuttle, we can just call the hotel and they will send one."

Marty shrugged in reply.

I told Aidan it was 9:30, and if they were still allowing us to get in the line, then they would be prepared to get us through the ride.

"Yes! Finally!" Aidan yelled, giddy with anticipation.

In line, my stomach began that familiar gurgling and cramping, and I didn't know if I could make it. As the party ahead of us talked about the ride, it sounded a little more intense than I thought Roan would like—or my stomach could handle. They told us how we would be strapped in a prone position as if we were actually Superman flying through the sky.

"Roan, honey, what do you think about what they are saying? Do you want to go on this ride?" I asked my daughter.

"No, I don't think so," she said.

"Okay, sweetie," I said as I put my arm around her. I looked at Marty and said, "I think I'll take her out of the line and sit with her. I

have to go to the bathroom again anyway and I'm not entirely sure this ride is a good idea for me."

"No, I'll take her," he said immediately as he grabbed her hand and marched off before I could say a thing.

"Okaaaaay," I said to Aidan, "I guess it's just you and me, kiddo. Are you excited? This ride looks pretty awesome!"

"Ohhhhh yeah!" he yelled, clearly excited beyond measure. "Mom! Look, they've got Superman comics on the billboards! This is soooooo cooool! I thought I wasn't going to get to ride this today, but this is awesome!"

The line moved quickly and the closer we got to seeing the actual ride, the more excited Aidan got. "Look, Mom! We're gonna really be *flying!*" As they strapped us in—in the belly-down, flying Superman position—I was relieved that I was feeling okay with no pressure to go to the bathroom. The ride was fast, and it looped once or twice, but it was actually a serious amount of fun. I was so glad Aidan wanted to ride it and that I'd pushed to let him do it.

When we got off the ride, it was 10:10. The park closed at 10:00 PM, but there were people everywhere slowly making their way toward the exit. I thought the timing was perfect, but Marty was fuming.

"Goddamn it! What took you so fucking long? The people ahead of you got off fifteen minutes ago," he barked.

"Well, I don't know, we just followed the line. What the hell is the problem?" I asked.

"The problem is, we're going to miss the shuttle and I'm going to end up being 'that guy' who rudely holds everyone up. These people want to get home. And here we are—the assholes making them stay longer," he shouted, gesturing toward the park employees.

"Marty," I said, trying to calm him down, "you see we are not the only people here, right? There are plenty of other people behind us.

And, remember, the shuttle driver said, even if we miss the last shuttle, they'll send another. They won't abandon us. We'll be fine."

As was so often the case, I sent the kids ahead in an attempt to buffer them from their father's obnoxious, adolescent behavior. I wondered how the last half hour had been for Roan, having her dad seething over all these imaginary problems he'd concocted in his head. She showed me the princess purse he'd bought her, so I knew he at least tried.

"I called the fucking hotel, and they said they just sent the last shuttle and they won't send another!" Marty nearly screamed.

"What? Well, that's too bad." I said evenly. "But they promised they wouldn't leave us, and I'm going to hold them to that promise."

We walked through the park's gate and headed toward the shuttle pick-up area. I called the hotel on my cell phone and got a guy who rudely confirmed what Marty had told me.

The guy insisted, "The shuttle driver went home, ma'am. There are no other shuttles coming to the park."

"This is completely unacceptable. Jason, our shuttle driver from this morning, assured us we would not be stranded. He said the last shuttle would be here at eleven o'clock. He said your company would make sure they had everyone accounted for that they had brought in the morning. I don't care who drives the damn shuttle, or if you personally come and pick us up, but we have two kids here, exhausted from a day at the park, and you cannot leave us here!"

I didn't know where my assertiveness came from, but it felt damn good to tell someone off.

"Fine," the man said, "I'll see what I can do."

When we got to the shuttle stand, amazingly, after all that, our hotel's shuttle was right there. And a number of joyful, giggling patrons climbed on. The four of us followed behind them, our heads hanging

low because every bit of fun from the day had just been abolished yet again by Eeyore.

When we got back to the hotel, Marty made a beeline for the bar and bought himself two Heinekens while I waited for the elevator across from the bar with the kids. He wouldn't look at me, nor did he ask me what I wanted. And I didn't drink beer, so I knew the second one wasn't for me. As soon as we got to our hotel room, I went to the bathroom. Marty camped himself out on the farther of the two beds, turned on the TV to whatever he wanted to watch, and silently drank his beer. The kids went to the other bed.

Aidan started to pick on Roan about something, as he often did.

"Aidan, please, we are all tired from our day, so can you just be nice to your sister?" I pleaded from the toilet. I cursed as my belly cramped and shot a zinging pain up my spine. That weird spinal pain always indicated an advancement of the condition. Overwhelmed with the reality of this illness I was trying to ignore, I began to cry. I knew I had to make some serious changes. I didn't know how, or when, and it wasn't going to be tonight, but I knew I had to do something.

I decided to do the best I could to get through the rest of the night, despite Mr. Crabby-Fucking-Pants in the corner. I composed myself, dried my tears, and asked the kids to brush their teeth and get ready for bed.

I went downstairs to the bar to get a glass of wine. When I got back to the room I saw the kids were lulled by the *Antiques Roadshow* episode Marty was watching. I sat next to them on the bed, talked about the highlights of the day, and then sent Aidan to climb in bed with his dad so Roan and I could get some sleep.

Two months later, in September 2013, Marty embarked on another tour with his idol—whom I'd begun calling The Diva. Marty left in our

Toyota Highlander to tour the Midwest for three weeks with the band. I had become sick enough to have to quit work—without pay. Many of our friends and family, who had tried to support me, were horrified at the idea of Marty leaving to do the tour. But I wanted him gone. The son-of-a-bitch drained my energy like a vampire so much so that I actually believed I could get better if he were gone.

I didn't. I got sicker.

After this Midwest tour, the band planned to take a one-week break, and then go on another three-week tour of California and the upper Northwest. Evidently my illness put a strain on the relationship between Marty and The Diva. Marty pressed him for more money because I wasn't making any, but The Diva wouldn't budge. He needed to stay in The Diva's good graces because he was beginning to suspect there was a possibility that he might get cut from his most coveted West Coast tour, so I'd become the perfect scapegoat.

After the three-week tour, Marty texted to inform me that the band was on their way home and were about a half an hour away. He told me to "be waiting in the kitchen" to greet them. I felt way too sick to be waiting downstairs, let alone be social with a guy I couldn't stand, so I ignored his demand and was in bed when they got to the house.

I heard them come into the kitchen and greet the kids, and then Marty came into the bedroom. If he'd had a tail with a rattle, there would be no mistaking I was about to be bit. He'd been gone for three weeks—during which time I was very sick and getting sicker—but he wouldn't even look at me. I'd sunk into the bedcovers, not wanting any of what he was about to dish out. I knew better than to expect a hug or a kiss or any indication that he missed me or gave a damn about the pain I was in.

"That fucker wants to 'borrow' my brand-new duffle bag," Marty said of The Diva, gesturing with air quotes and a snide, mocking tone,

"so I guess I'm giving him my fucking duffle bag." He spat as he began to unpack it. He threw one pair of jeans after the next on the bed, each one landing like a brick. Every time I'd gotten sick, I'd ask my dad to take care of the dog for me because any jolting of the bed—like a large standard poodle jumping on it, or a fifty-year-old man throwing jeans on it—was very painful given my completely ulcerated colon. Every time Marty threw down another pair of jeans, I winced and had to catch my breath.

"Could you please stop?" I said in a weak, raspy voice. "It really hurts,"

"Yeah, I can see that," he said, and proceeded to throw more items on the bed.

Who needs fists when you have. . .jeans? I thought. *But what kind of story does that make? If only he'd just hit me, and give me a black eye, then I'd have something tangible to show for his abuse.*

The Diva took the duffle bag, and then days later removed Marty from the California tour. Marty never said I was to blame, but I knew full well that he blamed me. He was even more surly and neglectful in a truly poisonous way. On Facebook, he posted pictures of the grocery cart he filled when he went to the store and received kudos from all his adoring fans for taking such good care of his family, and doing it so well by separating the cleaning products in the cart from the food items. To the world he was the poor sap who'd lost his chance with The Diva because he was such a good guy staying to take care of his sick wife and his two kids.

Four days after Marty got home, I was admitted into the hospital. I was in the hospital for a week before I was released with very little improvement. They gave me the standard course of four days of I.V. steroids and narcotics to manage the pain. They determined I was stable

and told me there was nothing more they could do, so it was time to go home.

After a week or so at home, the blood loss worsened, and I became increasingly light-headed. Trying to move my body was like dragging heavy tree limbs filled with lead. I became concerned enough to call the doctor who had me come in for some blood tests. My sister Carol brought me in.

My hemoglobin was 7.1. Anything below ten is an indication that an immediate blood transfusion is needed. They sent my sister home and admitted me into the hospital once again. It was a Tuesday in October. Marty had plans to go see a band that night in Madison, two hours away. After I waited in the hospital for ten hours, they couldn't find a blood match for the transfusion, so the nurses told me I needed to call my husband to come and take me home.

"Don't worry, we will find a match. The blood bank staff will be working through the night to find the blood you need. In the meantime, you'll need to go home, rest and come back here tomorrow morning when we're sure to have the match for you," the nurse explained. "Just give your husband a call, and then let us know when he gets here so we can help you get dressed. You're too weak to dress yourself, okay? We don't want you falling. So be sure to wait for us to help you."

When I called Marty he was seething. "I gotta to do what? Pick you up? I thought you said they had to do a blood transfusion?"

I explained to him what the nurses had told me.

"Christ! I've got to get the kids dinner and then I've got to get them to bed!" He was trying to find a way to get out of picking me up. He wasn't going to point out that he wanted to be in Madison. And no voicing of any concern for my well-being.

"The kids are perfectly capable of eating on their own, and I'm sure they could do just fine getting ready for bed while you come and get me, Marty. Am I supposed to call someone else?" I asked, trying to get him to see how ridiculous he was being.

"Fine!" he shouted and hung up the phone.

I didn't think about whether or not he was justified in his shitty attitude, I just didn't want to deal with his wrath, so I decided to try to make things easier on him. Against the orders of the nursing staff, I got out of bed and got myself dressed, slowly, while leaning on the bed to avoid falling. I texted Marty to tell me when he got to the hospital, and said I would meet him down at the main entrance. I covertly called the nursing assistant to wheel me down to the parking lot to save myself from explaining to the nurses what a dick my husband was.

I got in the car with the help of the young nurses' aid. Marty didn't even bother to get out to help me.

Once I was in and the door closed, I was immediately blasted by the foul mood in the car. Desperately trying to offset that, I asked him how his day went.

"It fucking sucked," he said.

"It sucked? Why?" I asked, almost amused as I wondered what he would come up with that was worse than lying in a hospital bed all day waiting for an emergency blood transfusion that never came.

"Because it was fucking boring— Oh, goddamn it!" he yelled out as he came up to the stop sign. "These fucking brakes are making that scraping noise again. I've got to take this car in, but I can't because you're sick—and we can't afford it because you're not fucking working!"

I reflected on how I'd ignored the nurse's admonition to ask for their help. I just took care of things as I always did because I didn't want

to further irritate Marty. Light-headed from a dangerously low blood count, thirty pounds underweight, emotionally and physically exhausted, I felt a surreal, out-of-body experience settle in. I saw myself as a magic genie rising like vapor from a bottle that my anger had uncorked. My genie-self floated above my body in the passenger seat and I saw my physical form from a vantage point that was up above and to the right of me. As if on command, I began to feel the slow boil of a very deep emotion. I was being treated like shit, again. I deserved to be angry.

No Carin, it's more than that: You need *to be angry*, I heard in my head. I didn't need to "fix" things for him. I didn't need to take his blame or excuse his behavior. It was time to be *done*.

We veered off the highway onto Oneida Street and the divine moment passed. But I felt as if I'd been given a gift. My awareness shifted back to the suffocating silence in the car, but I could breathe easier. My anger continued to percolate—I couldn't suppress it this time—but deep inside me, something or someone decided I wasn't going to take it anymore.

The next day the needed blood transfusion came when the blood bank found a match for me. At the same moment, I found the strength to leave this poisonous man.

A week later I asked Marty for a divorce.

Discussion Questions

- Has an illness you suffered ever felt as though it were because of how you felt about what was happening in your life?

- Has anyone ever callously dismissed your physical or emotional pain? Were you able to confront that person about it? Or were you too afraid they would leave you if you did? If this is happening in your life now, do you think you can love yourself enough to release the other person from your life for good?

CHAPTER 11

Limbo to Ambien

Enough had been thought, and said, and felt, and imagined. It was about time that something should be done.
—C.S. Lewis

I went back to work in a state of silent frenzy. I knew in my heart that the speed with which I healed from my current flare-up was because I took a stand for myself and asked for the divorce. Never before had I gotten so sick as to need a transfusion, but never had I healed well enough to be back to work within three weeks of leaving the hospital. But now what? My head was spinning with what would be the immediate consequences of my decision—telling the kids, Marty moving out, and telling the family. Fear began to paralyze me as I plunged into a daze.

Marty was the complete opposite. He took control of his side of things as he began to search online for an apartment. He also started a list of the things he wanted to take, in particular the many art deco furniture pieces he bought with our joint credit card.

He worked on me daily to drive home the reality of what divorce would mean to all of us. He wouldn't overtly say anything to make me feel guilty like "you're going to ruin our kids' lives," but he explained to me that my parents never divorced so I wouldn't know what it was like.

"It'll be pure hell for the kids," he said.

Never mind that all the years we'd spent together, he'd always said his parents' divorce was a good thing—that it never really bothered him much. Now, he described in vivid detail how the kids would begin to notice items being gone—like furniture and pictures on the walls—and how devastating that would be for them.

He told me he loved me over and over, and then he would add "but obviously, you don't love me."

We hadn't said anything to the kids yet. I'd needed time to process and observe, to really think through how, and what, I was going to tell them. I needed to fully understand my unhappiness and why I felt I needed to leave my marriage. But Marty was eroding my resolve.

I'd found a book a few years prior called *Feelings Buried Alive Never Die,* by Karol K. Truman, and I had it constantly by my side. It detailed the emotional components of physical ailments—conveying that it is our buried, unmanaged emotions that cause our physical conditions. Under ulcerative colitis it said, "often manifest in those with obsessive-compulsive behavior," "unable to express hostility or anger [toward] whom you feel it," "indecisiveness," and "a need to conform." For diarrhea, it said, "wanting to be done with someone or something," and "rejecting the visualization of something you don't want to accept." Under anemia, it said, "Lack of pure self-love," but that one didn't register with me. The anger, hostility, indecisiveness and rejecting what I didn't want to accept made a ton of sense.

I believed that when I asked for the divorce, I'd finally released the anger, hostility, and indecisiveness. Accepting the idea of divorce was the reason I'd turned the flare-up around almost miraculously. The medications and the strict diets were always so slow to help that I always wondered if they ever really did. I wondered, too, if the diets I worked so hard on actually added to the obsessive-compulsive behavior that contributed to the colitis.

Everything I'd read was telling me I had some deeply buried emotions that were manifesting themselves in my physical symptoms. It didn't seem fair to say that my husband made me sick—but there was definitely a dynamic in our relationship, and probably something that was held over from my childhood, that ate away at my health.

But my marriage wasn't just about Marty and me. I'd gotten children involved. I could now see that our marriage was sheer poison to me, but my kids were what mattered. I very purposely brought them into this world, and into this marriage, so I had to figure out without the tiniest bit of doubt that divorcing my kids' father was the best thing to do for them. If it wasn't, then I needed to suck it up and stay married. In my head, I began to feel unimaginably selfish. My heart, which had rejoiced at my asking for a divorce, was now silent while my head fought through the fog.

I scheduled an appointment with a therapist. My intention was to feel her out as a potential support for helping the kids get through the divorce. Her name was Sharon. When I told her about the last straw—the incident I'd begun calling "the blood transfusion day," she got excited because she believed she understood exactly what was happening.

"Marty was paralyzed with fear," she said. "He was afraid of losing you, pure and simple," she explained. "Obviously, he loves you, but

sometimes—especially men—don't know how to express that, and so they get scared and say or do hurtful things they don't mean."

I was desperate to believe her. She said a lot of what my other therapist, Ellen, had said years ago. Despite my resolve in asking for the divorce, I was still grasping at anything to find hope and to stay in the marriage. I decided to tell Marty what Sharon had said, to see how he'd respond. I told myself that if he said he would work with her, then it was my duty to at least see where Sharon could take us—even though the fact was solidly established that I was deeply unhappy in the marriage. Although I didn't want Marty thinking for a minute that I excused his behavior, I did hope that Sharon could help him change it. He agreed to go with me.

Sitting on her grey couch with the purple throw pillows week after week, my brain worked hard to rationalize away my heart's desire to get out. Sharon dismissed my heart as surely as I did. She believed the problem was Marty's fear, and she was determined to save our marriage. But we made it through only four sessions before Marty got sick and tired of her "wasting his time," because she was always twenty to thirty minutes late to our appointments. My head told me I owed it to him to work with a therapist if he was willing, but my heart rejoiced in the blessing her chronic tardiness became.

While my confidence waned, Marty fought hard to keep me confused with his declarations of love—and for the first time ever, he was giving me compliments on my appearance. After New Year's, he took me out for Thai food to convince me he was sorry for his behavior around the blood transfusion.

As we sat at our table with white linens and a glass of red wine, waiting for our dinner to arrive, he began to cry as he said, "What can I do or say to convince you that I'm sorry about that day?"

I thought about the expression *crocodile tears*, which I learned about in optometry school. They are the tears released from the eyes of a crocodile as it's eating its victim.

"I don't know, Marty." I said, "You weren't sorry about it even a week later when I told you how your conduct made me feel. You said 'we would have to agree to disagree' about *my* feelings. I think what you're actually sorry about, is that I asked for a divorce."

"*Yes!*" he said, "I'm sorry about that, but I'm sorry about that day with the blood transfusion, too. I was just so scared."

Yeah, you weren't scared of shit, you just got the idea of being scared from the therapist, I thought.

As the waitress set a plate of sweet curry chicken in front of me, I looked at him and tried to measure the talent he had to say he was sorry and to shed a tear—only I didn't feel an ounce of empathy. His apology was empty. I realized how much I hoped he'd have the right sentiment, but he just confirmed that he didn't care, and he was making it less and less possible for me to tell myself that he did.

With the cyclone in my head interfering with any attempts to get my coaching business off the ground, my business coach referred me to Bonny, a former couples counselor, who was now a certified couples coach. Bonny worked over the phone rather than in person, and she could work with us in the evenings. Marty had no reason not to work with her, and she was never even a minute late for our calls.

Bonny had an assignment for us. We were to listen to the CD program on money mindsets while going on a road trip to Madison. It was a weekend-long date, geared specifically for me to share something that was important to me, and for us to bond. Marty was all for the assignment, so we listened to the CDs both on the drive there and back.

In the follow-up call with Bonny, she asked me to please tell her how I thought things went. "Don't hold back, either. You're in a safe space here to share how you felt about listening to those CDs with Marty," she said.

"Okay, well, for the most part it was good—except the recordings where people called in to ask their questions," I said.

"Go on," she said, sensing my hesitation.

"Well, Marty listened, and then he just made fun of the callers," I replied.

"Of course I did. They were idiots!" Marty jumped in.

"Marty, this is Carin's time to speak. Please let her," Bonny said.

"But, when you made fun of them, you might just as well have been making fun of *me*. And your arguing about how stupid you thought their questions were, combined with giving your know-it-all answers to their questions, was maddening. You clearly don't understand the material, and you don't care to—but you're right in there anyway with your ill-informed opinion, arrogantly dismissing all of it, and me along with it." My voice was quivering. I was talking on the phone in the bedroom, and Marty was on the phone in the next room in his office. I was grateful for the physical separation between us because there was no way I wanted to be looking at his twisted angry face at that moment.

"That's not true," Marty said, "You can't say that! I just thought some of those people were clueless. Not all of them! The guy made

some good points. I just can't believe how much people pay him for his advice, that's all."

With Bonny there, I felt like I finally had a witness to what I'd dealt with for years. I didn't even plan it that way. I thought overall Marty and I had a nice weekend. There was just this little incident—him acting like everyone's an idiot while and he's the expert on money mindsets. That frustrated me, and in order to do right by Bonny's assignment, I had brought it up.

Bonny called me the next day. "Carin, I'm afraid I can't work with Marty," she said immediately. "I could work all day with you, but last night's call confirmed what I've been suspecting: Your husband is just not coachable, and you are not emotionally safe with him."

We'd had only four sessions with her, and she was already refusing to work with him. I was in shock, yet I felt validated in a way that struck a very deep chord. Part of me had been waiting for someone to see what I'd tolerated for so long, but I didn't know what to do with it now that it had happened.

Marty was pissed about her conclusion. He tried to convince her otherwise but she was firm. It was the end of our working together with Bonny, but I kept her number in case I needed her guidance in the future.

For reasons I was desperate to understand, Aidan was bullying his sister. At first it seemed like it was just annoying hyperactive behavior, but over the last couple years he'd gotten worse. He was being horribly insulting to Roan and berated her every chance he got. I was at a loss as to how to stop it. Roan and Aidan had been close when they were younger, but I could see Roan pull away as Aidan would relentlessly pursue her with irritating and insulting rude behavior.

Sometimes I had to scream to get him to stop, but all that ever did was make him scream back and tell me, "You think I'm a horrible person!"

He couldn't stand anyone being mad at him, yet he could be relentlessly overbearing, especially to Roan. I knew he was a good kid, with a good heart, but even my family began to pull away from him. My dad constantly lectured me about being too lenient with him. My sisters loved to tell me of his bad behavior whenever they'd been with him—always with an added dose of fierce character judgment. I knew Aidan was troubled; but I also knew he was a much better kid than what my family saw.

I did everything I could to get him help. I worked closely with his teachers to monitor for learning issues and put him in various therapies such as vision therapy to help with his visual processing, biofeedback, and auditory processing therapy. All it did was make him think there was something wrong with him. He began to think he was a bad person. I constantly told him he was good, and tried to help him understand how his behavior looked to others. I told him he was smart—with a different kind of smarts that would help him when he was older. I had no proof of that, but in my heart I knew he had talent and intelligence. I knew there was more to him than what met the eye. I also knew the damage that feeling he was bad and stupid could do to his self-esteem.

I watched Aidan lie to Marty all the time to avoid being yelled at. I tried to explain to Marty that he was teaching his son to lie, but he thought that was ridiculous.

Ever since Bonny had said that I wasn't emotionally safe with Marty, I looked at my kids' relationships with him even more closely. Marty constantly lectured Aidan, so I began to see how my son's confidence in everything waned. Aidan used to love to draw; he was a truly gifted artist, but he suddenly stopped drawing.

Roan was safe with her dad because she worked hard to be the good girl—like I had done as a child. If she ever acted out or misbehaved, it was only with me. I began to recognize that it was because she felt safe with me. Aidan couldn't do that. He coped with his problems differently, acting out no matter who was there to witness it. I couldn't put my finger on why he would get so angry and often be impossible to reason with, but I still loved him. I couldn't shake the notion that I was missing something or doing something myself to perpetuate his behavior issues.

The greater awareness I had of Marty's manipulations, and my fierce need to protect my kids, initiated a slow panic as I thought about custody. What might happen or not happen with our kids and their father if he had them fifty percent of the time without me to protect them? I wanted my kids to have a relationship with their dad. I didn't want to take them from him entirely, but I'd begun to see a significant defect in Marty's behavior that needed to be managed. I just didn't know how I could do that through a divorce.

One morning in June, on a rare Saturday off, I was lying in bed in that state between dreaming and wakefulness. I was in a blissful mood as I dreamed of my loving husband lying next to me, and my two beautiful kids in the other rooms. But as the dreamy fog lifted, I remembered that my husband wasn't loving, and he wasn't next to me. He was sleeping on the couch, which was his new habit after gigs.

Refusing to let that rude awakening ruin my beautiful summer morning, I went down to the living room where my babies had built a blanket fort that they were sleeping in. I went over to Aidan on his side of the fort, careful not to kick the blankets he had pinned around him to separate his side of the fort from Roan's. I snuggled with him a bit, loving his giggles as I gently tickled his neck with my "morning bug"

fingers. At thirteen he still laughed at that just as he did when he was two. Then I went over to snuggle with Roan on her side, rearranging her stuffed animals so I could get in close. She gave me a sleepy grin and then closed her eyes again when I kissed her on the forehead.

As I lay there next to her, I struggled to understand why there was such conflict between them. Why were they not getting along? Why was Aidan lying so often and being annoying—or downright abusive—to his sister? I'd tried to work with the kids to help them understand each other. However, when I'd asked Roan to please understand that Aidan's name-calling was just *words*—that she could be a strong girl, stand up to him, and let his insults roll off of her, it felt like idiocy. Or when I'd told Aidan that making fun of Roan's weight or picking on her for not exercising was excruciating for a girl and asked him to please have some compassion and stop doing that—it felt like foolish wishful thinking. All my parenting did for them was make things worse.

My intention to be the best mother possible was slipping through my fingers and I couldn't figure out how to stop it. Was I making everything worse because I wanted a divorce? Did that negative energy somehow seep into their consciousness? I was so overwhelmed with my problems with Marty that my children were suffering in ways that I'd only just begun to see.

Tears rolled down my cheeks as I asked myself, *How can I divorce their father, stating that we just can't get along, while I keep asking the kids to just get along?*

As I lay there next to my daughter quickly wiping my cheeks so she wouldn't see me crying, I knew my marriage was a disaster, but I couldn't break up my family. The problems my kids were having with each other would only be compounded with divorce, and my opportunities to help

them would be reduced by fifty percent because they would be with their dad half the time. Since my children were my top priority, I had to face the fact that divorcing now was the worst possible time for them.

I heard Marty go upstairs. A few minutes later I went upstairs to find him at his computer in the home office. I sat on the futon as he turned away from his computer to face me, sitting on the large leather desk chair a few feet from me.

"I don't want to break up this family," I said. "I'm done talking about divorce. I can't do that to my kids."

"Okay," he said, "that's good."

I got up and left the room without saying another word.

It was seven months after I'd asked for a divorce. We'd been in limbo the whole time, and I didn't know how we were going to come back from that, but I had to do it for the kids. The whole reason I'd married was to have them—and I wasn't going to ruin them by getting divorced. I rallied as I decided I owed it to my kids to be the best parent I could be and to help them through whatever was causing their trouble. I told myself I would just postpone the divorce until Roan was in college. That was only eight more years. I'd endured this long; I could do another eight years.

I expected that my declaration to stop talking about divorce would reinvigorate our marriage. We went on date nights, but I felt even more distant from him and they became unbearable. He would *allow* me to talk about my interests, such as the coaching programs I was developing, or anything spiritual, but "only for thirty minutes, then I'm done," he would say.

I felt like a child given a time limit to play on the teeter-totter all by myself.

"If you don't actually engage in a conversation with me, why would I want to just sit there and blather on while you drink your Old Fashioned?" I asked one night while we were at the restaurant bar waiting to be seated. "You don't even talk to me when I try to bring up music or the band or anything else that you might be interested in!"

"Whatever," he said, "talking is just not my thing."

"Yeah," I said, rolling my eyes. I wasn't even sure I had the right to be pissed because talking never was his thing—unless he was trying to persuade me to give him what he wanted.

In the bedroom, the sex was even more confounding. I'd always despaired over the lack of genuine intimacy with him, but at least he gave me little crumbs that allowed me to pretend he cared to connect with me. He'd look for the "perfect" music to play, or he'd let me light candles. And on date nights, we had an unspoken agreement that lovemaking would conclude our evening. Ever since I'd told him that I was recommitted to the marriage, things had changed. He rarely initiated, and when we did have sex, he'd often say, "I'm not in the mood, but you can just hop on if you want."

I suppose that would be fine if sex for me were just about the orgasm like it is in porn videos, but his indifferent tone suggested I was some slut he mocked for my need to "get it on." There was very little participation on his part. He still never kissed me during sex, but now it was even more conspicuous. He was barely involved in making love to me at all. He rarely climaxed even after thirty minutes or more.

I wondered out loud if my having given birth to two kids had made me less tight down there.

"I don't know," Marty said, "Maybe."

I found myself crying more often than not after sex. I began to

suspect that Marty was using a clever, passive-aggressive way to trigger my insecurities about my sexual neediness. All I ever wanted was to feel loved—but now I felt like he scoffed at me as if to imply that I was just a sex-starved whore. I became certain that his covert way of not making love to me was punishment for my asking for a divorce.

It also occurred to me one night as I lay next to him wiping my tears in the dark, that he could be getting his needs met elsewhere. I hated to think of that, but to consider it allowed me for the first time to fantasize about being with a man who truly loved and honored me—as I went into the bathroom with my vibrator.

In July of that year, I was offered a full-time position with Shopko Optical, which I accepted immediately. I was finally making a consistent income—higher than any salary I'd made thus far as an optometrist—and I'd have benefits, so I was covered if I got sick again.

In April 2015, I stumbled upon the website of a psychic in California named Vickie Emanuel. I felt a flutter in my belly as I looked over her website. I immediately reached out to her for a reading and got one scheduled two weeks later.

"Oh my God!" she said, laughing as she started the reading. "There's a woman here who says she's your mother and she is dying to talk to you!"

"Okay," I said, "but that could be my stepmother."

"She's a hoot!" Vickie said. "She's not very tall, has short wavy dark hair, and she's dancing!" She laughed. "She's telling me to tell you that you need to 'get rid of that loser'! She's talking about your husband in case you didn't already know," she added. "*And*, she says you need to change your lipstick color."

Vickie's reading made it even harder to keep living in the marriage. My head was still stuck on needing a clear, definable reason for ending my marriage and dragging my kids through a divorce. I knew I'd have a tough time getting support from my friends and family with just a psychic reading, and I felt my kids deserved a more concrete reason. So I reached out to Bonny and scheduled another appointment with her.

As I described to her Marty's day-to-day antics—more of the same story she'd already heard—she cut me off and asked, "Can you get to an abuse shelter?"

"Excuse me, a what?" I asked, completely confused.

"An abuse shelter. I think you need to hear other women's stories and see how similar they are to yours," she said.

"Are you suggesting that I'm being abused?" I asked, incredulously.

"Yes, I think you are, and I think you're codependent."

I felt my heart drop to my belly. *Me? Codependent?* That sounded pathetic. I trusted her, but my head spun with all the reasons why I couldn't be this woman she said I was. I was strong-willed, I was an independent professional, and I wasn't stupid.

She went on to describe emotional abuse and its effect on codependent victims. "I think if you went to a meeting in an abuse shelter, you would finally see that you've been used and abused, that you've justified and diminished it for years, and that you need to get out of that marriage."

I was completely deflated. Her words reached in and punctured the bubble of lies I was holding onto with all my might. The truth lay there in my hands: I was needy and for that I'd allowed myself to be used and abused. There was no way I could shove that truth back in the bubble and continue on in denial.

"I understand what you're saying, Bonny," I said. "This is a lot to process. I know I have some dysfunctional tendencies from my family. And

I've been suspecting that Marty has some passive-aggressive personality issues, but *abuse* and *codependence* are big words to swallow."

"I know, Carin," she said, "but the sooner you come to terms with these issues and deal with them, the sooner you'll find peace. It'll be a long road for you and the kids, but I'm certain you can do it."

"Thank you, Bonny, I'll keep you posted," I said, and hung up.

It was my day off, so I was alone in the house, and free to bawl my eyes out. But as I sat there at the granite counter in my kitchen, I was numb. Too exhausted even to cry.

Bonny was exactly right. I was needy. I'd been needy and codependent since the day my dad got down on his knees in front of me, to tell me my mother had died. As his body trembled, he looked at me with fear and anguish in his eyes. Big, grown-up words poured out of his mouth, but all I could focus on was his trembling as he wrapped his arms around me in a hug. I didn't understand what was happening. I was afraid for him. I'd never seen him this way. I'd never seen anyone seem as if they might unravel right before my eyes. I didn't want to ask him any questions for fear he might break apart. All I wanted to do was help him—soothe *him*—so I returned his hug and held him as tight as I could. I hoped it would be enough to keep him together. I stepped in to take care of my father's needs—to parent *him* in that moment—and he let me do it. In that instant, I began a life-long pattern of taking care of others as a backward attempt to take care of myself.

In the months that passed, my dad would hug me and my siblings, but it wasn't enough. He thought it was enough—and at first it was— but when my mother never came back home, I needed more. I *needed* to break apart and to be held together by someone else's loving arms. I *needed* him to talk to me about my mother's love for me. I *needed* his unconditional love. I *needed* a parent who didn't require me to validate

his needs to make *him* proud in order to get his love. I *needed* to know that my mother loved me—that it wasn't my fault that she left, just because I didn't give her what she wanted, because I didn't answer her question. I *needed* an adult to show me how to cope with my mother's sudden death. I *needed* a stepmother who was nurturing, not angry all the time. I *needed* not to feel like her love came at a price I couldn't pay. I *needed* a father who could explain that it wasn't me that made her unhappy—that I wasn't a bad child that no mother could love. I *needed* my father to teach me how *not* to be codependent.

When Marty showed up in my life, I had no idea of the nutrient-starved love I'd grown accustomed to expecting. It never occurred to me to demand more—to demand real, unconditional love—because I'd had no experience with it. After a childhood full of practice in giving everything of myself in order to get love, I fell very quickly into the same practice with Marty. And he used it to his advantage. My childhood experiences had me primed for giving him whatever he wanted—and to not even notice that he didn't care what it cost me to give.

I kept busy with work as my heart quietly plotted to leave the marriage. It was now eighteen months after I had asked for a divorce and twelve months after I'd talked myself out of it. But now I was clear. I concluded that, although I'd been staying for the sake of the kids, leaving was actually the best, most loving thing I could do for them. It would be difficult, but I would figure it out. I allowed my heart to begin to move me forward toward a second and final divorce attempt.

I just needed to find the right time. And soon.

My mind was numb. It was as if my heart had told my head, *Sit down and shut up. We're doing this!* The last weekend in July 2015 Marty's

family had planned a reunion in Shawano. His dad and stepmom were coming up from Texas to attend, but Marty had planned to go on a weekend tour with some band in Minneapolis that same weekend. His dad and stepmom arrived on Thursday, and an hour later Marty took off for his weekend gigs. There I was, left to entertain his parents until they left for the two-day reunion the next evening.

On Sunday, the kids and I drove the ninety minutes from home to meet the kids' Nana and Paw-Paw and other members of Marty's family at the reunion. Marty finally showed up late that afternoon—but only stayed for an hour. The kids had been invited by their Nana and Paw-Paw to stay overnight in the hotel with them and swim in the pool. So I saw my chance.

When Marty left, I went to Walmart—shaking with the fear of my intentions—and bought the kids pajamas and toothbrushes. I went back to the hotel room to drop off the stuff and give the kids hugs, careful to say as little as possible to keep my mind clear and steady. Then I headed home.

When I got there, Marty was already in bed watching TV.

"Hey hon," he said pleasantly.

I got a sense that he was feeling frisky.

"How are the kids? I'll bet they're having a blast with Nana and Paw-Paw," he said.

"They're fine," I replied as I went to my dresser to take off my jewelry.

"Thank you for taking care of them, really," he continued. "I had such a great weekend. The gigs were awesome, the bars were packed both nights, and we had so much fun. I didn't even get to sleep until six o'clock this morning."

He was being chatty, which was his version of foreplay. He suspected I was pissed at him for being left alone at his family reunion, so he thought

139

he could use sex to get me over it. I wanted no goddamn part of that. Sex with him was never inspiring, but in that moment, the thought of it was flat-out revolting.

"That's nice," I said as I took off my shoes, put them in my closet and walked across the room to the bathroom, closing the door while avoiding his eyes. I wasn't about to undress in front of him. Behind the bathroom door I slipped into my blue nightgown and matching robe, washed my face, brushed my teeth, and then took two—not my usual one—Ambien. I was determined to sleep soundly.

"How was the reunion?" Marty asked as I came out holding all of my clothes. "It looked like everyone had a good time," he said.

I didn't answer as I walked back across the room to throw my clothes in the hamper.

"Do my dad and Teri have any plans with the kids tomorrow? They aren't leaving until Tuesday, right?"

"I have no idea," I said as I crawled into my side of the bed, still wearing my robe. My heart was pounding like a battle drum. Finally, I said it. "I can't do this anymore, Marty. I need out of this marriage. And I think you moving out is the best thing for the kids."

"What the fuck?" he yelled. "Are you saying *divorce*?"

"Yes. I'm done. I want a divorce. I want a new life without you."

He began to protest.

I rolled over, pulled the covers up over my head, let the asinine noise of his voice fade into the background, and fell asleep to the rhythm of my heart. This time there was no going back.

Discussion Questions

- Has there ever been a point in your marriage when you let go of all concern for yourself and fought with your ego to make the best decision for your children, yet found it nearly impossible to know what to do?

- Once you decided what to do, what did it take for you to follow through?

- If you haven't yet decided, what do you think it will take for you to leave and move on?

CHAPTER 12

Marty Won't Quit

Nothing on earth hurts my soul deeper than conditional love.
—Criss Jami, *Healology*

When my alarm went off the next morning, Marty was not in bed. I could hear him in the next room where he usually worked on his computer. As I made the bed, I thought, *Maybe he's going to leave me alone this time until we can sort out how to tell the kids tonight.*

Just then he burst into the room carrying on with his trademark sarcasm. "It must be *so nice* that you can drop *that* fucking bomb and then just fall asleep like you don't have one goddamn care in the world!"

I didn't respond. I walked straight into the bathroom and shut the door to shower and get ready for work. I didn't see him again before I left the house.

On my way to the office, I called Marty's stepmom, to see when she thought they would bring the kids home. She said they'd be home in about an hour. I didn't tell her anything. It was Monday, and they planned to drive back to Texas the next day. I knew they needed to know; I just couldn't even *think* about telling them.

All I cared about were my kids. I expected we'd talk to them when I got home from work, but I couldn't figure anything out in my head. It was all I could do to take one step at a time and get through the day. Like the body of a marathon runner crossing the finish line, my mind collapsed after the emotional feat of asking for the divorce. I couldn't think about doing another thing. My mind had finally given way to my heart. I wasn't trying to justify, rationalize, plan, or undermine the decision my heart knew it had to make.

As I drove, my head flooded with panic when I realized Marty was not going to be rational. I had to wake up out of my haze and warn him that the kids were on their way home. I called him and coldly suggested he get his shit together.

"I want both of us to talk to the kids tonight. If they see you crying, they're going to want to know what's going on," I said. "Maybe you should tell your dad and Teri separately when they—"

"*Fuck you,*" he yelled and hung up.

When Jerry and Teri got back to the house with the kids, the kids lingered downstairs as they went up to the guest room—which doubled as Marty's home office—to drop off their bags.

Marty was at his computer with a red, puffy face, and completely bloodshot eyes.

"Carin said she wants a divorce. She just came home last night and said, 'I want a divorce,' and fucking went to sleep. She didn't even give a shit about me," he sobbed.

After he calmed down, Marty asked Jerry to go downstairs to get the kids.

"Don't you think you should wait for Carin?" Teri asked.

"To hell with her. She's washed her hands of the whole damn thing. It's all on me to tell them because she obviously doesn't even care about them," he said.

"Well, I don't think that's fair," Teri said.

But Marty wouldn't acknowledge her. He met the kids in our bedroom. "Mom wants a divorce," he blurted.

The kids couldn't process immediately what he said. They watched their father sob.

Aidan asked, "What do you mean?"

"I mean, your mom said she wants to live with just you guys—not me."

The kids had no idea what hit them. They walked over to the bed and put their arms around their dad and began to cry along with him, the three of them shattered by my selfish decision.

My day was fully booked with back-to-school patients. Marty sent me a text: *I told the kids. Now you can fucking deal with it.*

Oh, God. I dealt with it by immersing myself in my cases, detaching from all of it until I got home.

Marty operated in true Marty form. He chose not to wait so that we could tell the kids together. Instead he did it at the height of his emotional drama to invoke the maximum amount of pity for himself, and animosity for me. And it worked.

When I got home, I told the kids I was going for a walk and they were welcome to walk with me if they wanted.

They both agreed.

As soon as we started, Aidan said, "This is the worst idea you've ever had, Mom."

"I know it seems that way, sweetie," I said.

"I can't believe you're doing this," Roan said, unable to stop her tears.

I tried to put my arm around her, but she pulled away.

"You both have every right to be mad at me, okay? I want you both to know that it's okay to be mad at me, and sad, and whatever else you feel," I said. "And, you can come talk to me about it anytime. I'll always be here for you. But I want you to know, I spent *a lot* of time trying to decide what was the right thing to do for both of you, and I finally decided that a divorce was the best thing. I know that it doesn't make any sense right now, but someday it will."

They were both quiet. Aidan held my hand as Roan walked behind us, ignoring my offer to hold her hand, too.

Once we got back to our driveway, Aidan said he wanted to keep walking with me.

"Do you want to keep going, too, Roan?" I asked.

"No, I just want to go to my room," she said.

I knew she was emotionally exhausted.

"Okay, sweetie. I love you!" I called out to her as she walked up the drive.

"I love you too, Mom," she said over her shoulder.

My heart broke for my sweet baby girl.

Aidan and I walked for another hour. The shock of the announcement began to wear off as he listened to my G-rated reasons for wanting the divorce.

"You know how dad is just so moody all the time, right?" I said.

"Yeah, he can really be mean sometimes—and it's like he yells all the time."

"I've tried to work with him on that for years, sweetie, and I just can't do it anymore. He's never happy no matter what I do, so I'm done trying."

"Yeah, I guess I understand. But I still hate this," Aidan said.

"I know, it's not going to be easy, but we've got each other. I want you to come talk to me about anything you need to talk about, okay?"

"Okay mom, I love you," Aidan said.

I held him in my arms as we stood next to the Clovis Grove woods. I fought back my tears as I watched a squirrel scamper across the wooded path toward the park. I longed for those carefree days I'd spent in those woods, singing nonsense songs and feeling the love of home as I imagined I was in the house of my dreams in the midst of the dogwoods.

The lines of allegiance with Jerry and Teri were immediately drawn. Jerry loved me, but he needed to be there for his son. Teri had known me almost as long as she'd known Marty, and she always liked me better. She and I had an unspoken spiritual kinship— because of the similarities we saw in each other's husbands. In the past we'd discussed how poorly she was treated by Jerry. I'd always felt such compassion for her—as he often mocked and ridiculed her to entertain Marty and his siblings—but I hadn't been ready to admit what I was suffering in my own marriage. She began to see who Marty really was as I started to recount the exhaustive list of my frustrations with him over the years. She could especially relate to how heartless Marty had been when I was sick, because Jerry was the same way with her.

My forty-eighth birthday came a week later. It was also the weekend of the third annual Mile of Music Festival, an Appleton tradition of showcasing original musical talent, which had grown by leaps and bounds every year.

"I'll take you out to The Mile for your birthday," Marty said tucking away the pout he'd had on his face all week and replacing it with a sparkle of sweetness. "We'll go to that Mexican restaurant downtown on College and relax with some margaritas. It'll help you get your mind off things," he said. "I'll put it on my own credit card," he added, making it even more surreal.

He's going to actually pay for dinner? He didn't even pay for my Mother's Day flowers. I would've laughed if it weren't all so tragic.

"And I'll take you home any time you want," he added.

I agreed to go for the kids' sake, to facilitate an amicable separation and divorce. But I regretted it the second we walked into the restaurant. My throat tightened and I immediately bowed my head to hide the hot, sudden tears I couldn't stop from running down my face.

At first, I couldn't identify why I was having such a strong emotional reaction. Then I realized: I was suffering an intense longing to be loved and to feel attractive to the one who loved me. As I walked into a room full of strangers, I saw couples wedged in quaint booths talking closely, couples sipping cocktails at the bar with their legs entangled—all of them sharing the intimacy of loving each other, an intimacy I could only imagine but had never experienced. All of them were there tasting and enjoying what I'd longed for my whole life but had never experienced. I was overwhelmed with the undeniable reality that I'd never, ever felt loved by Marty since the very beginning of our relationship twenty-seven years ago.

I continued to scan the room. The women were beautiful and sexy, and the exchange with their partners was palpable. I longed to feel the glorious sexual attraction and loving devotion I imagined was at every table. I was out with my husband of twenty years who thought he was going to win me back—and I felt none of that from him. I knew without a doubt that he didn't give a shit about me, my well-being, or my fucking

birthday. He just didn't want to be divorced. He didn't want to have to try to live within his own paltry means. He'd rather live beyond my means and leave it up to me to scramble and pay the bills, and then belittle me when I couldn't. I could finally see the writing on the wall, and something deep inside me broke.

I kept my head down, using my hands to hide my tears. I barely touched my food. There was no way I was going to order a happy-ass margarita, so I drank water.

We left the restaurant in silence, stepped out into the rain and headed down the street toward Emmett's, a local bar where we were supposed to meet friends to watch a band. I was thankful for the rain because it masked my tears. But just past the restaurant, I had to duck into an alley because the sobs overcame me. There was nothing the rain could do to hide my heaving shoulders and scrunched-up face.

Marty followed me into the alley.

"I don't know why I'm crying so damn hard." I said between sobs. "I guess I'm—I'm just— All I can think about is love. I just love—*so much*! I love you, I love the kids, I worry that you might die when you're sleeping and you stop breathing for a bit—you've got to get that checked out because I think you have sleep apnea—but I'm so ridiculously unhappy in this marriage. You say you love me and I just don't believe it. I just don't feel it, no matter how much I love you. I just don't feel your love—"

"But I *do* love you, Carin. I tell you all the time!" Marty said, exasperated.

I cried even harder. I was exhausted with this conversation. We'd had it so many times over the last year and a half, but it never resolved anything. His words just didn't ring true.

He looked up and glanced around to see if anyone was near us. I knew he was embarrassed for having to be seen with me and my sappy

crying. He comically tried to pull me further into the alley, standing between me and the street so no one would see us.

I knew I wasn't making any sense. I said I loved him, that I worried about him dying, but that I didn't want to be married to him. I was never more certain that I needed to follow through with this divorce. I couldn't be married to this man any longer. I knew without a doubt that he didn't love me, yet love was all I'd ever asked for, all I've ever wanted, all I'd ever lived for. I could see it, I could feel it all around me—all those couples in the restaurant—but there was none for me.

"Let's just go to Emmett's," I said, with a hiccup and a deep sigh as I stepped around him to walk out of the alley.

I'd resigned myself to just getting the evening over with. Carol and her friend Michelle were expecting to see me there. I felt obligated to get there for them, and I hadn't yet worked out how I was going to get home because I didn't want to go home with Marty.

When we walked inside, I realized it was the first time I'd seen his friends since I'd asked for the divorce. They all stood up and gave me a hug. Everyone tried to be nice.

Marty's friend Jenny said to me, "Whatever you do, just don't hurt him. He doesn't deserve to be hurt."

Fuck! Like I'm not hurting enough! I coughed as my chest squeezed tight, and I fought with all my might not to start crying again. Her words tore at my heart as surely as if she'd had a knife. Hurting Marty was the last thing I wanted to do, but did she care that he was hurting *me*? No. I knew she didn't see that, and I knew there was no way I could convince her of that, so I said nothing.

Carol and Michelle showed up soon after with Carol's husband, Pat. They all gave me hugs and asked how it was going.

"This is horrible. It's complete bullshit. I don't even know what I'm doing here. I just want to go home," I said.

Pat immediately offered to take me home and I accepted.

"I can take you home. I promised I would," Marty said when I told him I was leaving.

"No, that's okay, you can stay here with your friends. I just want to go home." *There is no way in hell I want to ride home in the car with you.*

His niceness was sickening and I was starting to get angry.

The next morning, I woke up alone in the bed, Marty's side unruffled. I was relieved to see that he'd slept on the futon in his office, but I knew he wasn't done with whatever plan he'd initiated with our date.

After I'd gotten dressed, he came to the bedroom and said, "I want to talk some more about this."

I dreaded whatever it was he wanted to discuss, but I agreed to listen.

He sat down on his side of the bed. "I think you really need to reconsider this, Carin," he said. "I mean, why do you think you need to be divorced?" He spoke very calmly, with a practiced and calculated concern for me.

I saw right through his act. From the chair on the other side of the room, completely detached from the scene, I watched him speak as if I were witnessing a predator preparing to devour its prey. In my head, the whispering voice of an Englishman on a safari TV show narrated: *"See how the predator speaks slowly and articulates every syllable? The intention is to lull the victim into bewildered submission. You can see she doesn't want to be eaten, but does she want more not to offend, to please him by offering up her whole body, her whole life, for his satisfaction? Let's watch closely and see what she does. Will she fall prey to his skillful and diabolical plan? Will she be eaten? Or will she get away?"*

I knew the manipulative tactic he used had worked on me before. I couldn't blame him for trying since nearly every other time he'd talked to me like this it had worked. His soothing words had always crept in and created so much confusion in my head that I had no chance of not complying with whatever he wanted. But this time my head was clear, and my body was filled with an indomitable strength.

"I'm so unhappy," I said.

In the past I would try hard to give him facts and reasons for my unhappiness, and he would shoot all of them down with his twisted version of things. He would tell me I had a "real knack for fucking with reality," as he'd dismiss my feelings every single time I tried to express them. This always created a bigger mass of confusion in my head. This time, I didn't try to explain.

"But Carin, you've been unhappy your whole life, certainly during this whole marriage. It seems to me, you just can't be happy. Why would you want to break up this family for happiness you just can't have?"

I stared at the carpet for a long time. I heard the Englishman in my head whisper: *"This is it. You can see he's getting nervous. Her behavior has changed. I think she's going to get away."*

It made him uncomfortable that I didn't say anything or look at him, something that before would have made me self-conscious enough to make eye contact and talk. But not this time. This time I didn't care if he was upset.

I let the silence linger and savored my newfound conviction to resist answering him immediately.

When I was ready, I lowered my voice and mimicked his plodding, derogatory tone. "I deserve to be happy. I deserve to be loved, and I

believe I will have happiness, but not with you. I believe I will be loved, but not by you."

I stood up, drew my shoulders back, and paused to look out the window at the Clovis Woods across the street. I realized the conviction I had—that I would be loved—wasn't as strong as I wanted it to be, but I knew the truth that lived deep in the woods. I may have lost touch with it long, long ago, but my body remembered. Everything inside me knew that love waited for me. No matter how far I'd have to walk alone on the dark path, I would find it again, one way or another.

I looked up at Marty's frozen face, into his stone-cold eyes. I smiled, turned around, and walked out of the room—away from the loveless relationship I'd been clinging to since the day we met.

"My, my, my, would you look at that. She's getting away. Good for you, lass!"

Discussion Questions

- Has anyone ever tried to use your love against you?

- Has your intuition ever told you that someone is lying to you, even when that person is saying the words you want to hear? How did you react?

PART THREE

NO IDEA WHAT
LOVE IS

CHAPTER 13

Shell Shock

Only when you've truly had enough suffering in your life, are you able to say I don't need it anymore.
—Eckhart Tolle

Marty efficiently removed himself from the house and into an apartment by Labor Day. For that I was grateful. But he'd left a lot behind in Martyland. I knew it would be a giant pain in the ass to get him to clear all that out, but I was so happy to have him out that I didn't bring it up. I kept things business-like and amicable while keeping close tabs on what the kids were experiencing.

The following Monday night, just after school had started, Marty picked the kids up from the separate schools they attended—Roan in sixth grade at the junior high and Aidan a freshman at the high school. When they got home, Marty came with them into the kitchen where I was making dinner.

"Would you like to join us for tacos?" I asked. I didn't really want him to have dinner with us, but I was feeling guilty that he'd picked up the kids when I had gotten done with work early and could have gotten them myself.

"No thanks," he said, and then added, "I was thinking I'd like to have the kids stay over at my new place tonight."

The kids sat at the table as I served their tacos.

"That would be awesome, Dad!" Roan said, "I'm gonna go get my stuff!" She ran up the stairs to her room.

"But I thought we were going to stay there on Wednesday night," Aidan said.

"I know, buddy, but you can stay tonight, instead," Marty said.

We had agreed that he was only going take the kids two nights a week because I was "such a great mother" that they would be better off staying more days with me. I knew the "great mother" bit was bullshit— but I was so relieved I wouldn't be without my babies fifty percent of the time, that I didn't argue. We had agreed on Wednesday nights and one of the weekend nights, which needed to be flexible to accommodate his band schedule. Considering the time they spent sleeping, it was just a few hours two nights a week that I wouldn't have my kids home with me. It had turned out so much better than I'd thought it would be.

"But I'm not ready to stay there tonight," Aidan said, "I have school tomorrow."

"But you have school on Thursday, too. What difference does it make if you stay at my place tonight or Wednesday?" Marty asked, getting irritated.

Just then, Roan came down the stairs with her overnight bag thoroughly excited to stay at her dad's new apartment complex, which had a pool.

"Just come and stay tonight, Aidan," Marty begged. "It'll be easier if you do it this way."

"But I don't want to. I was just thinking it would be on Wednesday that we would stay there," Aidan said. "It just messes me up to change it now."

Marty sighed, rolled his eyes, and glared at Aidan—who wouldn't look at him.

"So you just don't want to be with me, then? That's just great, Aidan, thanks a lot."

I began to suspect that Marty had made plans for Wednesday that didn't involve having his kids, and Aidan was innocently messing that up.

I interjected, hoping to shield Aidan from any more of the toxic sarcasm. "That's okay, sweetie, I get it. You have your room just the way you like it, and to change up your system on a school night takes mental preparation. No big deal."

To Marty, I suggested, "Why not just take Roan tonight, and then both of them on Wednesday?" I thought I had given him a reasonable kid-centered solution he could work with.

"Then I have to stand here while they fucking eat tacos," Marty mumbled.

Aaaaaannnnnddddd there we have it. No way to stop it now. I knew the kids heard that. And my heart broke for them. I didn't even feel satisfied with the validation that divorcing this son-of-a-bitch was the right thing to do.

"We'll just stick with the plan to stay at Dad's on Wednesday, okay, guys?" I said matter-of-factly to the kids.

"Okay," they both said.

"Fine," Marty said with a big sigh. As he turned to make his exit he added, "I'll make it fun, guys, I promise."

Did he think he'd redeemed himself, or was he oblivious to what he'd just done to his son? Roan, seemingly unfazed by her father's shitty behavior, put her dishes in the sink and went outside to meet her friends across the street at the park.

"I'm really proud of you, Aidan," I said, not at all sure I was doing the right thing by calling out his dad's selfishness. "Your dad tried to manipulate you into doing what he wanted for his own reasons but you stood your ground. I understand perfectly why you didn't want to change the plans. It's not because you didn't want to stay with your dad, or that you don't like your dad. But that's how he tried to make you feel—like it was an insult to *him*—while not appreciating you or your reasons."

"Yeah, I just planned to be at Dad's on Wednesday. I wanna be in my own bed tonight," Aidan said.

I hugged him as I realized he was so much stronger than I was. I knew it boiled down to Marty not wanting to give up three nights of his week to his kids. He wanted to exchange this night for Wednesday, not add it. If he'd taken Roan for the night, that would have messed everything up.

I scoffed at my stupidity in thinking that getting Marty out of the house was going to make raising my kids easier. I kept telling myself to push through the divorce, but I'd just witnessed clear evidence that even so, I was never going to escape the plague of my husband's selfish ways as long as the kids were minors. The subtleties of his undermining made clear the intricate difficulty of co-parenting with someone bent on always thinking only of himself.

I saw that I'd grown complacent, dragging my feet on proceeding with the divorce because Marty was out of the house. It was going to take six months for the divorce to be final once I filed, so I needed to find an attorney and get the process started. Marty wanted the divorce to be as inexpensive as possible, so I Googled *mediated divorce* and found a list of attorneys who would represent both of us in the divorce. The mediation process was a much less costly way of ending a marriage,

and I wanted it over quickly and easily without fighting over anything. I was prepared to give Marty whatever he wanted so I could just move on with my life.

That Christmas Eve, Marty took the kids to their Grandma and Grandpa's house—Marty's mom and stepdad's—without me. This party was what we had done on Christmas Eve ever since Marty and I started dating in 1988. The festive mood, the cocktails, and the tons of food his mom always laid out was secondary to the mounds of gifts she would have wrapped for everyone—which easily occupied two-thirds of the space in the living room. Every year the room seemed even more full of presents than the last, and we'd all joke about how we didn't know how we were going to fit in the room with all the gifts. Once we had kids, the excitement for the party became, by far, the highlight of the year.

I'd worried for weeks about that night—what would be said about me, what my kids would hear, how awkward they would feel. But once the evening was upon me, I didn't feel as bad I as I'd thought I would about being left behind. I enjoyed my time by myself. I relaxed with a couple movies and glasses of wine while I ate appetizers I'd prepared for myself. When the kids came home they were happy, as any kid would be given the abundance of gifts they had received. That was the first big extended family "separation hurdle" for the kids, and I was pleased at how easily it went.

After the New Year, Marty's stepdad was diagnosed with liver cancer and quickly passed in late January. I'd really liked him, and I was truly sad that he was gone. The funeral was a genuine display of amicability from both my family and his, as we all wanted to keep the peace despite

the pending divorce. After the funeral, there was a traditional luncheon. Marty joined the kids and me at a table for four, displaying for all to see how well we could get along.

The next day Marty called me regarding some unrelated kid logistics while I sat in the car waiting for Roan's ice-skating lesson to be over. Our conversation was cordial and productive, when suddenly my skin started to crawl.

"It was really nice for the four of us to be together at the funeral," Marty said.

"Yes. . .it was." I responded cautiously.

His extra-sweet tone put me on high alert.

"Why don't we just forget this whole divorce thing and make it work—be a family again?"

Shit. I could feel my face get hot. I thought to myself, *Yes, I would love to be a family. I would love to not be getting divorced. But this man... I don't want this man. And I have already said as much—as nicely as I could many times—and now I'm having to say it again, in the face of pleasantries and niceties. And no clear fucking logic.* And I did it. Out loud I said, "I don't know how many more times I can say this, Marty. I'm not happy in this marriage. I can't be in this family with you. This isn't working no matter how badly I want it to. I've tried really, really hard, for a really, really long time. I'm done," I said.

"Wow," Marty said, "that was cold. You must think I'm some kind of monster to not want to keep this family together."

"I'm not trying to be rude, Marty, I'm trying to get my point across." He was making me feel like an asshole. The unexpected proposition conjured up a sharp, angry intensity within me. My heart had been steadily carrying me through this period of confused conviction, quietly

but firmly saying *Hold. . .hold. . .hold. You can't lose ground here. You've got to stay the course.* I reminded myself that Marty didn't want me, or the family—he just wanted the life he had because of us. I wasn't going let him manipulate me into stopping the divorce this time. "I do not want to discuss this again, and I've got go. Roan's class is done, Goodbye."

After I hung up the phone, I sat in the car a minute longer reflecting on how difficult all this was. I was proud of myself for not letting him get his claws into me. I didn't think he was a monster, but it was a monstrous job to prevent him from stopping me from going through with the divorce, as he'd done before.

I was surprised at what little trouble Marty gave me over the legal divorce process, which was probably because I just let him have whatever he wanted from the house. I knew I'd paid for most of it—and most people told me I was a fool to let him take it—that I should get it all appraised and sell it myself—but I didn't want the hassle, and I didn't want to deal with Marty any more than I had to.

My first indication that it was a sizable amount of money Marty would get for selling everything of value—aside from the furniture the kids and I were using—was that he turned down spousal support when our attorney informed him that it was an option for him. I fully expected to have to pay him support, which would have torn at me. After decades of giving him everything I could, it would have been pure torture to be legally beholden to keep giving, but in the same spirit of letting him have all the valuable items he wanted from the house, I was going to agree to whatever would help us be divorced more quickly.

I knew I wanted to leave Wisconsin, too. Marty and I had even discussed moving to California before I'd asked for the divorce. I had no

idea when I was going to be able to make that happen, but I made sure to put it in the divorce agreement in case I was able to pull it together before the kids were adults.

Marty was also informed that, given his decision to take the kids only two nights a week, he would be expected to pay twenty-five percent of his gross income in child support, to which he also agreed. At that point I began to suspect that he was as anxious as I was to end the marriage. I'd made it clear I wasn't going to budge on my decision. He seemed to have an ulterior motive to cooperate.

The shock of becoming divorced turned into anticipation for a life without Marty. I began to relax. I would be able to live where I wanted, decorate how I wanted, and see who I wanted. I believed my coaching business could finally take off without the constant distractions imposed by living with a man who was impossible to please and sketchy in his support of any efforts I pursued to fulfill my own purpose.

In the midst of the limbo between my first attempt to divorce him and the success the Ambien allowed, I'd gotten certified with the Institute for Professional Excellence in Coaching. I had visions of helping others facilitate real change in their lives, just as I was in the midst of doing for my own life. If it weren't for the world of coaching, which I'd stumbled onto in 2012, I don't think I ever would have found the strength to leave Marty. I was committed to helping others find their way, too.

I had another psychic reading with Vickie, who advised me to start dating. It was March, and the divorce hearing was set for late April. The thought of dating hadn't even crossed my mind until she said it. I wasn't sure I was ready, but Vickie's advice was usually excellent. She

said many times how my "kundalini energy" needed to be let loose. I knew she was talking about my sexual energy. I knew I'd bottled it up pretty tight. She assured me that I deserved to have good sex, and that with a little work I could have it and not feel the least bit guilty for it. I decided to allow for the possibility.

On an extended lunch break from work, I decided to take my laptop, go to Chicago Uno near my office, and create a profile on *okCupid* while sitting in a booth eating a salad.

Within ten minutes of completing my profile, I had seven emails in my in-box. Nothing vulgar or offensive. But as I scrolled through the messages, my heart pounded as I felt an unreasonable sense of exposure. I pushed my half-empty salad plate away to the edge of the table, pulled my laptop close, dropped my head, and turned toward the wall, trying not to lose it. My hands shook as I wiped my eyes and nose with my dinner napkin. I couldn't recall ever having been so immediately triggered before—or so clueless that I could even *be* triggered.

I had been excited about the prospect of dating, yet I was horrified at how stupidly I'd exposed myself. Why the hell did I use my first name? It had a unique spelling, so even though I didn't use my last name, I realized I would be pretty easy to find on Facebook. And then it would only take a nanosecond to discover where I worked and to schedule an eye exam. *Fuck! What did I do?*

Years ago, Ginny had made it clear I was a whore simply for being a woman—a woman who might actually desire the attention of a man. Then I married Marty. My devotion to him should have squashed any insecurities about being a whore, but it didn't. And Marty knew it. It was one of several emotional sores from my childhood that could never fully heal because Marty would pick at the scabs. He would shame me for

showing even a hint of cleavage, or talking to men who were obviously attracted to me—attraction I wouldn't even allow myself to see for fear of having instigated it. Or he would bitch and pout because some guy made a flattering or suggestive comment to me or about me. So many nights out with Marty had been ruined simply because I looked good. Getting attention from men had come to mean drama and trouble.

I told myself I was ridiculous for being triggered by the attention the men on the dating app were giving me, but I couldn't deny the fear. It was real, and I couldn't shake the feeling ingrained in my psyche that I was a slut for any attention I got.

I shut down the whole profile immediately, left money for my bill, and scurried from the restaurant. Once I got into the pseudo-safety of my car, I called a friend in the coaching world, Jodi, who was divorced and on the dating scene. She quickly agreed that I'd been triggered. She reassured me that my reaction was not unfounded, and she nudged me to try again with a different website on which she'd had good luck: Tinder.

Before long I was having conversations over the Tinder app with a couple of men. After a few weeks of conversations with a guy named Tom, we set up a date for dinner. I got a crash course in sexting from a friend's daughter, which enhanced my text conversations with Tom to a deliciously flirty level. He was easy to talk to and respectful with just the right hint of naughtiness to arouse that kundalini energy in me.

I was amazed at how comfortable and confident I felt in going on my first date just one week before my divorce was to be finalized.

Tom was a business consultant, nine years younger than I, good-looking and very fit. We met for dinner, had a great conversation and connected on a lot of levels. I was intimidated by his devotion to

Catholicism, and I fought to resist feeling scandalous when I ordered a Manhattan straight up while he ordered seltzer water. We slid right into our same easy, slightly indecent conversations we'd been having by text for the last two weeks.

When we finished dinner, he explained that his embrace of the Catholic religion did not include its take on sex and abstinence. He invited me to ride in his car to a bar for a nightcap. I laughed when he added, "That's code for 'I want to get you all to myself,'" as he stroked my knee.

I'd just met the guy, we weren't in love, but the sexual energy was delicious. I could definitely take more of this.

Once we got in his black Ford Explorer he immediately leaned across the gear shift for a kiss that I couldn't wait to reciprocate. I didn't know if I would be a good kisser, but then I kissed like his mouth held the magic elixir I was starved for.

"Oh my God, you are so hot!" Tom said with a flourish. "Your kisses are amazing! I've got to move us to a more private spot."

I giggled like a teenager. "That's an excellent idea!"

I thought about how kissing him made me want to rip all my clothes off—so it would be best to be secluded. I couldn't believe how ready I was for this. There was no Ginny in my head calling me a whore, and I had not one concern about Marty. I simply basked in Tom's attention. He drove around for about five minutes until he found a dark residential street, heavily lined with big trees. He parked and immediately leaned over to me again. I could feel a rush in my groin that transferred instantly to my lips like an electric pulse.

"You're even more stunning than your profile photos!" he said, breathlessly.

I inhaled his compliments as if they were as essential to life as oxygen. I felt the electricity coursing up from my clitoris to my breasts as I unbuttoned my blouse with Tom's help. His hand slid over the top of my unpadded bra, completely arresting my breath. Then he skillfully undid my bra's front closure, gloriously exposing my bare breasts to his soft hands. The instant his fingers touched my nipple I arched my back to give him more, feeling as if the portal to my sexual essence had finally been blown wide open.

"Mmmmmm, these nipples are so perfect. Oh my God!" Tom said as he took one in his mouth—and I nearly exploded. "We gotta get in the back seat," he said.

I didn't even bother to answer him. I kissed him deeply and then climbed into the back, gently pushing his notebooks and papers to the floor.

"Don't even worry about those, just throw them on the floor."

I took my shoes off as he maneuvered himself into the seat next to me. He went immediately for the button on my jeans. I was amazed at the response of my body. His compliments kept coming and I wasn't even tempted to not believe them. I felt sexier than I ever had in my entire life—more for the certainty that I *deserved* this pleasure than the pleasure itself. I helped him pull down my pants, purposely leaving my panties for more ecstasy as his fingers explored through the satin fabric and caressed my labia with excruciating dexterity. He knew right where my clitoris was and exactly what to do with it while I moaned with abandon.

I had no intention of letting things go this far, I thought as I reached for his belt buckle as if I were literally starving. "Do you have a condom?" I breathed.

"Not with me, but I do at home."

I marveled at how quickly I'd gotten his erection in my hand. He lived thirty minutes north and I lived forty minutes south of where we were, and despite how far I'd let things go, I suddenly felt stubborn about not spending the night with him on our first date. The kids were both at sleepovers at friend's houses, but still, I wasn't even officially divorced yet.

We let the logistics of what was next slide while I stroked him. I'd never actually watched a man ejaculate straight into the air, something I'd thought I would have found repulsive given my neat-freak sensibilities, but my whole body reacted as if I were having my own climax.

"Oh my God!" I exclaimed as I looked on like a child watching fireworks. "That was so hot, Tom! Oh my God, I'm trembling." I held my hand out, palm down, for him to witness the immense energy of what I'd just experienced course through my body.

He laughed as he grabbed a towel from the floor to wipe up his mess. "You've got to come to my house! I want to spread you out on my bed and just look at you with all the lights on lying naked on my sheets and I wanna run my hands over every damn bit of this gorgeous body." As my legs were splayed over his thighs, he rubbed his hand on my belly—something I'd always felt self-conscious about, but not this time. I lay there naked except for my black satin panties and let myself believe everything he said. I never imagined sex with the lights on or being with a man who was as into looking at and touching my naked body as he was. It sounded amazing and not the least bit intimidating.

"I would love that, but I just can't. I'm not prepared for that. You know this is my first date in twenty-seven years. And my divorce won't even be final until Tuesday. I don't know why, but it just feels wrong to stay with you tonight." I couldn't believe my conviction after I'd

completely abandoned all of my sexual hang-ups to be with him in the backseat. "But I would love a second date. I would even love to plan a sleepover for that date. I don't know what's holding me back tonight but I just can't."

"I understand. I get it, that's okay, Carin," he said, kissing me.

I realized in that moment how I had fully expected him to push me to get what he wanted. My heart swelled with joy that he didn't. I straddled him and kissed him back as if to suck all the air from his lungs. When I stopped to take a breath he came right back at me for more, laying me back on the leather seat, pulling my underwear down just enough to deeply insert his fingers. I groaned loudly. My orgasm came faster than I ever remembered, making my whole body convulse while he held me and softly said, "Yes, yes, yes. . .so beautiful, Carin."

After we got our clothes back on, giggling at the vigor that had overtaken both of us, he drove me to a quiet bar nearby. I ordered a Blue Moon and he ordered a non-alcoholic beer while we got to know each other better between tender kisses and caresses. I wouldn't allow myself to think about anything else—not if he was the one; not how much of a better lover he was than Marty; not how long this was going to last; nor how it was going to end. I just settled into the beauty of a great conversation with a handsome, respectful guy who thought I was gorgeous and worth the respect he was giving me.

I cautioned myself not to get attached. This was just the beginning of my dating experience. To glom on to the first guy was ridiculous, but I really wanted more of what Tom was offering. I knew the experience I had must have tapped into that kundalini energy that Vickie was so adamant about my letting loose. I was grateful she had set me free to do it.

My date took place on the same night that Marty was accepting an award at the annual WAMI (Wisconsin Area Music Industry) awards ceremony. The next day he sent me a video of him telling the packed auditorium about our pending divorce, and he dedicated his award to me, "the woman who for over twenty years has been my rock."

Watching that video felt distinctly icky. I was certain he intended to drum up guilt in my heart. But I did not feel guilty in the least. What I felt was more like foreboding, like I'd just glimpsed something horribly wrong, despite how seemingly innocuous it appeared. That video depicted the man I'd devoted myself to for over half my life, behaving exactly how he always behaved, but this time I saw someone different, someone truly disturbed.

Two days later, on April 25, 2016, Marty and I met in court to finalize the divorce. I showed up five minutes late, which Marty took as a personal affront—never mind that the judge wasn't even ready for us. Despite the circumstances, it was comical to me how he behaved like a martyr who was wronged by his wife and how he wanted everyone in the courtroom to see it.

The judge reiterated the divorce terms: "You agree that you have chosen not to receive spousal support; that you have chosen to have your children with you just two nights a week; that you agree to pay twenty-five percent of your entire gross income in child support; and that you also agree to Carin moving the kids out of state if she so desires?"

"No," Marty said. My jaw dropped as I watched the judge lower his head to look over his reading glasses at this man-who-can't-be-my-ex-husband-soon-enough on the other side of the room.

"You understand, sir, that until you agree to these terms—terms that have already been laid out to you and that you already agreed to—we cannot proceed here today?" the judge asked.

I was fascinated as I watched this judge, who did not attempt to hide how ridiculous he saw Marty's behavior to be. It was as if he knew exactly what he was dealing with. That was a comfort to me. The judge didn't show any allegiance toward me—he was just doing his job. And he clearly saw that this guy in his courtroom was being a turd.

"I understand," Marty said. "I agree. I just was thrown off by your saying that about them moving." It still didn't make any sense that he was behaving this way. Perhaps he wanted to show the court that he cared more for his kids than a father who requested to see them only two nights a week would indicate. And maybe he did, but I doubted it. If he did, he would have requested equal placement. But he'd never been more than twenty-five percent involved in the kids' lives before, anyway. He was always too busy with his bands and social life, counting on me to take care of the kids. Actually, since we'd separated, the kids had seen more of him than ever before.

The judge's I-smell-bullshit attitude validated me. I didn't think the judge had any concern for me, but I still felt deeply comforted while my soon-to-be-ex tried one last manipulative trick to tear down my resolve, and it didn't work.

"Then, if you are in agreement with the terms," the judge declared, "the court awards you shared custody of your two children, with placement of them with you two nights a week. You will not receive spousal support, and you will pay twenty-five percent of your gross income in child support."

It still wasn't clear to me why Marty had not requested spousal support. I made almost three times as much as he did, and I was pretty sure I would

have just paid whatever he wanted to be rid of him. I'm really not sure I would have fought it, despite the fact that paying him any damn bit of money would have been ridiculously unfair. I've always felt guilty about making more, but given my follow-through on this divorce, perhaps he expected I would fight him on support, and then it would have cost him more than he was getting in all the items I'd paid for that he'd taken from the house.

Who cares now? I am done with it! I got through it. I divorced him.

I knew it wasn't entirely over. But I believed the thorn had been pulled from my side and now all there was to do was heal.

When I got home from work that evening, Roan wouldn't speak to me. She was lying on the couch in the living room with her back turned toward me. She tugged her shoulders away from my touch. Roan was in a familiar state of pre-teen angst, which I knew better than to argue with, so I let her be, and went to talk with her brother.

Aidan was in the garage getting ready to ride his bike. I asked him if he knew why his sister was so upset.

"I don't know why he had to say anything!" Aidan explained, clearly angry. "I figured you guys were divorced when he told us you were getting divorced! But, nooooo! He had to go and bring it all up today and tell us 'it's official'!" He mocked his dad's words, ridiculously contorting his face—presumably to poke fun, but it didn't make either of us laugh.

I sighed. "I'm so sorry, sweetie." I gave him a hug.

Damn it, I was afraid of that! That frickin' whiny-ass piece of shit had to tell the kids of our final court proceedings when he picked them up from school. Never mind that it would hurt them to have to go through the process again—for absolutely no reason. He just needed to show off his pain and take another opportunity to make me out to be the bad guy who had done this horrible thing to the family.

I went back to the living room and sat on the couch next to Roan, who still wouldn't look at me. "I understand that your dad told you guys that the divorce was finalized today. I'm sorry that he did that," I said. "It wasn't necessary to put you through that, honey. But Roan, if you think about it, haven't you spent more time with Daddy in the last eight months than you ever had before?"

"Yeah," she said quietly.

"And, haven't you had more fun with Daddy than you ever had?"

"Yeah," she agreed.

"Then it's just a *word*, right?"

To this she sat up, gave me a strong hug, and said, "Yeah, I guess so."

We sat there holding each other for a few moments as her mood made a complete 180-degree swing.

She then jumped up and announced, "I love you, Mom, and I'm going to make you some cookies!"

She gave me one more quick hug before she spun around and headed for the kitchen.

This isn't going to be easy. But my kids are amazing. We're going to get through this together.

Discussion Questions

- What will it take for you to stay the course? What will you use as motivation to never go back to an unhealthy situation?

- Can you allow your heart to have enough compassion for yourself to no longer tolerate abuse and manipulation from anyone?

CHAPTER 14

Liberation

Life gives you lots of chances to screw up, which means you have just as many chances to get it right.
—Candace Bushnell, *Sex and the City*

My date with Tom, followed so closely by the divorce proceeding, gave me reason to believe I'd become a whole new me—with all my kundalini energy fully unleashed. No more second-guessing, no more fear of the unknown, no more chances that Marty would try to talk me out of it. Because *it* was done.

I didn't fully understand how I'd gotten into that marriage and why I allowed Marty to take such advantage of me, but I did know I wasn't going to let anyone do that to me ever again. Any relationships I'd have going forward would be on *my* terms—with someone who worshipped the ground I walked on. I would make sure it was someone *I* wanted and not just settle for a man who wanted me. I felt stronger and more confident than I ever imagined I could be. And I was determined to have more fun with dating.

I was right to warn myself about getting too attached to Tom. We had a great week of sexting and planning for our next date where he'd invited me to have dinner at his place and to spend the night, but then four hours before the Saturday night date, he called to tell me about his Friday night.

"You remember that I mentioned I was going out with my buddies from the spiritual retreat I went on a few weeks ago, right?"

"Yeah, I remember," I said.

"Well, I was talking with my friend Keith about you. He's married, a little older than me, and he's kind of my idol. He and his wife are Catholic and they have five awesome kids. Anyway, I told him how much fun you and I were having and our amazing sexual energy. I also told him that you'd just gotten out of a pretty oppressive marriage and were not in a place to settle down."

"Yeah," I said, feeling apprehensive.

"He said you sounded great, but then he asked me why I would spend my time with you when—as I told you—I really want a family."

Tom had never been married, and the weekend before, at the bar we went to after our fling in his SUV, he told me that at thirty-nine, he felt the clock ticking because he really wanted kids—at least five—and to do that he needed to find a younger Catholic wife.

I had teased him and said, "Okay, I'm forty-eight, and I already rescued myself from my Catholic upbringing years ago, *and* I'm not about to have five more kids!" Given the carefree mood I was in at the time, and the amazing sexual energy that was still radiating between us, I hadn't given what he was saying much thought; but now as we talked on the phone, I sensed it really was important to him.

"Go on," I said.

"I could have fun—lots of fun—with you for months, but then how do I find this woman to make a family with if I'm spending all my time with you?"

"Okay, I get that. But she's not sitting there next to you now, is she?"

"No," he laughed.

"Well, it sounds like you feel like you need to cancel tonight. Am I reading that right?"

"Yeah, I was really looking forward to tonight, but Keith got me thinking. I hate to do this to you, but I need to end this right now and focus on what I want."

I sighed deeply. "I appreciate what you're saying, Tom, I really do. But I want to try to talk you out of this, at least for tonight. I was so looking forward to this—"

"Me, too, Carin, seriously. But I just know if we get together tonight, then we'll want to do another night, and another, and pretty soon it's six months I will have lost from finding the life I really want."

"I understand," I said, "It's really disappointing. But I get it. I'm on a whole different path." We talked for over an hour, which helped ease the disappointment I felt for being dumped after one date by a really great guy who may or may not have been chasing a pipe dream. I was going to have to be strong and accept that this was going to happen, as long as I was honest with my dates about my intentions. I was not going to play games and pretend I was looking for anything more than fun. So, that meant that some great guys—who were great by virtue of their not wanting to just fool around—would pass on me. I told myself decisively: *That doesn't mean I'm not lovable or not worthy of them—just not in the right place. And there is nothing wrong with that.*

I was impressed with how my disappointment in the cancelled date didn't invite any admonitions in my head about my longing to have sex with Tom. I believed I had finally dispelled all my hang-ups around my sexuality, all the guilt from Marty, and all the shame I'd been burdened with from Ginny for my sexual desires. I credited Tom with opening up my sexual vault. I was ready to shed the ethos of my beliefs about my sexuality. I grabbed on to the passion I'd been hungry for my entire marriage and slammed the door on that part of me that claimed I was an undesirable slut. *Moving on.*

I called my sister Carol and told her that my highly anticipated sexy evening had just been cancelled. "I understand why he ended it," I said, "but I'm really, really bummed! I *so* wanted that hot night, which he'd been describing to me by text all week long! I'm kicking myself for having turned down his offer to spend the night with him last week."

"It sounds like I need to take you out so you can get right back up on that horse!" Carol said.

I laughed and said, "Absolutely!" The kids were with their dad, so I was free to do what I wanted.

We went out to a bar to see a cover band whose front man was an acquaintance of Marty's. I always liked him, so between sets I went up to him at the bar where he'd just ordered a drink.

"Hey! You guys sound awesome! I'm having a blast on the dance floor!"

He sat looking intently at his beer. I knew he heard me, but his energy was odd and he wasn't acknowledging me so I started to turn and walk away.

"I was at the WAMIs," he finally said. "I heard Marty's speech. Maybe you don't know it, but you fucking broke that man's heart."

I could feel my face flush as I turned back and looked him square in the face, trying to decide how to respond.

"Did you ever consider maybe he broke *my* heart?" I declared.

I knew it was useless to plead my case, so I just walked away. I went around to the bar on the other side of the room to get another rum-and-coke while I fought to keep my mind from thinking about the auditorium full of people attending the WAMI Awards and what they all thought of me. *I am not letting him ruin my night! I am not letting Marty ruin my night.* I went back to the table where Carol was laughing with some guys she knew who were clearly flirting with her.

The band started up again with one of our favorite Prince songs, *Raspberry Beret*, so we finished our rum-and-cokes, waved to the guys, and went out to dance. I danced like I always did, with full abandon. I was in my own little world, and thoroughly enjoyed the ride my hips afforded me. The alcohol pushed aside all my cares about Marty or his friends—or who was or wasn't watching me. When the song ended, I looked up and saw a handsome, bald man with a goatee and the physique of a body builder smiling at me from a nearby table.

"Wow! You are something!" he said. "Where did you learn to move like that?"

I laughed. "Buy me a drink and I'll tell ya!"

I let Pete take me home that night after Carol grilled him for a good ten minutes to make sure he wasn't a psycho. He was very sweet, and rather simple-minded, but he was easy-going and totally on board with my "dabbling" with him, as I called it. I made damn sure he didn't have any expectations about me, which I reiterated every time I saw him—for the next six weeks.

I was on two dating sites: Match and Tinder. Tom explained to me that Tinder, the site I'd met him on, was considered a hook-up site. As he described it, "It's pretty much just, 'you're hot, I'm hot, let's fuck.'" And he was right. I found this to be hilariously true with some guys.

Not every man I met on Tinder was that direct. But there was one guy I swiped right on whose intentions I found were exactly as Tom described. The minute I gave him my cell number and we left the safety of the Tinder app, I was awarded my first dick pic. It had occurred to me when I started dating that I could be sent such a photo—I even told a few guys, "Please don't *ever*"—and then this guy did just that before I could even think to ask him not to. I was horrified for a second and then I couldn't stop laughing. I doubt that was the response he expected, so I just texted back, *Wow!*

We corresponded—well, mostly he kept telling me, *cum get my cock!* or some variation of that—for a few weeks. But he lived ninety minutes away from me in Milwaukee, so I couldn't decide what to do with him. I talked to him on the phone one evening. My instincts told me he wasn't a bad guy, just devoted to sex and finding hook-ups with, in particular, older women (he was ten years younger) with absolutely no attachments. He didn't want to know anything about me. He just wanted me to spontaneously come to his house—or he would come to mine—with a two-hour notice. This was not practical since I had the kids most of the time. Actually, *planning* an encounter didn't fit in with his fantasy. I wasn't sure if I ever wanted to see him, so I stalled. I laughed with my friends at the blatant profanity he'd text while I was out on dates with other guys.

I loved the confidence I had and the attention I got from men without feeling like I was doing something wrong to attract their lust.

My boundaries were clear and my instincts were good. I didn't waste my time on men I sensed were not right for me. This meant that if I did agree to a date, we'd have fun, maybe have sex; and then if I were certain there was no real connection, I'd call it, with a gentle spirit and a strong logic that wouldn't hurt anyone.

I was feeling sexually liberated after years of passionless sex and shame regarding my attractiveness to men. I fully embraced my sexual goddessness and didn't give a damn about anyone judging me.

I achieved more personal growth with every date. My friends enjoyed living vicariously through my exploits. I was entertained and entertaining with my dating stories. I would tell my friends of my adventures using nicknames for them like "Catholic Boy," "Mr. Dick," "Sweet Pete," and "Biker Bill," to name a few. I was having a blast. I called it "my inner slut," and I loved who I was!

Vickie had taught me that I needed to learn to love myself—and I figured I was doing just that. I felt a strong sense of who and what was good for me, and I went all out for it.

On Wednesday, July 13, 2016, I received a text that changed everything. I had no idea how precarious the new me actually was. I had no idea how much pain I had yet to suffer. I had no idea how little I loved myself and how much of a liar I was.

Discussion Questions

- What judgements from others are you afraid of? List them.

- Can you see that these judgements come from you first?
 Do you see that if you can let go of your judgements of
 yourself, then others' judgements will have no power
 over you?

CHAPTER 15

The Ordeal

I have to confess that I had gambled on my soul and lost it with heroic
insouciance and lightness of touch.
—Charles Baudelaire

I was between patients when I saw a text pop up on my phone. It was
from an unknown sender: *Hi, Carin. You should be thankful that you*
got rid of the asshole.

I knew immediately the message was regarding my ex-husband,
but that's all I knew. I almost didn't respond. I was not in the mood to
rehash what a prick my ex was. But my curiosity got the better of me.

Okay, but, I don't know who you are. I texted back with no clue of
who could be texting me, or why.

He's so unbelievably selfish, was the next cryptic text I got.

I replied: *If you're not going to tell me who you are, then please lose*
my number. I was feeling a little creeped out, not wanting to get caught
up in someone else's bullshit.

Sorry. This is Diana, came the response.

The only Diana I knew was a beautiful, brunette—one of the nice groupies of Marty's band. Not the obnoxious one with the tattoo who once had the audacity to send my husband pictures of her wet, white-T-shirted tits. I knew this because I'd glimpsed them one day when Marty's Apple account was accidentally merged with mine. Instead it was her friend, whom I'd always thought was sweet.

Interior decorator Diana? I asked, just to be sure.

Yes, she texted.

Marty and I knew her years ago when she worked as an interior designer for the flooring company we hired when we remodeled the house. But I still didn't understand why she was texting me in the middle of my work day.

I responded *Hello :)* to offset my rude remark to lose my number. *I'm sorry for whatever trouble he's caused you.* I sensed there had to be something going on.

How are you? :) she answered.

I'm great! Been making up for lost time, LOL!

That is awesome to hear! Please don't tell him that we are texting.

Absolutely not!

I'd always seen her, and her friends, as prone to gossip; so as I finished up with another patient, I started to think about how to end the exchange. I didn't see the point of it. I didn't want to get caught up in whatever drama she was looking to initiate, especially since it didn't seem to involve me directly.

I have tried to help him through things as much as I could, until now when I got the bomb dropped. She was still being vague, but it was clear to me she was getting close to the point.

Can I ask?

Did you hear about his new love?

I began to understand. She had been dating Marty since the divorce, and then he dumped her for someone else, and she was hurt. Who better to reach out to when a guy hurts you, than the other women he's hurt? I knew Marty was dating because Carol had told me she'd seen him out with a woman who was quick to divulge the "size of his junk."

However, that wasn't who Diana was talking about. That woman's name was Susie and she was younger than Marty. The woman Diana was talking about—whom he'd dumped her for—was Kim, who was a year older than Marty. Diana sent me a picture of Kim. She was a beautiful brunette who, according to Diana, was financially loaded. Marty told her he'd only been seeing Kim for ten days, but he was convinced she was "the one."

Diana thought it was important that I know this, because Marty told her he was going to introduce Kim to my kids.

Of course, I thought. *He is going to move fast if she is attractive and has money. Certainly he'll pay no goddamn mind to how it might affect his kids.*

I wondered if Diana's motivation was to tell me about his plans to introduce this new woman into my kids' lives—so that I'd give him shit about it as a way of revenge—or if there were something else she wasn't telling me. It just didn't seem like that was all of it. I sensed that there was more. After we talked about the kids a bit—how strong they were—as well as a mention of my upcoming date with a hot corrections officer, I decided she was beating around the bush. It was time for her to divulge what she was really after.

Hey Diana, I have a question. And I'm just curious. I am very devoted to non-judgement, so you can trust me when I say it really has no emotional impact for me, because the divorce is over, happily. But I'm wondering if you and Marty were involved while he and I were still together.

We were very close, she responded. *We texted and talked daily. That is how I know so much. And I am extremely hurt right now. I am still married, but not very happily. Hope that makes sense. I was wondering if that thought had ever crossed your mind. Please don't be hurt. I just want to be honest with you. I honestly don't know how he would have gotten through the divorce without my support. I was there for him every step of the way.*

Okay, I texted back. *I'm going to ask this question point blank, and please know it is seriously just out of curiosity. . .but. . .did you ever have sex with him?*

Yes I did. And we've been close for about six years. He was into me until he found Kim.

I felt way more sorry for her than I did for myself. I purposely refrained from pointing out to her that clearly, he was screwing around with others—at least others who had no shame in telling the world about his manly merits.

She went on to tell me how selfish he was; how ridiculous she thought it was that he would take his kids only two nights a week; how he shamed her about other men giving her attention; how prolific his Facebook page was; how he placed so much importance on his image; and his constant bitching about having only ten dollars in his checking account.

I found it all hilarious and validating.

But I didn't really want to deal with this. I had to set the phone down to do an eye exam. As I peered at the retina of a completely oblivious patient, I immersed myself in my duties and disengaged from the uninvited revenge drama coming at me through my phone.

Once I finished with my patient, I couldn't stop thinking about this new information. I knew Marty was an asshole, so what more was there? *I'm done with him,* I thought. *I divorced him. I'm not going to let this throw me. I'm strong and smart. I'm beyond Marty and his stupid life.*

But as Diana texted on, and told me she couldn't believe how Marty had left me to go on tour with The Diva in September of 2013 when I was so sick, it hit me how courageous she was for coming to me. She felt bad not only because she'd been dumped by Marty, but because she was a party to hurting someone she suspected didn't deserve to be hurt. Despite Marty presenting me to her as a cold-hearted bitch who didn't understand or give a damn about him, she had compassion for me. I didn't blame her for the affair. I suppose most women in my position would; but I understood how Marty operated.

I had a date that night with Justin, a corrections officer. I didn't want to think about how my husband had been sleeping with another woman—all the while pressuring me to stay married, guilting me about breaking up our family. I just wanted my date to worship me. And he did, all night and the following morning. I believed his attention was all I needed to ignore the fact that my husband had been having an affair *for the last five years of our marriage*, which I'd fought so hard to save.

But then Justin ghosted me, leaving me to think of nothing but my ex-husband's infidelity.

The next three days I had to work, but my schedule was light. I had time for more texting with Diana. She had more to unload about how Marty was treating her in their break-up, and I actually found myself coaching her on how to deal with my ex-husband. It was surreal. But it kept me from absorbing the reality of his cheating. I told myself I'd been increasingly more miserable in the marriage for the last several years, so it didn't matter that he cheated. Diana's confession simply gave me more validation that divorcing the heartless bastard was the right thing to do. *I am done with him. Why should I care what he was up to for the last five years of our marriage?*

Then I realized the timing of the affair. It would have started in 2010 after he'd begun to play bass in that local cover band, when he was immersed in boob-flashing groupies every weekend. It was right in line with the incident of Marty's pushing so absurdly hard to get that mobile home in Shawano. Did he want to use it as a secret liaison destination? Maybe my not letting him get it pissed him off enough to justify cheating. Or maybe he was already cheating. Maybe he'd always been cheating.

Diana said he'd told her that I "just wouldn't ever listen," which was laughable. The real trouble Marty had wasn't that I wouldn't listen to him; it was that I began to listen to him more closely.

I felt a burgeoning sense of panic as my imagination kicked in. I was grateful we were only texting because I got chilled thinking about actually staring into Diana's face—knowing it was the face my ex-husband had been looking at, being intimate with, whispering *I love you* to. Did he kiss her during sex? Did he "make love" to her and then come home to me—where he slept on the couch for lame reasons, merely shrugging when I blamed myself for our sexual issues?

I didn't need to think about all this, so I initiated a mantra in my head: *Who cares? I divorced the fucker!* I said it over and over again to myself. I wasn't going to address this. I wasn't even going to tell Marty I knew. I was going to play it cool like I just didn't give a good goddamn about his stupid games.

But the more I ruminated on what had happened—how even as we were going to counseling and he said he was committed to saving our marriage, he was sleeping with Diana—the more pissed off I got. I really didn't want to give this son-of-a-bitch my energy. I didn't want him to know I cared enough to say anything. But I did.

I realized that the thorn I thought I'd pulled out when I left the court room was still there, lodged in deep and festering. I was hurt and I didn't want to acknowledge it. But my mind simply could not fully suppress it any longer.

Two days after Diana bravely told all, I sent Marty a text: *You know, Marty, you're not a monster. A monster has strength. A monster has conviction, and has even earned respect. You are worse. You are a liar. A liar who lies solely to serve himself and no other. You are a coward. A coward of the worst sort who does cowardly things only to preserve a completely false god: yourself. And you are weak. A weakling who can only derive strength from sucking it out of fools believing you are worth giving their power to.*

As I wrote this text, I was feeling superior to him more than hurt. After months of allowing him to make me feel guilty—either directly with his whining appeals and pathetic displays of martyrdom; or indirectly through the kids, by reminding them who had wanted the divorce that had upset their lives—I felt deeply righteous. I just wanted to bask in being right for awhile.

It took him several hours to respond. I knew he was texting Diana because she was copying and pasting his texts to her and sending them to me, such as: *I just got a long scathing text. I'm guessing someone said something. My life is fucked forever.*

Eventually, Marty responded to me: *I received your texts and I would like to take the time to sit down and talk with you about it. Please let me know when you would like to do that.*

There was no way I was going to meet with him. I knew I wouldn't get an actual apology. He'd zero in on my insecurities and drop suggestions and phrases that he'd expect would make me think that maybe I deserved to be cheated on. He'd think he could win me over with justifications

for why he was the epitome of a shitty husband. If I allowed him to speak to me in person, and listened to his twisted apology, I couldn't be sure I wouldn't get sucked into believing I was a mean and heartless person—that I was so terrible he couldn't do anything but cheat to save himself. I'd done this with every other problem we'd had—assumed responsibility, believing it was all me. It would be sheer stupidity to allow myself to get sucked in this time.

No thank you, was my thought. So absolutely no response was what he got.

After a few days of texts regarding only logistics with the kids, Marty sent: *I am so sorry for hurting you. There's no apology I can ever give you to undo that. All I can do is sincerely apologize to you and be a better, honest, and faithful person going forward. And I will. I'm sorry I was a bad husband in your eyes. Thank you for being good to me, being a great mother, and trying to stick it out longer than you desired.*

Wow. I'd just pulled into the driveway coming home from work and I was sitting in my car when his text arrived. He was a bad husband in *my* eyes? What the fuck kind of apology was that? The kind I could expect from Mr. Fake News—one spun on a truly professional level to fit his agenda. He wouldn't have said anything about being a "better, honest, and faithful person" if Diana hadn't come to me. He desperately wanted me to see him as a good person who made mistakes—to see him like any other human—as I did throughout our entire marriage when I was in the dark about his covert activities.

I refused to be the spineless chump he married, the woman who looked the other way or told herself, *It's not that bad.* Those words—*in your eyes*—were especially nauseating but representative of his skill: using

three little words to undermine the responsibility he'd just claimed to have taken. This was his gift. This was how he subtly, and effectively, flipped the table, and dropped in the hook that enticed me to latch on to my own self-doubt. It's how he continued to weave an insidious narrative that said, *There's nothing wrong with me, but there is something wrong with you.*

When you fundamentally believe that about yourself, that hook works every time. Instead of calling bullshit, instead of looking at him and holding him accountable, I'd run off to look in the mirror and say, *What's wrong with you?* And there was no winning. If I'd try, I'd get caught up in a spin, thrash about, pulling on his line as he used all his muscle to reel me in. Even if I somehow got the hook out, or relented and gave him a tiny scrap of forgiveness or validation, he'd still take a piece of flesh, rip open a wound, and weave it into some twisted thing that made him right, something that upheld his story of innocence and righteousness.

But I saw the truth now: He cared nothing of how much he hurt me, only how much his reputation had been hurt.

I kept my texts to only business regarding the kids, and only if absolutely necessary.

"Mr. Dick" texted me regularly. I hardly responded to him, but I didn't discourage him, either—because frankly, he was hilarious in his desperate persistence. Until I started dating, I never had a man talk dirty to me, and I never thought I'd like it. But when I'd driven home from my date with Tom, he called to accompany me on my forty-minute drive home. He asked me how I liked to masturbate and what sex positions I preferred and how many times in a row I could climax. When the

words *cock* and *pussy* echoed out of my car's blue tooth in Tom's reverent whispers, they turned me on rather than made me cringe; they had me craving my vibrator when I got home.

The texts from Mr. Dick didn't quite inspire the same sensuousness. They were definitely more profane. But I was getting more comfortable with phrases like *let me pound that wet pussy* and *my hard cock is waiting for you to cum suck it.* They made me laugh every time. I even grew to find them endearing after a while because they helped take my mind off Marty and his affair. They kept me connected to the strong, confident version of me. The more I'd absorbed Diana's confession, the more I felt that version slipping.

I knew my emotional cajones were shriveling because I agreed to another date with Justin, even though he had ghosted me. He had apologized and suggested we meet up to see a band after he was done with his shift one night. I knew it was stupid to trust him, but I put on a new black-and-white-striped, form-fitting dress, and a pair of four-inch strappy black platform wedges, and went out to the bar to wait for him. As I waited, I noticed a number of men paying attention to me—because damn it, I was hot!—but soon it was an hour after Justin said he'd be done with his shift and my texts got no response.

However, Mr. Dick was blowing up my phone. *Come on babe! It's time! You gotta cum get this throbbing cock!*

Yeah? I texted him. *I just got stood up, so maybe I will.*

Yes! Come now! He sent me his address. It was pure insanity—and I decided it was absolutely what I needed to do. I texted Carol his address and told her I was going for it. Mr. Dick was going to get his fantasy fulfilled.

As I drove, he texted me his demands while assuring me he would pleasure me beyond my wildest dreams. *You better have on a skirt and heals and no panties! Are you wet? My cock is waiting for you, babe!*

I arrived at his house appropriately pantyless at 1:40 AM. I nervously entered his enclosed front porch where he greeted me, naked—as promised—in the glow of the moonlight. I was relieved to find he was as fit and good-looking as his photos depicted, which was all I needed to commence with his game.

"Fuck!" was how he greeted me. "You're even more gorgeous than I thought, babe. Come here, get on your knees and suck on my big cock that's been waiting for you."

"Absolutely," I said. I would have laughed at the ridiculous porn dialogue if I weren't a little nervous about what I'd gotten myself into.

"Then wrap your lips around it, now!"

As I kneeled down, I marveled at how the photos he'd repeatedly sent me had enhanced his very average-sized penis. I wasn't disappointed. But it helped me understand why guys love to take pictures of their dicks: Because they look a good thirty percent larger than they actually are.

After a minute of fellatio, he pulled me up to slide his hand up my dress. "Now that's a nice wet pussy," he said. He slid off my dress as I undid my bra. He told me to walk into the house, completely naked other than my platform shoes, directing me toward his brightly lit bedroom.

"Goddamn! You are sexy as hell in those heels," he said as he came up behind me. He directed me to lie down on my back, then immediately reenacted every porn scene on cunnilingus he must have watched—that is to say, he was way too enthusiastic. Given his confidence and take-charge demeanor, I decided I wouldn't bother to give him any guidance. After a minute or so I was relieved when he stopped, stood up, and pulled out a condom from nowhere, expertly applied it, spread my legs and entered me, telling me repeatedly how "fucking hot" I was.

Once I was sure he wasn't going to murder me, I relaxed. His "pounding" felt fantastic and went so deep I groaned as I felt him hit

places inside me that made me more and more wet. Then he turned me over and entered me from behind, reaching spots I didn't even know were possible as I thrust my hips back at him. We fucked hard for a long time. And it was over just as I was ready for it to be over.

Minutes after he finished he said, "You can stay over, but you have to leave early—like seven o'clock—because I've got to go to church."

"Church?" I smiled at him and chuckled.

"Fuck yeah, I go to church, and you'll need to be gone when I do."

"Yes sir," I said with a salute. "May I use your bathroom?" I checked in with Carol to let her know I survived and that it was all pretty damn sexy once I got over the initial shock of meeting Mr. Dick in person.

In the morning I left as I was instructed and laughed the whole way home. I had no idea why I felt safe with that guy, and why I tolerated his demands—other than I knew it was all for the fantasy—but I was proud of myself for knowing that and feeling confident enough to play along. I could judge myself, and certainly others would judge me; but allowing judgements to shut me down felt like sheer poison to my progress. On the contrary, I needed more than ever to not give a fuck and have fun!

The following weekend, Carol picked me up and we met some friends at a bar for an evening of live music. There was a guy there named John whom one of my friends knew. He was kind of cute, he could dance, and he had some style. We danced when the band was playing, and chatted at the bar between songs.

"I recently found out my piece-of-shit ex-husband was having an affair for years," I told him. I cringed as I spoke. I hadn't wanted my night out to be about that bullshit; but the alcohol had loosened it from my aching heart and there it was.

"Oh man, that sucks," he said. "I'm so sorry. I never had to deal with that. My wife and I had a pretty amicable divorce, so I just don't know what that's like."

Since I'd started it, I told him a little bit more about how my ex was a musician, how long we were together, the house we lived in and how much shit he'd left behind, when suddenly John said, "Holy Shit! I know who you are! I know your ex-husband! I've been to your house!"

All I could do was stare at him dumbfounded, trying not to be pissed that Marty seemed to be all over my life, still. Even on Tinder, the new feature showed who's connected to whom—and so many guys on there were Facebook friends with my fucking ex-husband.

"You guys had those Packer parties, and I was there for the 1997 Super Bowl game," John said. "I remember you had a giant white poodle."

"Yeah, that was my house," I said, thinking it wasn't really all that weird that he knew Marty. Marty knew everyone. But shit, I couldn't help but feel a little creeped out talking to this guy who knew my ex-husband.

"Yeah. . . ." John spoke, hesitating. "You know, you're going to have to ask more questions." He was looking me straight in the eye.

"What do you mean?" I asked.

"There is no way there is just one woman. I always thought of that guy as a real womanizer. He's slept with a *a lot* of women. And sorry, but I always thought you were kind of a bitch. I think most people thought that, so they didn't think anything of Marty sleeping around," he said. "But you're actually really sweet," he said as he kissed me on my bare shoulder.

I looked at him for a few beats and then turned my head toward the bartender to flag her down for another drink. "You're kinda sweet yourself," I said, "and you're a good dancer! It's not often that guys can dance with me."

"Well, I'm not sure I can, but it's nice being the one next to you on the dance floor while all the other guys are watching," he said. "You could go home with any one of these guys here. You know that, don't you? It's kind of intimidating."

"I don't think about that. I'm just kinda attached to you." I kissed him hard on the mouth and led him back out to the dance floor. *Fuck Marty, fuck his shame, and his piece-of-shit lies.*

I decided not to think too much about what John was telling me. I just kept kissing him, dancing with him, and eventually landed in a steamy heap with him in the backseat of his Saab. I wanted to have fun, be a slut, and not give a goddamn what Marty would think—because I deserved to have some fun. I didn't deserve to have to sit and ponder an even bigger pile of shit my ex-husband had dumped on our marriage.

I repeated my mantra: *Who cares? I divorced the fucker!* I enjoyed my evening with this doting gentleman who found out first-hand how *not* a bitch I truly was.

The next day, I texted Marty: *I know there were others, fuckhead. And the thing is, the infidelity so goddamn pales in comparison to how you treated me, shamed me, for "breaking your heart"—as if you have one—for just being attractive to other men, giving everybody a reason to think I'm the asshole bitch for what I did to you.*

He responded immediately: *You, obviously, deserve to vent on me and I will take all of it. I deserve it. If you want to sit down and talk, I will take whatever you want to throw at me. I DO feel a ton of remorse. I was foolish and selfish and can't apologize to you enough. That being said, I WILL be a better person. I am very ashamed and have learned my lesson and I will grow as a person from this and I will be the best person I can*

possibly be. I know you are thinking it's bullshit and I am not capable but you would be wrong. I am and I will.

He wrote almost the same words to Diana, which I knew because she was still cutting and pasting all his texts and sending them to me.

He was saying all the "right" things. Except he wasn't answering my question.

So I texted him again: *How many others have there been, and for how many years? You must have been doing this even before we were married.*

Still not answering me, he responded: *Listen, I am stripping my life down to ground zero. I know what I need to change. I need to change a lot. I am not arrogant, I am confident. I am going to be true, open, and honest, and be the best person I can possibly be.*

John was right. There had to be quite a list—because he was trying so hard to distract me from pressing the issue.

For five days it went on, with him telling me how virtuous he was going to be and me disregarding all of his bullshit and restating my request: *Give me names and dates, asshole.*

Finally, on the sixth day, he texted me the names of four women—all of whom I knew, all of whom were at my wedding—but he was vague about dates. One woman he said he'd had a *small fling with in the mid-nineties*—ignoring the fact that we were married in 1995. He added: *As you can see, most of this was early in our relationship and at after-bar parties. No excuse. But you just weren't around and that's what it was. I was good during our marriage, until Diana. I didn't feel listened to, and there would be up to two-week intervals where you and I weren't having sex. That's no excuse. But that was the reasoning. So, you see, you were not the only frustrated one.*

He sure tried hard to save face, but what kind of dysfunction drives someone who's been caught cheating to justify it as merely casual sex

with someone after the bars closed because I was away at school, or "early in the relationship"—when he was telling me in those very early days that he loved me? And why was he denouncing materialism and declaring that now he would be "the best person I can possibly be?" The twisted nature of his logic was especially disturbing because I realized there was a time when I might very well have accepted it. I felt like I had trained him to regard me with this surreptitious disrespect—and I was the asshole for no longer turning a blind eye.

I knew he had no idea who might be filling me in on his infidelities, so he was keeping it very tight to the chest. There had to be others. Certainly when he was on tour, since he loved the attention he got from the groupies. The wet T-shirt photo he kept on his phone was proof of that. I got so angry I wanted to explode.

My rage was only a marker for a far deeper hurt that was brewing. I fought hard not to think about the women from before we married. Their existence was way more onerous than Diana. They represented a fact that I'd been desperately not wanting to face: that Marty never, ever loved me. He just used me, and nearly destroyed me in the process.

The pain and remorse of a lifetime lost had settled in and rendered me practically catatonic. I shifted back into autopilot like I had before the divorce, just to get through my days.

In an attempt to alleviate my pain, one day I texted Marty: *I did not deserve this, fucker! Not any of it! Our marriage sucked because you stepped out. I did every goddamn thing I could. EVERYTHING!*

His response was: *You stepped out, too.*

What the fuck!? Was he trying to bait me?

I texted back: *I never did. And that's why you "loved" me.*

I got absolutely no relief. I swore he had some kind of emotional defect that wouldn't allow him to even fathom how much he'd hurt me, because he was too obsessed with playing the victim. He couldn't seem to accept the fact that I never cheated on him, that he was the one who had cheated.

WHY THE FUCK DID YOU MARRY ME AND RUIN MY GODDAMN LIFE, YOU FUCKHEAD!!!!!!!!!

I copied and pasted that message fourteen times to him, until he finally called me. I dismissed the call, but he called again. He kept calling back until I answered, sobbing and screaming incomprehensively until I choked.

Calmly he said, "I married you because you were the most stable person I knew."

My sobbing subsided as I waited several moments to respond.

"That, I believe, is the most honest thing you have ever said."

"I loved you, too, of course. I still do," he said quickly before I hung up.

I wanted to vomit. How the fuck did I not see all this? How could I have wasted so many years—twenty-eight years between our first date and the divorce?

For weeks the texts continued. I refused to sit down and talk with him, in person, even though he kept asking me to. I wouldn't talk on the phone, either. The last call had me twitching. Just the thought of hearing his voice again made me feel so violated I wanted to scream. I was sure he would get some weird, twisted, high from a face-to-face meeting or a phone conversation.

Marty was asking Diana to "sit down and talk" too. And I kept telling her to avoid it at all costs. I couldn't shake the feeling that he took pleasure in our pain.

Diana kept me informed of what was happening on her end as well as giving me other bits and pieces of information about her clandestine encounters with my husband. She described how she'd spent time with my kids and Marty, who introduced her as "Dad's married friend." I remember her giving them gifts, their names in wire wrapped with ribbon. She told me how Roan helped her dad pick out Diana's Christmas gift one year. A shirt and necklace that were "totally in line" with Diana's taste.

How nice, I thought. *My daughter picked out my husband's girlfriend's Christmas gift.*

I'd been adamant about not telling the kids of their dad's affair... until this point. Suddenly, all I could think about was whether the kids might overhear a conversation in my family. Marty had "come clean" with an apology he had group-texted to all my friends and family after Diana's big reveal. What if their cousins were to hear something from their parents and then tell my kids about their dad? It would have devastated Roan to know that her father was actually having an affair with that sweet, married lady she liked so much and had picked out presents for. I knew my daughter. She worked to keep the peace, to be liked by her dad, because she never wanted him to yell at her the way he yelled at Aidan. If she knew, she would be keeping it to herself, but then suffering under the weight of knowing—while I had no idea what was going on in her head. What if in her young mind she even felt accountable for the affair—because she had picked out Diana's present, or simply because she liked her? *Goddamn it! What the hell do I do with that?*

I realized I had to get the kids into counseling. I'd never gotten the desperately needed counseling I should have had as a kid, but my children were not going to suffer that same fate.

I texted Marty about this latest information and explained to him that it was impossible, now, not to talk to the kids about this. His

apology to my family and friends was clearly an attempt to control their impression of him. Keeping up his image was so damn important to him. I believe it was the same reason he had been quick to offer to tell the kids about Diana, too.

I knew he just wanted to rip off the Band-aid, come clean, and declare to the world that now he was going to be an upstanding citizen. Maybe he even believed it. But I knew it was not possible unless he got some serious professional help. That, he refused to do, though. He kept declaring that he was already a changed man; he didn't need any counseling.

After work the next day he picked up the kids from the house, took them to a park, sat them at a picnic table, and said, "Mom's really mad at me. I did an awful thing to her." He went on to explain that his friend Diana was actually more than a friend, that he really hurt me by being with Diana, and that I had a right to be angry.

They were not gone for more than twenty minutes before Marty brought the kids back, and they immediately came to hug me. They both wanted to support me.

Roan especially held me tight and said, "You need to go out and find a boyfriend, Mom!" In her eleven-year-old innocence, she believed that I needed a man to fix my troubles. Then, after she thought about it, she said, "Actually, you need treat yourself to a trip to Italy—all by yourself!"

I laughed and joked that the movie *Eat, Pray, Love* must have had an impact on her.

The massive degree of damage Marty's affair had done to me was coming to light. And I couldn't even fathom what my kids were going to suffer, for how long they were going to suffer it, and what it would look like when they did. Would they have trust issues? Would they struggle to ever believe they could be happy in a relationship? What kind of

bullying would they suffer at school? Would they lose friendships from kids whose parents were not divorced? Would they get caught up with the troubled kids? With drugs? My list of worries grew exponentially the more I thought about it.

I called Bonny to tell her what I was dealing with. She referred me to a therapist named Ruth who could also work over the phone. I contacted her immediately. I was grateful that Ruth assured me that because I was getting them into to therapy right away, I had done the right thing by having Marty tell the kids about his affair—given the fact that he had involved the kids in his relationship with Diana.

I set up a call with Ruth for the next week.

First I talked to her, then she talked to Roan by herself, and then Aidan—who wanted me to be on the call with him. I could immediately tell that Ruth was going to help take a lot of the guesswork out of my parenting decisions, which was a giant relief. She was also going to help me see more clearly the damage that had been done to me by my years with Marty. This was something I knew I needed to see, but I was still trying so hard not to look. I wanted to maintain my habit of fooling myself and stuffing my emotions deep inside until they bubbled out in physical pain. I just wanted to be "done with the fucker"—as I thought I was on the day I walked out of the court room.

The stark truth was, Marty had married me only for my income and status. My heart had been whispering this fact to me over the last few years—whispers that Ruth would now amplify.

"Marty doesn't punch you in the stomach, but he takes your hand, punches you with it, and then blames you for it." Ruth explained. She alluded to the term *narcissist* with regard to Marty, but she didn't say it outright because she hadn't evaluated him directly. Many people around

me who had witnessed the drama I was going through called him that, so I Googled it. I learned that *narcissism* is a condition with a spectrum people fall within, much like autism. Marty seemed to have many of the characteristics on the list: taking advantage of others to get what they want; an exaggerated sense of importance or superiority; and belittling of others. I didn't know what to do with this information. I couldn't see how it would change anything about how much I hurt—or what to do with the pain.

I decided to let go of trying to understand Marty's behavior and I surrendered to Ruth's push to understand my own. She explained that as the victim of emotional abuse, I'd been in the habit of ignoring or diminishing the abuse while sustaining wounds that now needed to be uncovered, scrubbed, disinfected, and allowed to heal. It was a process I had to go through, a pain I couldn't yet comprehend. In my attempts to cover up the wounds, I had no idea how bad it really was.

I had no idea how unloving it was to myself to love my emotionally abusive husband.

Through Ruth's therapy, I looked closely at the habit I'd formed of lying to myself, looking the other way—diminishing all the words, glances, and actions that were now haunting me. I thought about the look between Marty and presumably his lover of the moment, Marissa, in my newly remodeled kitchen. A look that I knew even then was too intimate for their "friendship." The niceties of Marty's women friends I now saw as purely patronizing—because they either were his lovers, or they knew of his affairs. The part of me that had been fooling myself about the so-called love in my marriage began to die with the information I was getting from Diana—especially when she told me that he'd said he never wanted to marry me in the first place. Of course, he would say that

to someone he was having an affair with. But for once his words actually matched his behavior. Words I should have heard twenty years ago.

And then I thought about Carrie. Scouring over my life trying to make sense of everything, I remembered this woman Marty must surely have been with as well. Soon after we married, Marty and I were at the wedding reception of some friends. We were standing with our cocktails in hand as Carrie, a long-time friend of Marty's, walked up to talk to him. She seemed to hardly notice me, but as the three of us stood there, she engaged Marty in a hilarious commentary about something. She had the gift of capturing an audience in any situation, so we were in stitches—prompting Marty to say, "Seriously Carrie, you really should go into stand-up comedy," as if he were continuing a previous conversation that I hadn't heard.

The intimacy of the comment struck me as odd at the time, but I'd immediately dismissed it. They were good friends. I refused to allow for any other possible narrative. Suddenly, Marty stepped away from us to talk to someone else. I turned to Carrie, expecting a conversation, but she wouldn't even look at me. She looked around as if I were completely invisible. Dumbfounded by her squirrelly behavior, my jaw dropped as she spun on her heel and rushed away in the opposite direction from Marty. I'd considered her a friend, and I stood there in shock feeling the graceless unease of having been socially shunned for no reason I could fathom.

Now I had an idea of what that was all about. I reached out to her on Facebook to test my hunch, and was immediately rewarded with a confirmation of my suspicions. She had been sleeping with Marty. And when he proposed to me, she told him they needed to end it out of respect for me. He didn't want to, and at the time of the reception,

he was still trying to convince her that his marriage made no difference to their relationship.

I just think he was commitment averse, she texted me via Messenger.

As I recounted my discovery of Marty's affair with Carrie, people began to ask me, "What does it matter how many women there were? He's a piece of shit no matter what." But Carrie mattered. Not so much in her being an addition to the numbers, but her twisted insight into our marriage gave the whole business another dimension.

She wrote via Messenger: *I don't think anyone knew how things worked in your relationship so instead of ignorantly blowing something up, most chose to leave it to you two to figure it out.*

Wow. She didn't name names, but she confirmed for me the fact that most people were aware of Marty's cheating—which echoed what John had said—and people presumed I was also aware, and just put up with it. Naturally, just as I had fooled myself into believing Marty's heart was true, I'd fooled myself into believing at least most of his friends liked and respected me. But as the fog lifted, I began to get the idea that I had been slandered, unfairly judged, and universally considered to deserve Marty's infidelity. Given his propensity to lie, as well as my text conversations with Diana and Carrie, I realized Marty had painted a delicately crafted picture to slyly portray me as someone no one in their right mind would put up with, with himself as the innocent man who tolerated me.

My desperate need for love had blinded me over and over again, but not just with Marty. I'd clung to my friendship with Jenna as well for the same reason. She and I had remained friends since college. She

lived about three hours away and we had always made it a point to see each other every few months, alternating who was visiting whom. I told myself that having a long-term friendship meant that I was a good and worthy person. She made me a better person, I thought, and I loved her for it.

But I thought back to one of her visits. We were sitting at a restaurant bar drinking Old Fashions waiting for our table. Our conversation fell into its usual easy cadence. After catching up, I asked her a question that had been nagging me:

"Do you remember when I told you about Jeff our freshman year?"

"Yeah, I remember," she said slowly as she stirred her drink. "I was bothered by that for a really long time," she added, avoiding my eyes. "I'll admit I didn't think very much of you back then for sleeping with him, but I did eventually get over it and forgave you."

She forgave me for being raped.

For a moment as brief as a hiccup, I had fought the urge to feel outraged. In the next moment, I sat quietly as my mind scrambled away from the searing pain of knowing I was never going to get her to see the truth—and I started in on berating my stupidity once again. I knew it was futile to use the word *rape*. It just pissed her off. And I couldn't handle her anger. I wanted to kick myself for endangering one of the most precious relationships I had.

Jenna had shamed me, too, with regard to sex. And I had allowed it all because I thought it was better to tolerate her judgement and accept that I was a slut, than to lose a friend. So many comments she'd said to me over the years were suddenly replaying in my head. She had many harsh comments about me and about my kids, and I had allowed them. I rarely challenged them because her friendship was more of the love I couldn't give to myself. But like all the love I'd sacrificed myself

for, it had conditions that I wouldn't dare not meet. It took me three years after my divorce, but I finally saw my way through to letting go of her friendship.

Throughout my sessions with Ruth and the unfolding of more revelations, Mr. Dick was ever-present and insatiable. He hounded me with obnoxious texts—which for me continued to be a soothing potion of comic relief and distraction. Then we would manage to get together—usually on the side of the road or behind some building just off the highway midpoint between our cities. Then the hilarity was transformed into a spectacular sexual release!

One evening, Marty was bitching to me over text about money, but I was on my way to Milwaukee for a rare, full evening at Mr. Dick's house. I ignored Marty's texts and marveled at how pissed off he got that I wasn't responding. When I arrived in Milwaukee, I was once again greeted by a naked and freshly showered Mr. Dick. He fucked me with his usual abandon in three rooms of his house, taking a break to make me blueberry waffles and yammer on about his church and the box of fresh Georgia peaches he'd special-ordered. Again, he talked only of himself because he wanted to know nothing about me—which was actually refreshing—but since the texts from Marty kept coming, I mentioned my adulterous ex.

"All men cheat," he said. "I know it sucks, but it's true. My dad cheated on my mom, my friends all cheat, and even *I* cheated. My girlfriend was a gorgeous Columbian goddess, and I fucking cheated on her. That's just life."

After waffles he fucked me one more time on his giant leather chair and then told me I had to leave. "Sorry babe, I don't do sleepovers. I just did that first night because it was so late, but you gotta go!"

I thanked him for the waffles, and the "giant" cock, as he referred to it, and went on my way.

Before I drove off, I texted Marty the answer to his question and sweetly added, *Sorry I wasn't responding, but I was too busy getting gloriously fucked. . .but this time not in the head, as is your forte.* I laughed so hard as I pulled into traffic, I had tears running down my cheeks. I felt strong in the defiant spirit Mr. Dick always inspired in me.

In September of 2016, two months after Diana's life-altering text, I was persuaded by my friend, Lisa, who was always such a great help with my kids, to go with her to Aidan's football game. I wanted to see Aidan's game, but I didn't want to see Marty. Since I knew he was going to be there, Lisa offered to be my buffer. We each came from work in separate cars. As I drove around to find a parking spot, the sense of foreboding that I'd tried to suppress all day came bubbling up to the surface.

I berated myself for being so ridiculous when my phone rang. It was Ruth calling to reschedule our next appointment. The moment I heard her voice, I burst into tears.

"Oh dear, what's going on?" Ruth asked.

"Nothing," I said, trying to compose myself. "I'm just trying to find a parking spot to go to Aidan's football game. But I'm shaking and I feel nauseous and my heart is pounding. I know it's because Marty is here and I feel so fucking stupid! Ruth, I just don't think I can look at him. I just don't think I can go to my son's game—because his goddamn father is there!" I cried harder.

"Of course you can't, Carin," Ruth said with her classic voice of reason. "You're not ready! There has not been near enough time passed for you to safely face him, so of course your body is responding to that fact. Right?"

"I know what you're saying is true, but I feel so stupid. And I should really be there for Aidan! I shouldn't let Marty have that control over me—where I can't even go watch my son play football!"

"There is nothing about this that has to do with control, Carin. Aidan loves you and respects you! Certainly, he of all kids will understand if you don't make this game."

"Thank you, Ruth." I said, feeling calmer. "I know you're right, and I can't believe your timing! I was just going to push myself through this because I couldn't give myself permission not to go, but you have. And I'm grateful."

"I'm always here for you, Carin. Call me if you need me, but otherwise we'll talk next Tuesday, okay?"

"Thank you again, Ruth."

I hung up and texted Lisa that I wasn't coming. She fully supported my decision to go home.

As I started the drive home, my emotions hit me like a tsunami and choked the sanity and logic right out of me. I should have pulled over to collect myself, but I couldn't get home fast enough. Tears poured down my face, snot gushed out of my nose. I kept seeing the image of a beast as it climbed out of the tip of a melting iceberg. I knew there was going to be more to deal with because of the pain and torment I'd suffered in my marriage.

There was a much bigger, more monstrous pain I needed to face before I could put all this behind me, but I didn't have the strength yet to face it.

Once I pulled into my garage, I released everything as my whole body shook, and I wept. I'd realized I'd spent the entire day in the very same pattern of denial I'd used throughout my marriage, desperate to tell myself, *It's not that bad, just push through it and don't listen to what your*

heart is telling you. You can't trust it. I was using that very same thought pattern to deny the fact that I wasn't ready to face Marty—that I knew it would devastate me to look him in the eyes and have them suck me back into the dark cell of his mind-fucking manipulations that had held me prisoner for so many years. I knew more acutely than ever how bad it would have been for me to have given him an opportunity to grab hold and pummel me with my insecurities. I knew I was still susceptible to being dragged around like a pathetic dog devoted to making him happy regardless of the damage he did.

For the first time in my life, I was finally coming to realize just how serious the damage of a lifetime of dysfunction was for me.

As I sat there bawling in the garage, a growing sense of delayed panic set in, as if Ruth had just pulled me away from getting hit by a train. I didn't want to be the person I'd been in the marriage. That was a fate worse than death. If I went back, if I ever got sucked back in, I knew it would be the end of me.

I had to face what I hadn't faced before. I had to face the truth: that Marty had the power to punch me with my own hand. I had to face this truth by not facing him, by not looking at him, and by not talking to him.

I had to be strong until I could be stronger. I had to love myself.

Discussion Questions

- Have you ever fought to *not* see a truth because to accept it would mean your entire approach to life since you were a child was dysfunctional and dangerous—not only to you, but to your children as well?

- Have you ever evaluated your understanding of love and the meaning of sex? Do you find that sex without love or even without the potential for love still serves you? Does it make you question what love means?

- What sexual awakening have you had and how important was it to your ability to love yourself? If you haven't had that experience, do you want it? Can you allow yourself to have it despite all the questions and judgements it raises?

CHAPTER 16

The Slow Death of the Old Me

*Suffering has a noble purpose: the evolution of the consciousness
and the burning up of the ego.*
—Eckhart Tolle, *A New Earth*

Once I had escaped the football game, my real healing could begin.
As Ruth explained it, now I could do the necessary and deep
work to find my way out of the pain. I was scared, however. I didn't
trust myself to let go. I didn't trust that I could allow my emotions to
pour out again since I'd bottled them back up after the game. It was
too much to feel. I trusted Ruth to hold me, but I didn't trust that she
or I could handle the beast if I completely freed it from the iceberg of
denial I'd cultivated my entire life.

There was more here than being betrayed and damaged by the
man I expected to love me. There was a far deeper hurt—of which my
troubled marriage was merely a symptom. I'd have to dig much more
deeply to root it out, and I feared I didn't have the strength to face it
without completely falling apart.

Mr. Dick became the perfect buffer, an erotic distraction. He was
just the icy-hot salve I needed on my wounds. I told myself he was

emotionally safe for me—because he was always good for comic relief, he was unapologetically honest, and he didn't play any mind games. I found him funnier than he intended to be. There was no intellectual connection, but the sex was good—for pure, baseless, loveless sex, that is.

So when he texted me one beautiful Thursday afternoon in September, on a day I had off, and demanded that I drop everything and come to him at once, I did. I followed all his "rules" and landed in his living room two hours later wearing a black pencil skirt, pink platform pumps, and a matching pink-flowered blouse.

His energy was different this time. He'd just finished tiling the backsplash in his kitchen, which he'd worked on all day, and he was drinking a beer. I'd never seen him drink because he said he hated alcohol. He didn't seem drunk, but he was less friendly and didn't even offer me a beer. He talked non-stop about the work he'd done and how he'd not eaten all day, while I stood in his kitchen waiting for him to shut up. When he suddenly stopped yammering, I reeled in my wandering thoughts and looked his way.

His gaze moved up and down my body from across his kitchen.

"Damn, woman, you look fine," he said. He walked toward me.

"I've got an extra special treat for you this time."

He moved his hand up the inside of my thigh to make sure I had obeyed his number-one rule of "no panties," and he slid his fingers inside me. In my heels, I stood about three inches taller than he was. He had to look up at me as I closed my eyes and turned my head away. I gasped, allowing the pleasure of his fingers to take my breath away.

He quickly pulled his hands away and said, "Take off your clothes and go lie on my bed. But keep those sexy shoes on! I'm gonna take a shower, then I'll be right back to give you my cock."

I did as he ordered. In a flash he was back. On his way to the bed he stopped and pulled a black scarf from one of his dresser drawers.

"Tie this over your eyes and then lie on your back with your arms stretched out over your head."

I obeyed, then heard the unmistakable rip of Velcro near my head. I felt the weight of him kneeling on the bed to wrap a padded band around my right wrist, then my left, securing the bands with the Velcro.

"Oh my God!" I giggled, "I always wanted to try this!"

"I'm gonna give you the best fucking present you've ever had," he said. "You're so lucky I took the day off. Show me your pussy," he said.

I spread my legs, securing my platform heels on the footboard. An instant later he worked his fingers and tongue with his usual gusto. I moaned and pushed my pelvis toward his busy tongue, finding my own rhythm.

I writhed and whispered "yes" over and over, anticipating something more exciting to come, when suddenly he stood up.

"You like that, huh? But now you want my cock, don't you?"

"Yes, please," I said, smiling big as I fought to keep from laughing. I wondered if he consciously memorized classic porno scripts, or if it just came naturally to him. It was probably the latter.

"Fucking-A, you're gorgeous," he said.

I heard the crinkle of a condom wrapper, and then he lifted my legs over his shoulders and entered me, seemingly all in one move. He rocked me hard as my heels clapped together behind his head. I pulled at the restraints, arched my pelvis toward him, and pumped just as hard.

He repeated over and over, "You like my cock, don't you? God! You're so fucking hot."

As always, he never asked me if I was ready for him to finish.

I was so close to orgasm, even without the help of my own fingers, but he finished before I could get up the nerve to ask him to wait.

He pulled out, uncuffed me, told me to move over and collapsed on the bed beside me.

"That was awesome!" I said.

"Fuck yeah, but now you gotta get the fuck out."

I looked at him and laughed, because I was sure he was joking.

"I'm not kidding. I'm starving, I'm going to my favorite sushi restaurant, and you're not fucking invited!"

He put on the only clothes I ever saw him wear—a baggy T-shirt, shorts and flip-flops. I could feel his aggression and it pissed me off.

"Jesus! Go get your fucking sushi, then! I'll just lay here and relax until you get back and we can do it again," I said with a smile.

"Don't act like a fucking wife! Seriously, I don't mean to be a dick but you can't stay here and I'm not gonna say it again, *get the fuck out!*"

He left the room while I got dressed. I was fuming. I didn't know what to do, or what to say.

"God, you're a *fucking asshole*! Who the fuck would ever be married to you?" I yelled to him down the short hall to where he was in the kitchen. But my anger felt completely pointless.

"Sorry babe, but you're not my fucking girlfriend and I'm not fucking buying you dinner," he said, grabbing my bag as I zipped up my skirt.

I followed him to the living room, where he held the front door open for me.

"I wouldn't want to be your goddamn girlfriend, anyway. This is the last fucking time you'll see me!" I yelled as I walked past him.

He followed me down the sidewalk to my dark green Jeep Cherokee parked at the curb. I unlocked the doors as I walked around to the

driver's side. He opened the passenger's side and set my bag on the black leather seat.

"This is a nice car," he said.

"Fuck you!" I said.

"No, really! I'm looking to get a new car, maybe an SUV, and this one's nice," he said.

"What-the-fuck-ever!" I said, rolling my eyes as I got in and slammed the door.

He slammed the passenger door and started walking down the sidewalk. I pulled into his driveway to turn around and go back the way I came. When I drove past him, I stepped hard on the gas, squealing my tires as he walked toward his sushi.

After the last six weeks of spontaneous liaisons, I'd become more familiar with his rude intensity. He was always demanding, called all the shots, treated me like a whore and pretended he didn't know my name. Yet I knew it was part of the role-playing—because he was weirdly respectful, too. He always made sure to compliment my body, how I looked, and he never insulted me. It'd been perfect for me to be treated like a slut while I knew not to judge myself for it. He had allowed me to let go of whether he or anyone else thought I was a whore so I could confidently enjoy the sex.

I didn't need attachments. I needed sexual experiences to help me develop my stunted sexuality. With Mr. Dick, I found I liked a take-charge lover. His role-playing was a little over-the-top, but once in a while he'd drop it and be a human with me—like making me blueberry waffles—and it had been just enough not to trigger my sensitivities around being a slut. He over-powered me and empowered me at the same time. He didn't judge me, he just fucked me, but respectfully.

Until that day.

I'd driven ninety minutes to get to his house in the middle of the week, having dropped everything I'd planned for the day. And after thirty measly minutes of sex, he demanded that I leave? I didn't even know what the hell the "special gift" he had for me was. Was it the restraints? Other than being cuffed and blindfolded, he didn't do anything different to me from what he'd always done, only he did it faster, ending the whole encounter in record time and telling me to *get the fuck out*.

And that sure as shit wasn't a gift.

My emotions burst out of me all at once with a primal rage. I pulled over to let it all out. Of all the potentially dangerous things that could have happened to me with this guy, I thought I was safe and in control. I thought I'd owned all my power. And then in a flash I was blindsided. It felt like he'd just slapped me across the face—and that I deserved it because I actually was a disreputable, sex-starved bitch.

Twenty minutes later, back on the road, I realized that, yes, I was pissed at him—but ultimately my anger was with me. I didn't need or want his love; I just wanted him to glorify and please me. I gave my body to him willingly, yet in four short words he ruthlessly changed the game and took my dignity. *Get the fuck out.* This phrase drummed up the same anger I'd had for Marty when I found out about all the women he'd been with. He, like Marty, treated me with zero regard for my heart—with not a care in the world for how much he hurt me.

I had to question if I would ever not be treated like that, if I would ever not *deserve* to be treated like that. I hadn't given away twenty-seven years of my life this time—but I'd given away my power just the same.

I had let myself be used and discarded once again. But this time I felt it. I didn't even try to suppress it.

That, at least, felt like progress.

Once I exhausted my anger on the drive home from Milwaukee, the only emotion I had left was embarrassment. I needed to figure myself out. At the age of forty-nine I'd never been in a mutually loving relationship. I knew that emotionally I wasn't ready for a fully committed relationship, but I was desperate for validation. I needed to know I was at least lovable.

I had relied on dating to give me "love." I knew sex wasn't love, but I was stuck because a part of me still wanted sex to be about love. Yet in the liberated way in which I was having it, it just wasn't. It wasn't at all.

No amount of loveless sex was going to liberate me from the desire to have love-filled sex. I craved for men to give me morsels of attention and praise to feast on. I'd allow my brain to convert that into the love I needed and to fool that part of me that wanted it into believing that it was enough. I was still fighting to get love, still lying to myself about what love was, while I slowly began to realize my dysfunction about it.

My desperation for that kind of validation of my lovability led to a series of no-shows. My honesty with my dates—telling them that I wasn't ready for a fully committed relationship—backfired on me repeatedly, sometimes by men not strong enough to tell me to my face. Often I was ghosted—or dragged along with scraps of delayed texts that drove me mad with second-guessing until I would eventually find out they chose another woman over me. This caused a flood of confusion in my mind as to why I was upset they chose another—when I didn't fully want them, anyway.

As this happened more and more often, it drove me to try to re-frame what I wanted from dating. But I just kept ramming into a wall:

my need not to experience another Marty. Marty always said he was my "biggest fan"—of my writing, my spiritual studies, and coaching—yet he never read my blogs, never allowed me to coach him, and ultimately told me all my beliefs in spirituality, psychics, and astrology were bullshit.

Marty's piles of lies made me hyper-aware of even the slightest smirk or twinkle in the eyes of my dates. Keeping my guard up like this was not conducive to healthy relationships. I didn't trust myself. I didn't want to end up latching on to a guy just because he treated me better than Marty did.

I thought I just needed to keep it casual. Certainly, Mr. Dick kept it casual. But I knew I wanted more than just sex. I wanted respect, companionship, stimulating conversation, and sex with someone who didn't try to use me, own me, or kick me out the door when he was done with me.

If I could find that, I wondered, would love follow?

Ruth didn't discourage me from dating. She knew I needed to live through every experience—even with Mr. Dick—in order to find my way toward *loving myself first.*

But I was still stuck in holding out hope that I would be rescued by one of these men. I had hoped that one of them would see I was worthy—even if I didn't. But I couldn't find my way to that conclusion.

Time and again, they proved to me what I believed about myself: that I was not worthy and that some other woman was. Like a hungry bird, I still pecked at anything resembling love that came my way, always hopeful I'd get the sustenance I sought, only to collapse with exhaustion when, once again, I didn't find it. I couldn't let go of needing from a man that which I needed to give myself.

I decided to give it up altogether. I took down both my Match and Tinder profiles.

I knew it took significant courage to retreat; however, courageous was the last thing I felt. Rather, it felt like a bitter pill my ex-husband had made me swallow. I remembered him saying, "Carin, you'll never be happy," implying that my unhappiness in the marriage was because I was flawed. It was still difficult not to believe that I was defective.

Standing up with righteousness in my mind for the fun I knew I deserved, I have no idea how I heard my heart's gentle wisdom tell me that the fun wasn't worth the pain. But somehow I did hear the message—and so I deleted all the men's numbers from my phone and gave myself space to lick my wounds.

I tiptoed through my days holding my breath. I fought hard to keep my anger in check, to keep it from setting off an avalanche of pain I couldn't control. I'd completely stopped my blog and any efforts to run my coaching business. I couldn't imagine coaching anyone given the way I felt. It was excruciating to try to act normal at work while seeing patients, to keep my voice from shaking as my mind replayed all the scenes from my life where I had expected love, and never got it.

When I was done with my patients for the day, I'd pack up my things and speed-walk out of the optical center with a wave to my staff, praying they'd be working with patients and not want to chat. I was certain I couldn't hold back my tears if they stopped me to say anything. I'd rush to my car to get in before my sobs drew attention. On my drive home, I'd stop midway to pull over onto a secluded road and let loose the emotions that had been threatening my composure all day. I'd scream so loudly my throat hurt. I'd think of how Marty, that coward, had stolen my life with his selfish needs—how I let him do it—and of how many years were lost. And now I was broken.

I couldn't stop ruminating.

And yet I knew, deep down more than anything, that I was built for love. I always wanted to be married, yet here I was, divorced and incapable of loving or being loved. Now, I couldn't love a man even if I wanted to.

Once I'd exhausted my emotions, I'd lay in a heap on the steering wheel, torn open as my broken soul seeped out into the cold, dead air, stagnant amid the detritus that was my life.

"I felt the love of heaven once," I told Ruth. "It was in a dream I had of Ginny after she died. She came to me and surrounded me with light. It was the most pure love you could ever imagine. For just an instant she enveloped me in her light and I knew that love was infinite."

Tears overcame me as the experience replayed in my body. "I tasted what it feels like to be loved unconditionally," I continued. "In that dream, I touched what it was like to feel love so strongly that no fear of judgement—or of needing to earn love—existed. It was the most real moment I've ever had in my life, and then it was gone."

Ruth reminded me that unconditional love is always here for me—that it is the love in my heart, the love of the Holy Spirit—a love that cannot ever be blocked or taken away other than by our own thinking.

Yet, I couldn't feel it. I knew it to be true, but I couldn't feel the truth of it in my body.

"Yes, I do *know* that, but I don't *experience* that," I told her. "It was gone the second I woke up. Outside the dream, I have to work hard to remember the love. I have to work for the memory of love. I had it handed to me; I know it's there. And yet I have this beast scoffing at it, batting it out of my hands and telling me I don't deserve it and calling me foolish for ever thinking I did."

"Carin," Ruth said gently to counter my angst, "can you think of another time you might have felt this love from the Spirit?"

I was quiet for a long time.

I finally found the words. "I think so. It's not as profound as it was in the dream—but I suppose that it's the contentment I feel when I'm in nature, like hiking at High Cliff State Park. I remember when I was a kid I'd spend hours by myself in the woods across the street, singing while I picked wildflowers or creating 'rooms' for my 'house' among the dogwood and buckthorn. I have so few memories from before my mother died, but I do remember that," I said, calming down as I conjured the memories in my mind. "And, you know," I added, "probably when I'm dancing, too."

"Yes, Carin," Ruth said. "Absolutely! And we will keep working to help you tap into that unconditional love permanently. You absolutely deserve it."

"I know," I said, "but it still feels like a lot of work."

I had lost the easy feeling from the memories of my time in the woods. I felt exhausted.

"We will get there, Carin. We will kill the beast," Ruth assured.

I was desperate to believe her. It seemed that as long as the beast existed, I wouldn't be able to completely surrender to loving myself. I had no idea how to kill it—or even if it could be killed—but I recognized that I could have enough self-love for me to have faith that it could.

I started the habit of taking a bath nearly every night. I'd soak in the tub for hours, sobbing and listening to an ever-expanding Spotify playlist that I'd created, which I called *Embrace My Heart*. I collected songs that made me cry, made me smile, made me feel the pain I'd buried for decades, and made me feel strong. Spotify and the bubble

THE LOVE LIAR

baths became my security blanket. I immersed myself in the tub and the music and felt safe to embrace any damn emotion my heart brought to the surface. It was comical to think of anyone spying on me. They would see a mad woman, crying then laughing, then dancing (yes, while horizontal in the tub), and then outright bawling uncontrollably in a five-minute time span, over and over for hours. My fingers pickled, proving how much time I'd dedicated to processing my pain, to loving myself and taming the beast.

I felt a thousand times lighter after those baths as if I'd washed away several pounds of debris from my body. But then a few hours later, I'd feel the weight of more pain which would rise from an infinite source of hell bubbling up from my soul.

Dying became a lovely thought. I fantasized about a fresh prescription of Ambien. I visualized myself opening the cupboard in my bathroom, popping off the childproof cap, and downing the entire bottle of the tiny white pills. Then I'd sob as I pictured my kids' lives at the mercy of their father. With me alive, he was a lousy parent. If I died, he'd be an abomination. He was only capable of thinking of himself. The children would have no nurturing, no unconditional love if I were gone.

This wound is gonna cancel me out. The lyrics of singer Nathaniel Rateliff in his song *Still Trying* came through my headphones as I soaked in the tub. It began to reverberate through my head so I used it like a pick-axe to work out a thought deep in my mind. I knew it was dark and ugly, but my curiosity was piqued. The thought was imbedded in my solid intentions of keeping the depression at bay, but this particular verse drove me with blind determination to unbury it. To my horror, listening to the verse finally let free the thought that came to my mind: *Ever wonder why a mother who commits suicide takes her children with*

226

her? It's not selfishness, it's because she can't bear to leave them suffering in the world without a mother.

Oh my God. My labors had unearthed the horror of horrors no mind wants to see. Of course I would never, ever. But the thought showed me that the intensity of my depression was far worse than I'd imagined. I had actually entertained the thought of ending it all.

I prayed for guidance: *Dear Heart, Show me how to be here for them. I hurt so bad. I can physically feel the pain like a sharp dagger slowly pressed into my chest. I can feel the piercing of my skin, the cracking of the bone, the slow motion of the blade as it slices through my heart.*

I am always here, I will always hold you, Heart replied. *Feel what you must feel and trust that I will never let it consume you.*

At that moment, I committed to trusting my heart—to shifting my fantasy from committing suicide to becoming more deeply determined to survive. I would see the three of us through this nightmare.

But again and again the thought that I would never find love, never find peace, never find relief from the pain, would overwhelm me completely—and I'd have to start all over. Every day I vacillated between wanting to end it all to be done with the pain, and rallying my strength and courage to live for my children.

I believed nothing would have stopped me from downing that bottle if I didn't have my kids. And I also knew there was more to it than that. The times I sank down to the darkest, coldest depths of my sea of despair, I felt the undeniable force of my heart holding me. That force didn't chastise me for my melancholy or show dismay at my thoughts; it didn't even try to pull me up; it just held me in a dimly lit pocket of love. My pain was too great and too dense to let much of the light in,

but like the glow of the earliest dawn, I sensed more than saw that the pure love I knew from my dream of Ginny was holding me all the same.

I needed no words to tell me that I was to simply wait out this pain. I knew that in time I would be able to use that love—that pure unconditional love that didn't come from anywhere but my own heart—to leverage myself out of the dark and live in the light. This and this alone was what allowed me to not pick up that pill bottle. To not panic at the horrifying thoughts around suicide but to understand that the thoughts were there and needed love. I knew, somewhere in the depths of my despair, that I would live through this pain, and one day be stronger for it.

Discussion Questions

- Have you ever been able to respect the depression you suffer? Have you had compassion for yourself while you're in it? Or do you judge yourself for it? Can you see that loving it is to be aware of your melancholy and to simply allow it to be?

- Are you willing to allow whatever horrors your mind imagines while you're depressed, and maintain faith that they will never happen? Can you give yourself the grace to know that the horrors you create in your head are part of your healing—and that not to acknowledge them may prolong the healing process? They are an emotional toxin that needs to be safely released with the understanding that although they are there in your mind, they need not happen in your world.

CHAPTER 17

All on My Own

Hunger hurts / but starving works when it costs too much to love.
—Fiona Apple, *Paper Bag*

B y some miracle or divine mercy, I was clear of any colitis symptoms. Patients who'd followed me for years and become friends of sorts would ask if I'd suffered anymore with that debilitating auto-immune disease. And I'd tell them I'd "kicked that habit the day I kicked my ex-husband out of the house." It was always good for a laugh, and sometimes prompted a deeper conversation with patients about emotional pain and related physical disease. But I wasn't just trying to be funny, I believed it with all my heart. I was proud of the fact that I'd survived Marty, survived my marriage, and survived ulcerative colitis. I had no reason to revisit any of it. Moving on wasn't happening as quickly as I'd hoped, but I was "doing the work": I was feeling the pain before it corroded my colon.

While I struggled with bouts of depression and with learning how to love myself, Marty found the "love of his life." The other woman he

had pressed so hard for, Kim, the one he left Diana for, dumped him before he ever got around to introducing her to my kids. Two months later he had a new catch. A petite blonde this time. Her name was Tracy and they *were made for each other,* he told me by text one Saturday afternoon in response to my text enquiry about Roan saying she was asked to work in her dad's *new girlfriend's boutique.*

In an attempt to impress me with how perfect she was for him and our kids, he texted back, *She cheated on her husband, too, so she understands what it's like to put people through so much pain.*

He was eager to involve the kids in his relationship immediately.

I texted him that it wasn't a good idea. *Ruth strongly advises that the kids not get involved in your relationship at this point. They just found out about your affair three months ago. They need some space!*

I don't agree, Marty replied. *Seeing their dad happy and in love, and starting a new family is good for them!*

We argued over this for months. My best intentions—to help his kids, my children, to develop the best possible relationship with him, without them having to deal with the awkwardness of being around another woman and her kids—were lost on Marty. He just wanted to replace me as quickly as possible. Getting the kids on board with that plan was all he could think about. I tried every bit of reasoning, even pointing out that if he didn't have the kids around, he could concentrate more fully on developing his new relationship with Tracy. But apparently that didn't matter to him.

Even though I knew the relationship was pure shit, it still hurt like hell to see his texts declaring how he was *never so happy,* and how she was *the love of his life,* and that they would be moving in together when his lease ended in six months.

The declarations of his affection for her struck me deep in my chest, triggering the chronic notions that I wasn't worthy of love. It was a daily battle with my heart to keep from believing that maybe he *did* actually love her, that he *could* actually love; he just couldn't love *me*.

I was out to dinner with my brother one night trying to explain my heartache to him.

"Why can't you just get over it? Marty's an asshole so why don't you just accept that and move on?"

"Twenty-seven years of abuse is not something someone can 'just get over,'" I explained. I wasn't angry, but I wanted him to understand how I felt. "I devoted myself to a liar. I had children with a man who seems *incapable* of empathy. So I have a lot of shit to heal from with no clear idea how to do it."

"I guess, but you'd be happier if you'd just let it go," he said.

I was being a downer. I was usually a great source of entertainment, amusing him with my Mr. Dick encounters. But his words had cut deep. He didn't understand. And what was worse, I knew my pain made him uncomfortable. He just wanted me to stop feeling so damn much.

I had to face the fact that the people in my life had never been through what I'd been through. It wasn't their fault that they couldn't relate. But I knew that they loved and supported me. So I believed they could understand my suffering if I could just find the right words to describe it.

The same was true with Jenna, the friend from college I was still holding onto at that point. One evening at her house, we sat in her kitchen drinking wine. I told her of my latest frustrations with my ex-husband and she asked me with irritation, "You know, Carin, it takes two to make a

marriage work, so I think both partners should take responsibility when it doesn't. You keep blaming Marty, but aren't you to blame, too?"

Again, these were words from someone I'd counted on, which devastated me because she couldn't grasp the depth of why I suffered so much. How did she not understand that responsibility is what I took—all day, every fucking day—in that relationship? How did she not hear me *blaming myself* all those years? *That* is what was wrong. I could definitely take responsibility for *that*—that I took all the blame and responsibility, and Marty took none. I could take responsibility for putting on blinders—blinders which made me imagine that I was loved by the man I loved with all my heart. But I wasn't responsible for his infidelities, for his cold-blooded disregard for me, and for his heart-shattering abuse of the best parts of me.

Jenna's oversimplification broke my heart. I knew after all our years of vulnerable conversations, if she didn't understand me or what I'd been through, then I would have to accept the devastating idea that I'd put blinders on where she was concerned, too. I remembered how she'd reacted when I'd told her that I'd been raped, and how years later she said she *forgave* me for that rape. The lifting of the fog that I allowed to blind me in my marriage was also happening in my relationship with my best friend.

At a time when I needed her the most, I had to admit to myself that Jenna was a liability to my healing. I was going to have find my distance from her. But I couldn't do it yet. I hung on just a while longer to the illusion that she had my back.

I'd also begun to pick up on innuendo from friends and family that implied that because I'd been so oblivious to Marty's antics, clearly I had a serious defect—which interfered with my my ability to be a good parent.

If I had been fool enough not to see how Marty took advantage of me and cheated, then naturally my son could also be taking advantage of me.

"Aidan is lying to you all the time," my sister Carol told me. "He's just like his father. And if you don't crack down with some tough love, you're going to have serious trouble with him."

She scoffed at me when I explained that I knew about the lying and that I was working on helping him to trust me so he didn't feel he needed to lie.

"Yeah, whatever. That's bullshit. He's just going to keep lying to you," she insisted. "He needs to earn *your* trust, not the other way around."

Aidan struggled in school and bullied his sister, and Roan kept her problems to herself because she didn't want to upset me. But Carol didn't understand the difficulty I had in parenting my kids. She refused to consider their pain or even acknowledge that it was anything I needed to address. In her mind, if children misbehave, as a parent you need to be firm and scold and discipline them harshly, not try to understand why they are misbehaving. According to her, my getting "soft"—trying to be compassionate about their feelings and challenges—just gave them the opportunity to take advantage of me.

I couldn't believe that she couldn't relate, given her own childhood. She had been treated just as callously as she was treating Aidan now— she'd suffered cruelty which devastated her own childhood, leaving her nowadays fighting depression and countless physical ailments her entire adult life. She was considered the black sheep of our family—cast aside by parents who had unsuccessfully employed the same tough-love tactics she was telling me to use on Aidan.

How could it be that I had no one in my life but my therapist who really understood me and had my back? But at least I did have Ruth. I was grateful for that.

The blame I felt from seemingly everyone in my life—other than my kids and Ruth—revived the beast I battled. It told me, once again, that I was not deserving of their love or respect—this time because I was a fool. I convinced myself that they would let go of their judgment and find empathy for me and my kids if I just explained myself better—a task I took on every chance I got.

I began to have more control over my emotions as my work with Ruth helped me understand them. I was able to get through most days without breaking down into fits of tears. I began to look for something fun to do that was just for me—something that wasn't dating—so I signed up for classes at an aerial dance studio. I dabbled in the silks classes, hammock, hoop, and pole dancing. I immediately took to pole dancing and soon it was the only apparatus I worked on. I realized how much I'd been starved for that "something pretty" that I never got to do when I was a kid because my dad had insisted on swimming. At least three nights a week I was at the studio learning to dance and spin—feeling stronger and prettier by the week.

I also began to look at my future beyond Wisconsin. If I wanted to move out of state, if I wanted to find a new life untainted and unburdened by my old life, the first thing I needed to do was to get the house sold. The idea of selling the house—my childhood home—hadn't landed. I couldn't let my mind fully absorb the reality of selling it and what it might mean to me. But I had to get it done.

Marty demanded that I "stop stalling" on getting it sold. But I had more stake in selling it than he did. He just wanted the money. I wanted a new life. I wanted to no longer live within the most painful scenes of my childhood and married life. Every day I was reminded of how unsuccessful I was in creating the life of joy and happiness I'd dreamed of since I was a kid.

I met with a realtor to get started on the process of preparing the sale.

Marty assured me I would get no help from him. "You wanted the divorce, and you wanted to stay in the house, so you can sell it," was his argument. Yet there was so much that needed to be done before the house could be sold.

I had to give him an ultimatum: Clear out the basement and everything else you want from the house by the end of February or it all goes to Goodwill.

He complied, sort of. He removed almost everything that was valuable, leaving about half of his crap behind. The only things he'd left of value were a drill press, a circular saw, and a band saw. I am not a handy person in the least. I'm not at all sure what a drill press is even for. These were items I was never going to use; yet Marty said he'd left them for me, "in case you need to do some work on the house." He also left his eight-foot-long tool bench heaped with all kinds of odds and ends. There seemed to be one of everything from our local hardware store on that bench—opened packages of nails, nuts and bolts, and obscure plumbing pieces. There were various sanders, sanding belts, bike parts—all for a man who also was never handy.

Plus, there was a gravel-floored room—a fruit cellar, which I'd always avoided even as a kid—that he'd packed full of the old carpeting and padding we had replaced in the living room five years earlier, along with warped 2x2s and 2x4s and wallboard left over from the construction of Martyland. It was a 6'x9' room literally packed to the door frame with nothing but dumpster-worthy junk.

Aside from removing all that Marty had left behind, the big-ticket items the realtor insisted I needed to address were: Several rooms needed painting, the hardwood floors needed refinishing, the front door needed to be replaced; and the leak in the basement needed to be fixed. So I

picked out a new door; hired a friend's husband to paint those rooms that needed it; and brought in a hardwood flooring company. Then I had to get a quote from a contractor who specialized in reinforcing foundations. It was a huge task to get the house in top shape to sell it for the highest price possible.

I knew Marty was expecting a big payday once the house sold. But I told him I would be taking whatever money I put into repairs and updates off the top of any proceeds that came from the sale of the house, since he refused to pay for any of it. He agreed, since he wasn't going to lift a finger to help. But that all required him to wait—and waiting was not his forte. He threatened often to sue me for his half of the house because he thought he could get his money faster that way. But he dropped it when I pointed out the court costs we would incur.

I wouldn't get it sold as quickly as he insisted. But I was as anxious as he was to sell the house and get on with my life. I set my target for February of 2018, which gave me a year to have the house ready for market. This was ambitious, because there was a lot to do. I was still working to pay off credit-card debt and refused to add to it. I paid for everything as I went, other than the basement repair, for which I took out a loan.

It was spring, and I decided I'd healed enough to get back out on the dating sites. I just wanted to feel wanted, again. Why should I punish myself any more with lonely nights? Wasn't loving myself about enjoying myself with others? I wanted someone I could devote myself to and who would devote himself to me. *I've spent the last five months focusing on me and loving my damn self, so I must be ready for others in my life by now,* I decided. Ruth encouraged me, so I created a new profile.

I dated a few guys, but they were all just about sex. So I kept looking. That's how I met Michael. He was smart, liberal-minded, he had a PhD, and he was a marathon runner. I took my time getting to know him with conversations on the dating app. I wanted to be sure he was what I was looking for—while not entirely sure I should even be dating. But after a few weeks I decided to meet him for drinks.

We met at a quiet, dark wine bar. He was already there when I walked in—easy to spot amidst the very few patrons. He was about my height, which made him shorter than me in my heels. He was soft spoken, and had a gentle, intellectual nature that drew me in. I'd daringly stated on my profile that I believed in "reincarnation, the study of past lives, and a good psychic." I regretted putting that on my profile as soon as Michael asked about it because I suddenly felt shy and thought it would be nearly impossible not to come off as a loon. But I did my best and Michael listened. He really listened. He even asked a few questions.

"My mom sort of gets into that stuff, too," he said, "It's not my thing, but I respect my mom and some of the things she's read about are interesting."

It was a good date. He said all the right things, in all the right ways. I didn't feel creeped out or played. We had a lot of similar tastes in movies and music, and enjoyed an easy rapport. Plus, he asked me about *A Course in Miracles*—which I'd also brazenly put in my profile—and wasn't squirrelly or clever in his response. I sensed genuine respect and no intimidation. Too often I'd dated men who were clearly uncomfortable about my level of education, my title of doctor, and my income. Rarely had I come across a man whom I felt safe enough with to divulge my spiritual beliefs.

The more I dated, the more wary I became of men. I was never sure they wouldn't just lay on the charm, take what they wanted and then

leave—as if they all were an avatar of Marty. I was forever suspicious of compliments. Although I began to agree more and more that I deserved them—a sure sign of the growing love and respect for myself—I rarely believed men were sincere when they gave me compliments.

Michael seemed different. He was the first man I ever dated who had a PhD. He struck me as wholesome (which I was slightly leery of, given my desire to keep exploring sexually), and he was honest and humble. He was the absolute opposite of Marty.

After a few more dates, and a very hot backseat liaison that dispelled all my silly notions about his "wholesomeness," we set off on the exact kind of relationship I had been looking for. He was perfect for me for now. I told him I wanted to keep it casual, and not to involve our kids in our relationship. I also explained that I needed to have my own life outside our time together, as well as time with my children. I also wanted to be exclusive. Other men were communicating with me via text, but I ended all those conversations because I wanted the simplicity of monogamy—and Michael agreed.

We saw each other two or three times a week. On Tuesdays I would stop by his apartment after pole class in my booty shorts and sports bra, feeling strong and sexy. He would have dinner ready for me, but usually I was hungrier for him than for food. We'd sit together on his couch and eat, which usually lead to foreplay. Foreplay with him was fantastic, made even more intense when we went together to a strip club. He was discreet, which was refreshing after the likes of Mr. Dick; yet he enjoyed sex as much as I did. We also enjoyed each other just as much away from the bedroom.

Many a Friday or Saturday night we'd go out to dinner and then to see a band or a movie, or we'd go to a comedy club. He was a good listener, a good lover—and he treated me with respect and just the right amount of

adoration. It felt wonderful, and right. *I deserve this*, I thought to myself. He would listen to me talk about my spiritual passions, my psychic readings, and my studies of the soul, even though it was "not his thing."

"I'm really an atheist, I guess," he said to me one night, "so I can listen to you talk about all this. But I don't have anything to contribute to the conversation."

I tried not to let on how disappointing that was. *To each his own*, I thought, yet I knew it would get increasingly awkward to talk about these things with him. This was how I knew he was good for now, but not right for a lifetime. I needed his attention, though. His gentle presence and tender lovemaking helped me further heal my broken heart.

In the back of my mind I wondered: Was I distracting myself from the real healing—which wouldn't involve the attention from another person?

By the end of July, I'd gotten the whole basement cleared out. The drywall and framing had to be removed from the one wall where the basement specialists needed to work. Roan had a great time getting out her anger with a sledgehammer on the dry wall, and my brother Craig along with Carol's husband, Pat, helped me clear out the framing. It took *five dumpsters* to get everything out. I sold what I could, which wasn't much, and the rest I took to Goodwill. Three full loads in my Jeep Cherokee. Another three loads went to Habitat for Humanity, and two truckloads were picked up by the local thrift shop.

Marty complained that I'd thrown away a lot of valuable stuff he claimed to have thoughtfully left for me. I just shook my head and smiled.

I did throw it all away—along with the maddening memories of the ridiculous arguments and the toxic energy attached to all of it. All this hauling away was a major part of my continuing work to get through to the healing of my pain. I was determined to get there.

Discussion Questions

- When you have children with an emotionally abusive and manipulative partner, co-parenting is simply not possible. All you can do is protect your kids as best you can; help them separate the person from the behavior; and teach them how to have a relationship with the toxic parent on their own terms, not on the abuser's. This can be difficult to do without a therapist—yet if you have a therapist who doesn't understand the personality disorder of the abuser, you could have even more trouble on your hands. You must remain a diligent advocate for your kids, and you will have to do it alone. No one else will understand what you're dealing with unless they've been through it themselves *and* gained wisdom from the experience. Often those who are going through it are unaware and/or uninformed, and their ignorance will make matters much worse for you. Beware. You must choose your friends and support system very carefully. That's it. No question here. Just the most important advice this book will give you.

- Now, can you decide to let go of those you thought you needed, who are not actually supporting you?

CHAPTER 18

A Shattered Heart's Safe-Keeping

Keep your best wishes close to your heart and watch what happens.
—Tony Deliso, *Legacy: The Power Within*

It was August 7, 2017, my fiftieth birthday. Michael and I had been seeing each other since May. I was delighted to have him in my life for this milestone. His adoration allowed me to focus on how fabulous I was at fifty—and keep at bay the thoughts of how *un*fabulous it was to be divorced at fifty.

Michael held out a huge bouquet of flowers when I greeted him at my door. It was a spectacular arrangement of unique flowers from a local florist.

"Oh my gosh! Those are gorgeous! I've truly never seen such a beautiful arrangement!"

"Well, they'll never surpass your beauty," he said as I took them from him.

I rolled my eyes at the compliment and laughed as I kissed him with sheer joy in my heart. I went to find a vase large enough to put them in and then followed him out the door to his car. He had fashioned a

birthday celebration for me of which I had only a vague idea. But I'd have been just fine if the flowers were all of it. I already felt that he had put a lot of thought into the bouquet, making me feel special to receive them.

"So, where are we going?" I asked as he drove.

He shifted the gears of his black VW Jetta, then put his hand on my thigh. "I've packed us a picnic basket. I thought it would be nice to have a picnic at Calumet County Park and watch the sunset over Lake Winnebago," he said with a squeeze.

I took his hand in mine. "That sounds perfect! Boy! I sure love having my birthday in the summer!"

We found the park nearly empty and a picnic table waiting as if it had been lovingly set out by the squirrels and chipmunks. Michael set his basket down on the bench, pulled out a flowered table cloth, laid it over the table, and unpacked the deli salads and sandwiches he'd brought. With a cute flourish and an eyebrow-raised grin, he pulled out two wine glasses.

"Oooooh my," I cooed, being all cutsie to match his corniness as he uncorked a bottle of Cabernet Sauvignon and poured us each a glass. "You make me feel like a queen!"

Lake Winnebago in the August humidity is always overgrown with algae—and a stink resembling dead fish stuffed with rotting produce—but fortunately from our vantage point we couldn't see or smell any of the green slime on the surface. All we could see were the softly rolling waves that gently caressed the rocky shore a stone's throw from our seats, completing the serene ambiance Michael had orchestrated.

We sat side by side holding hands and exchanging kisses as we watched the sun morph into a glorious orange-pink orb before it slid into the lake. With the lingering lights of the sunken sun, we packed

up our picnic and headed out to a restaurant with an outdoor patio for dessert and more wine. It had become our custom for us to each order something different so we could share.

She's a good girl, loves her mama / loves Jesus and America too. . . . And I'm free / free fallin'. . . .

Michael sang along with the Tom Petty song playing over the patio speakers. He had just a little dab of nerd in him, which I found endearing.

That fall, we took a trip to Door County. I was uncertain about the idea of a romantic weekend when he suggested it. I didn't want to lead him into thinking there could be more to us than what we had. I loved our time together, but I knew I didn't love him. I wanted to, though. I wanted that part of my life to be settled—to be loved and in love for the rest of my life—but our differing world views and my distrust of my own judgement wouldn't allow that to be. However, I decided to surrender myself into the weekend as if it *were* all settled, and savor the affection we shared without any worry.

We had reservations at a notoriously romantic restaurant our first night. When we were seated at a table for two, which had a booth on one side and a chair on the other, I sat on the booth side and Michael sat in the chair.

I sized up the table immediately and asked the waiter, "Is it okay if he sits next to me?" I looked at Michael for his answer.

"Of course," the waiter said, picking up Michael's place setting and moving it to my side.

Michael grinned as he ducked around the waiter to join me. I'd suddenly felt like I couldn't possibly have him close enough to me. I had to restrain myself from looping my leg over his thigh as he put his

hand on mine. Sitting side by side, we shared everything—our cocktails, our dinners, our desserts, our stories, and our kisses.

Next to us was a young couple celebrating their wedding anniversary—on opposite sides of the table, not even holding hands. I smiled to myself as I thought how we were the kind of couple I'd always envied when Marty and I were together.

The time we spent being a couple felt so delicious. Yet the weekend trip tugged at my doubts about the logic of staying with Michael. The duplicitous thinking—playing at love but knowing I wasn't ready for love—was becoming exhausting.

I saw that I was pretending that we were in love. But it just wasn't love and never would be. During the months following the divorce when I'd learned not just of Marty's lies in our marriage but also of my own lies, I knew it all had the purpose of teaching me to stop lying and follow my heart's truth. To be in love with Michael was not that truth—even though I resented the fact that it wasn't. I didn't blame him for that, but I knew I couldn't just pretend to be in love with him until something came that would break us up. That was not a healthy fantasy. So I reigned it in and tried to find a healthier way to be in the relationship with him.

I still had so much more healing to do before I was right for love. Knowing that made me feel very enlightened. I knew I could have ignored my doubts. I could have gone all in—succumbed to my fantasy. But I knew I needed to protect both of us from the damage that would result from such a deception.

But what does being so enlightened matter if the loneliness I felt left a chronic ache in my chest? Thoughts of my defectiveness were never fully at bay as I allowed myself to enjoy our time together.

I kept very close tabs on my heart.

Ruth felt that Michael was important to me because he showed me what it was like to devote time to an actual grown-up.

"Carin, your relationship with Michael is the most adult relationship you've ever had," she said. "I know it's your habit to second-guess every nice thing he says given your experience with Marty. But he's not Marty. You can trust him. Just enjoy him. Enjoy yourself."

I wanted to believe her. I told myself I could trust him. Yet I couldn't stop myself from looking for evidence that his compliments were insincere, or that his agreeing with me on anything was disingenuous. Was that my paranoia? Or my heart preventing me from lying to myself once again?

Marty's money-management problems had grown more serious. Although twice he'd gone with his girlfriend to Cancun, Mexico just in the last year, I still had some empathy for him. Marty's dad had passed away that August of cancer. Marty had taken the kids down to Texas to see their beloved Paw-Paw one last time, and then again for the funeral. But my empathy got me nowhere—as he grew nastier regarding all financial matters.

One day he texted, *I want to talk about splitting the kids 50/50. I'm sick of paying fucking child support!* Then he added, *You wanted to split them 75/25, so you got 75/25. But now I want to take you to court and change that to 50/50. Then I can be done paying you the fucking $900 a month in child support, and you can figure out how else to buy all the nice new furniture you've got.*

He never ceased to amaze me with how he casually dispensed with the truth. He now claimed his taking his kids only two days a week was *my* idea. He pulled out all the stops to exploit my usual hair-trigger guilt,

as he also continued to threaten to take me to court for his portion of the house. He didn't understand that I was no longer the push-over he'd married and had successfully manipulated for so many years. I wasn't going to let him make me feel guilty for the financial distress he'd created for himself.

What you're talking about is going to cost money, I texted back. *Court costs and attorneys are not cheap. Plus, we would need to get an appraisal on the house, and pay fees to rework the mortgage to get your name off it. I'm sorry about your dad. I'm sure you had to spend a lot of money getting the kids down there. But I can't help that. If you really want to give up half of your week to your kids, I will fight you on that. You will then pay half of Aidan's car insurance and expenses, and half of everything else I've paid just to avoid having to deal with you.*

These tit-for-tat exchanges went on for months. Nearly every time he came into the house, he'd take an inventory of anything new I'd bought, and throw it in my face with another text. He behaved as though I was taking his child support money and going straight to the mall. I was finally making good money and being able to spend it the way I wanted. It made me so angry that he still thought that what was mine should also be his—and if it wasn't, then he was going to make me "pay" for it in guilt.

I was smart enough by now not to let him know that I felt guilty, but that didn't stop the tortuous ruminations in my mind.

He also accused me of turning the kids—especially Aidan—against him. I was hurting desperately from Marty's actions and continued behavior, so I knew I wasn't a saint when discussions with my kids involved their father. There was a very fine line between showing them when their father's behavior was inappropriate to protecting them from his manipulations, and straight up bashing his character. It was a very

fine line—and I had to walk it like a tight-rope every single day, slipping off the rope more often than I wanted to admit.

I was afraid of how all this looked to Michael. I told him about the arguments I had with Marty, hoping for his validation that I was dealing with a deeply unreasonable character, yet I worried incessantly that my recounting of Marty's behavior seemed too preposterous. I was afraid that Michael would think I was exaggerating or in some way lying. Ruth believed me, but I needed Michael to understand as well. I needed someone with whom I was romantically involved to confirm that I was a sensible person who was being attacked—not the narcissistic bitch Marty claimed I was.

One evening, after the holidays, Michael and I were at my house watching the news on yet another school shooting. This time it was in Florida. Michael was very political and especially pro-gun-control. I was not nearly as political, but I was definitely liberal-minded and certainly advocated gun control. However, I also felt it was not as simple as changing laws and taking guns. As I saw it, human beings were shooting those guns, so there needed to be some attention given to that.

"I just read an article regarding shooters and bullying," I told him. "I loved the author's approach to school shootings—which is 'to catch 'em early' by paying closer attention to the emotional attitudes of the kids who are typically lost in the shadows, *and* the emotional attitudes of other kids toward those who are in the shadows."

"No," he sighed with deep irritation, "we're never going to stop these shootings unless we get the guns out of their hands."

"I guess," I said to him, "but that approach doesn't seem to be getting us anywhere," I said. "It's all so tragically complicated. We're not going to fix the problem without opening our minds."

"I don't believe it's complicated at all," he insisted. And then he started to prattle on about the Republican agenda. I immediately resigned my argument, given his tone. I dropped the conversation, and eventually he did the same. The article I'd read had spoken deeply to my sense of compassion and non-judgement for all—the cornerstone of my spirituality—but Michael was far from impressed. He gave no indication of being open to discussing the article.

I couldn't shake how insulted I felt about the way he dismissed me. I didn't need him to agree with the article I'd brought up. But he sounded so peeved. I might as well have been a teenager giving my naive opinion to a disgruntled granddad commenting under his breath, "That's the damn problem with kids these days." It was as if Michael thought my viewpoint was ridiculous—that *I* was ridiculous.

There had been other times over the holidays that I'd heard irritation in his voice regarding something I'd said, so I was becoming more aware that I didn't trust him when he'd say, "that's not my thing but I respect what you think." It was way too much like Marty telling me he was my "biggest fan" yet he clearly had no appreciation of me. I didn't feel safe to discuss my concerns with Michael because I was afraid I was right—that he'd grown impatient with what he saw as my flakey world view, and that he was just putting up with me because he hadn't the courage to break up with me. I didn't worry about infidelity, but I increasingly believed that here was yet another man who barely tolerated what I thought to be the best part of me: my spirituality.

Whatever had happened in that exchange, somehow I felt we'd just reached a breaking point, that our days were numbered. And I was going to have to be the one to end it.

My digestive issues emerged again. They'd started around the holidays but I didn't want to acknowledge them. I didn't want to face the fact that they were the kind of issues that mark the very beginning of a colitis flare-up. It wasn't consistently bad, but it was happening enough to be ominous. I didn't say anything to anyone. I thought it couldn't possibly get as bad as it did in 2013. But I was still getting scared.

The final task of painting the kitchen to get the house on the market was done. It was ready to be shown. But I wasn't ready for the stress of showings—keeping the house clean; getting the pets out of the house within a few hours' notice; and praying someone would see past the toxic energy that still lingered in the house, and fall in love with it.

I was bitter. I had to do it all by myself—while the colitis increasingly eroded any peace I could find when my ex-husband wasn't slamming me with texts to get the house sold. I told him I was getting sick. He said he was sorry and granted me a reprieve from his abusive texts for a day—but then started up again, chastising me for dragging my ass, oblivious to the irony that my ass *was* dragging.

Marty played as if I were living in paradise—that I thought it was fun to torture him. He knew full well how the symptoms I had could progress, that it could be a very serious problem. He had experienced several times in the past how the disease would sap my strength and energy. But he didn't care any more this time than he had any other time. I wasn't surprised, but I was still disappointed.

Why couldn't my mind understand that he would never give a shit about me?

Instead, I hoped he would see that the stress with this flare-up was worse than ever, and say he was sorry for being so demanding. I wanted

him to acknowledge that he was treating me horribly. I was trying so hard to give him what he wanted—within reason—and I wanted him to say that he understood that this illness could be life-threatening.

I wished he would tell me to just rest, that he would take care of everything and not to worry. I'd just wanted someone to see the pain— the physical, emotional, and psychological torment—and tell me that this time, I could just lay down, rest, heal, and not have to worry about a thing.

Of course this was never going to happen.

I decided it was prudent to see my doctor. Dr. Jeff, who'd taken care of me since my first flare-up seventeen years ago, had retired, so I was scheduled with a new associate, Dr. Constance Langdon.

By the time I saw her, I'd started myself on forty milligrams of the prednisone tablets I had left over from 2013. Because I was in a panic, I hadn't wanted to wait for my appointment to get started on the drug. But I'd gotten the impression she was offended that I'd started treating myself.

She scheduled me for a colonoscopy in mid-February, where we discovered I was indeed suffering a mild to moderate flare-up. I didn't care for her brusque bedside manner, but I cut her some slack since Dr. Jeff had been exceptionally compassionate—a hard act to follow. I was relieved to be in someone's hands. I trusted her and told myself I caught this one in time, and I would be okay.

The realtor, Dave, assured me that he needed only one signature to list the house. I was relieved because Marty had insisted that it be listed at $2,000 over what Dave advised and he had called Dave an idiot. I trusted Dave's thirty-year career in realty and went with his advice over my ex-husband's arrogance. I signed the papers in mid-February.

I emailed Marty a spreadsheet itemizing the repairs and updates I'd paid for since he'd moved out of the house, and reminded him that we agreed I would take everything I spent on the house off the top of the proceeds of the sale. I didn't do anything that Dave hadn't advised, or that I hadn't already told Marty I was going to do. But Marty was livid anyway. He argued over the numbers and nitpicked every item, claiming they were things that weren't necessary. He kept saying, "Dave is an idiot! He just wants top dollar from his percentage of the sale!"

I added in the spreadsheet the projections of what he would get if the house sold at the initial asking price after all the fees were factored in. He said this was unacceptable to him and he took every opportunity to let me know I was making decisions without his approval.

Once the papers were signed, and Dave left my house, I sat in my kitchen and reflected on what it would be like to sell my childhood home to strangers. I'd been so preoccupied with preparing the house, responding to Marty's demands, and worrying that I wasn't being fair, that I'd lost sight of what I was actually doing.

I needed time to mourn. I felt a deep sense of regret and anger for the life the house had witnessed. I was nostalgic for what could have been—what loving memories could have lingered in these rooms, in the scenes I'd replayed in my mind if things had been different. Instead, I was struck daily by memories of stupid, unreasonable arguments with Marty; Ginny's cupboard-slamming fits; and years of dysfunctional family scenes. The nightmare scenes played out in front of me—in the kitchen, the bedroom, the basement, the living room. Around every damn corner I was haunted by a life of frustration and pain that was covered in the soot of obliterated hope.

Tears ran down my cheeks as I thought of my mother's wide-eyed optimism at the idea that my father had built her a "mansion."

Why couldn't we have had all the love she envisioned? Is it because she took it with her? Was I destined never to find love because the foundational love I should have received from my mother was taken from me so completely? That couldn't be true. But it was all I knew to be true.

I implemented another plan to help alleviate my stress. I attended Vickie's annual Goddess Retreat on the beautiful Hawaiian Island of Kauai. Even though it took place right at the time I'd put the house on the market, I still thought the timing for a retreat was perfect.

It was a magical week and I had the best time of my life. There were only three other women aside from Vickie and me. The soul connections I made with my fellow goddesses were deeply nourishing as I began to see what a truly unconditional friendship could be. I couldn't even image how it would have been if Jenna—whom I'd considered a best friend for years—had been there with me. My relationship with her was nothing like what I felt from these women in just the six days we were on retreat together. Unfortunately, none of them lived anywhere near me, but even now I can feel their unconditional love through Facebook.

I did do a great deal of deep spiritual work—or so I thought. Although I've long since rejected organized religion as a means for my connection to a Higher Power, I never stopped believing. In my faith, I had every expectation that I would turn the colitis symptoms around simply because I was meditating, doing yoga and visualizing a healthy colon. I had no break-through, though.

Alas, I had no great epiphany that gave me the reason for my illness or how to overcome it. My symptoms didn't go away, they merely

stabilized. Whatever the lesson in this illness was, I wasn't going to be able to skirt around it through prayer or wishful thinking. I had no idea that I was going to have to plow right through it.

While I was in Hawaii, Michael called to tell me he'd invited his former girlfriend, Alyssa, to stay at his apartment for a week. She'd had a contentious break-up with her fiancé and had no place to go until she could move into a new apartment the first of March, which was two days before I got home. Michael said he wanted me to know, which I appreciated. I dismissed it as not a big deal—my usual modus operandi. He said he would never sleep with someone while he was in a relationship because he found it "too confusing." So, I knew he wouldn't do that. He was just a nice guy taking care of someone in need.

This development made me feel more acutely that our relationship was coming to an end, but I wasn't ready for that. I wondered if maybe I was using him as he might be using me. I loved having a regular sex partner, and I loved being affectionate together whenever we went out. But I realized I needed to keep the best part of me—my spirituality and deeper thoughts around that—to myself. And that didn't seem fair to me. I also kept the ugliest pain I suffered regarding my marriage away from Michael. I worried he wouldn't appreciate it. No one else except Ruth seemed to understand, and I couldn't let myself suffer more of the indifference I got from others.

A week after I got home from Hawaii, Michael and I went out to see a band. Later that night, as we were snuggling in my bed, I asked him how things went with having Alyssa stay at his apartment.

"It went great!" he said, "We got along really well and talked a lot. The time with her made me realize that I still have some feelings for her."

My head started buzzing. I felt like I suddenly had a fever as I tried to process what he was saying. "That's good," I absently replied, not knowing what else to say. "I'm pretty sleepy," I added as I got up to go to the bathroom.

I struggled to grasp the emotion that set off the sickening sensation I felt in my body, and I needed to get my distance from him. I sat on the toilet with my head in my hands. My mind began to sharpen, and the buzzing in my head coalesced into a fierce point of indignation as my stomach cramped painfully. *How could he feel so perfectly comfortable telling me he had feelings for another woman while I lay naked next to him? He was so blasé about it!* He didn't sleep with her, and given the perspective Michael had of my marriage—knowing my husband had cheated on me—maybe he figured that if he didn't have sex with her, I wouldn't think it was any big deal to say he still had feelings for her.

Fuck! She gets to have his "feelings"?

I knew I was being unreasonable, *and* I also knew I needed to honor what I felt. It's not that Michael didn't have feelings for *me*. He called me his lover, and I loved acting the part. In fact, I'd been so fierce guarding my boundaries with him precisely because I sensed how much he cared, and I didn't want him falling in love with me. I knew he wasn't right for me and I didn't want the toxins from my shattered heart to hurt him.

I suddenly realized that amidst my boundary-setting with Michael, I'd actually given him my broken heart. I'd tucked it in his pocket, but only for safe-keeping. I'd never let on that I'd done that for fear he'd think I'd given it to him for real.

He never knew that he had my heart in his pocket, so it wasn't his fault that he'd inadvertently dropped it. When he did, my insides screamed for him please not to step on it. Then I watched in horror as he unknowingly did just that.

Two years prior to this, I wouldn't have had the sense to be angry. My brain had had a lifetime habit of hearing slights and insults—and in this case, unintended insensitivities—and immediately filtering them out of my awareness and never confronting them.

That wasn't happening this time.

As I got up off the toilet, I saw more blood than I'd seen since before Hawaii. I sat back down, crossed my arms over my belly and cried. It was impossible to fool myself that I could stop the progression of this flare-up any longer. Too much was coming down on me to control.

I knew ulcerative colitis was related to an unhealthy need to control—as I'd learned in Karol K. Truman's book *Feelings Buried Alive Never Die*—so my bowels were giving up control. *But how the hell do I let go of trying to control, when so much is on my shoulders?* This question was what I had tried to get answered in Hawaii, but when I didn't, I just buried it along with all my feelings of anger and frustration at my perpetual unhappiness.

I washed my face, took an Ambien, and climbed back into bed where Michael was already snoring. As I lay next to him, my heart raced, and my stomach throbbed. I rolled over, with my back to him, as my body absorbed the sleeping pill.

The next morning, Michael got up at 4:00 AM to get some work done on his laptop. He always got up that early and typically came back to bed at 6:00 AM to say goodbye. Sometimes we'd make love. That morning, I made a special request that he do just that. And he did. He crawled naked back into my bed. I shut off my racing thoughts and allowed myself to enjoy the sweet pleasure and fantasy of being loved.

When he left, I slowly slid back into reality and gathered the strength to formulate a plan to break up with him. I let go of trying to control that piece of my life. Maybe it would be enough to heal my insides.

Two days later I went to his apartment with a bag of the few possessions he'd left at my house. As he let me in the door, he took stock of the bag. I handed it to him as I shook my head and started crying.

"I can't be with you anymore, Michael," I told him. My words were a whisper, as I was barely able to speak with my tightening throat. It was as if I'd swallowed a poisonous substance that worked to swell my windpipe. He set the bag on his coffee table as I sat on his couch. He sat next to me and held my hands, patiently waiting for me to compose myself.

I finally spoke. "You loved Alyssa, and now you say you still have feelings for her—presumably feelings of love—and I just can't live with that."

My crying resumed its intensity and I felt ridiculous. He knew I didn't love him, so why would I be so upset?

"I don't know that I'm *in love* with Alyssa," he said, "but we had something really special and now I know it's not fully gone. And I can't say I won't ever see her. I will continue to meet with her for coffee or lunch here and there. But there is no physical relationship—and there never will be so long as I'm with you." He spoke with a mixture of incredulity and tenderness—the former being the true sentiment, the latter sprinkled in with what seemed like an afterthought the moment the words left his mouth. He really didn't understand why I was so upset that I'd want to break up with him. But he also had the good sense to see I was deeply hurting.

I could feel my own strength and my healing. I knew I was advocating for my heart. This was a very strange practice for me. I was scared, but continued to articulate my feelings. "I want love, and I can't bear to have it around me if it's not for me," I said. "Maybe that's petty and selfish, but it's how I feel. And I can't *not* feel it!"

"I'm very fond of you, Carin—of who you are, how you move, your wit and sense of humor, your beauty—"

"But it's not love, Michael. And I don't love you either. I want love so badly, yet I have to fight to believe I'll ever have it." Deep sobs choked off my words as Michael put his arms around me. "Because I'm... not... sure I even... deserve it."

"Oh Carin, how can you possibly say that? I don't want this to end! We've had such good times together, and we still can!"

I had no strength to explain it to him. He would never understand. No one but Ruth understood, and I had to pay her.

"I know you had no intention of hurting me. You're a good man with strong integrity. And you just wanted to be honest with me about Alyssa. But it would have been so much better if you had kept it to yourself—at least until you moved to Germany for your job in January. But as it is, I... a woman who has never had love... I would have to harden my broken heart to your feelings for Alyssa. And that's just not fair to me. I know that's probably an indicator of my immaturity in love. But I will not suppress my feelings."

"Oh, Carin, I'm just so sorry."

I sat like a lump on his couch as my crying dwindled into stuttering sighs. He held my hands and peered at me with genuine concern.

"Thank you for listening to me, Michael, but I have nothing else to say. And I just need to go, now."

He sighed deeply as he stood with me and gave me a hug. "I do hope we can remain friends. I hope in a few months, maybe, we can put this behind us and have dinner?"

"I dunno," I said with a shrug. "We'll see. I just can't think about that now."

I walked to the front door with Michael still holding my hand. I turned to give him one last hug as my eyes squeezed out a few more tears. Then I stepped onto the small stoop and headed toward my car.

Ruth was proud when I told her of my reaction to Michael, the feelings I acknowledged, and the action I'd taken to break up with him. It had taken a lot of courage to just allow myself to feel hurt. But her praise didn't make me feel any better. I knew I was still missing something really big that kept me from truly healing and being happy. My failure at not being able to figure it out weighed heavily upon me.

I was getting sicker. I'd begun to lose weight and I was exhausted as the disease relentlessly drained my strength. Two weeks after breaking up with Michael, with great trepidation and guilt, I gave myself permission to take a leave of absence from work.

Discussion Questions

- In the first relationship you find after breaking free from an abusive one, how can you be sure that person is right for you—and not just being nice to you?

- What other abusive relationships are lurking in your life? Don't assume that doctors always have your best interest at heart.

PART FOUR

THIS IS WHAT LOVE'S GOT TO DO WITH IT

CHAPTER 19

Resurrection

We may encounter many defeats, but we must not be defeated.
—Maya Angelou

I had reason to be hopeful as I faced this flare-up. I did just break up with my boyfriend and I had just put my house on the market—but despite this stress, I was going to beat colitis once and for all. I would soon sell the house and get on with the fabulous life I deserved.

I had showings scheduled requiring I keep the house clean and tidy at all times. I had two teenagers, as well as two standard poodles—Sunny, as well as Dixie, my dad's poodle I took on after he had a stroke in 2017 and could no longer care for her—and Aidan's cat, Snickers. I couldn't really shut down and just take care of me. I didn't have anyone who would take care of things for me. So being off work made everything easier. I was sure I'd be okay.

Five days after taking a leave of absence, I'd gotten much weaker and the pain never let up. It hurt to move and it hurt to have the dogs jump on the bed. I could hardly find the strength to get out of bed, but was forced to when the cramping amped up and I had to rush to the toilet.

I'd been here before, and I knew I'd reached a point of no return. I shifted my expectations and accepted that I would need a hospital stay, but I maintained that after that, everything would be okay. It was my habit to embrace optimism like a child hugging a giant stuffed panda. I used all my might to trust that the panda would magically make everything better.

I called Dr. Langdon's office and spoke with her unfriendly nurse.

"I'm feeling so much worse. The medication is not enough," I told her. "I think it might be time for me to be admitted into the hospital," I said.

"Well, Dr. Langdon is out sick today," she replied tersely. "That would be Dr. Langdon's call."

"So what do I do? In the past, Dr. Jeff would admit me when it got this bad."

"Well, he's retired," she said condescendingly.

I could almost hear her rolling her eyes at me.

The nurse continued, "Dr. Langdon needs to admit you. And she's not here."

"So is there another doctor in the practice that could admit me, please? I really need help!"

"They don't like to take on other doctors' patients," she explained.

"I'll get a ride to the hospital and they can deal with me there," I said and hung up. I didn't care what she said, they were going to have to admit me.

I called Carol and asked if she could take me to the hospital. Then I arranged for friends to take the dogs, and I texted Marty to tell him he'd need to take the kids and the cat for at least a week.

Once I got to the hospital, Carol sat with me as we waited for an hour. No doctor would admit me. I don't know what finally shifted,

but eventually I was taken to a room and given I.V. narcotics to manage the pain. I worried that maybe I'd exaggerated my symptoms; but the compassion I felt immediately from the nurses dispelled my doubts. They could see how miserable I was and responded with a loving, take-charge approach that made me cry at the ease with which they cared for me.

I told one of the nurses about my experience with Dr. Langdon's office and my difficulty in getting admitted.

She put her hand on mine and said, "I'm sorry for that, but you are not the only patient who's been treated like that. When you're better and out of here, I hope you'll write a letter to the hospital and to that clinic because they are notorious for crappy treatment of their patients."

After she left, Carol said, "Wow, even other patients are complaining about this woman's shitty care! You better write that letter!"

"Absolutely I will!" I said. I'd begun to relax. I would be under the nurses' care for four to five days, go home, finish recuperating, and then get on with the task of selling the house and moving on with my life. I wouldn't allow myself to consider how long recovery from this disease was really going to take or to recall how the last time I needed a blood transfusion.

Back then, I'd had to experience and acknowledge the heartless indifference I got from my husband and I'd decided to request a divorce. This time I was already divorced. I had already taken command of my life. And my new life was just waiting for me. It was going to be different this time.

I had only mild improvement with the I.V. fluids and steroids, however. Four days of I.V. steroids was the protocol for treating ulcerative colitis in the hospital, so Dr. Langdon insisted it was time for me to go home. I hated staying in a hospital, and wanted to get home anyway, so I took her prescriptions for steroids plus the Vicodin for pain, and went on my way.

It was the Thursday before Easter when Carol brought me home. She knew I wasn't much better than when I'd gone into the hospital, so after she helped me settle into bed, she gathered the kids in the kitchen to talk. Before leaving, she came back to my room to see if I needed anything, and to tell me what she'd said to my kids.

She stood next to the bed with her arms folded over her chest. "I told them they had to help you a lot more than they have been, Carin. There's no reason why they can't take care of you—because I can't keep coming over here. You've been taking care of them their whole lives; now it's their turn," she said. "And you need to stop trying to make it easier for them."

Her tone was hard and authoritative. I cringed.

"They have to do much better at cleaning up after themselves, too—especially Roan. Her room's a pigsty." She looked me straight in the eye. "And I let Aidan know he's got to stop screwing around, answer your texts, and do better in school. I swear it's like he doesn't even care how much he's stressing you out! He's narcissistic just like his dad!"

I stared back at her blankly. My belly cramped hard, and I felt like I was still a kid trying to please grown-ups who were completely uninterested in understanding what I thought, or even in considering what I was experiencing. That old familiar ache deep within me arose, only it was more acute. It was not just my suffering anymore, it was also my kids' torment.

Carol glared at me, likely waiting for my approval and appreciation. I said nothing. All I could do was imagine that my love was a fuzzy blanket with superpowers that I could wrap around myself and my kids to protect us all from the same adult indifference and compassionless expectations to be "good" and "not bother others with your pain" that had shaped my entire life.

I realized in that moment that my whole reason for having kids was to raise them so they wouldn't have to suffer the fate I did. Yet here they were being indoctrinated into the very same pattern of rebuke: to "suck it up butter-cup, and behave if you want love."

I hadn't died like my mother did, but all the same, my kids now had to face a very difficult, very scary situation, with no adult appreciation for the complicated thoughts and emotions that swam through their heads. I knew firsthand there was no way they could fully articulate their feelings, or advocate for themselves. They needed an adult to give them direction and the space to sort out what they were experiencing—what they could let go of and what they couldn't. But they didn't have that, except from me—the one person who was too sick to help them. It was apparent I was powerless to protect them from the heartless impatience my sister delivered.

"Trying to make them feel like bad people isn't the way to motivate teenagers," was all I could muster.

"I'm not making them feel like anything, I'm just telling them to behave, help, and stop stressing you out." She avoided eye contact and headed toward the door. "I'll bring you some leftovers tomorrow," she called over her shoulder as she left the room.

The next few days while on spring break, Aidan and Roan did the best they could to help me. But they were always at odds with one another, bickering over who should do what and emotionally ill-equipped to see what their mother needed. They needed me but they'd been told not to stress me out—which added to their confusion and frustration.

I hoped Carol would compassionately parent my kids for me while I was sick. But I was asking too much of her. She couldn't understand the subtleties of what we needed any more than my kids could, so she

became overwhelmed. Her natural response to that stress—which her childhood had taught her—was to bully my kids into submission.

Three days later on Easter Sunday, I called Carol over to meet with me and the kids in my room. My intention was to rally them to work better together to help me. But I was stuck. I didn't want to offend Carol—to bite the hand that fed me—but I felt I owed it to my kids to make an attempt at finding a way to have them work better together and take the stress off me.

"I know I can beat this," I said, my voice shaking. "I know it's bad this time, but it's been bad before. I'll just need to lean on all three of you guys even more than I have." I looked at my sister to see how my words landed with her. Her head was down, her elbows on her knees with her hands clasped in front of her as she sat in the chair across the room from me.

She lifted her head and said, "Yeah, you guys need to not stress your mother out so much and help her, okay? You both can do so much better!"

"If I could have you guys work together—and not point fingers at who's not helping with what, that would greatly reduce my stress." I said, hoping that Carol would see that I was talking about her, too. "It's so hard to get downstairs and get something to eat, or to even think of what to eat. I just need to be completely taken care of for just a little while."

I was feeling more reluctant to ask Carol to do anything for me, but I really needed her to bring me at least one meal—just dinner—to my room every day. She had done that a few times, but I needed her to do it a little longer. I knew it was risky to ask without offending her and losing her help altogether, yet I fantasized that she would sit with me as I ate that meal she brought. I hoped she would be with me, support me without judgement, and keep me company without telling me how badly

I was parenting my kids—without giving me any reason to believe that I'd asked too much, needed too much or didn't deserve to be loved enough to be seen for all I was suffering. I needed my sister not to be resentful of what my pain was costing her, to do *everything* in her power to show me that she did not, nor ever could, resent my neediness. I needed her to understand my desire to protect my kids from our childhood legacy—to know they are loved, respected, and heard; and that they have the right to be troubled and troubling; and yes, maybe even narcissistic.

I knew I couldn't say all of that. But before I could say anything, she stood up to leave.

"You kids just do what your mother says. Stop stressing her out and making her sicker!" she yelled. Then she turned to me and said, "I'll bring you some leftovers from Easter dinner. That should last you a few days. But maybe you need to just get the damn surgery, Carin! You can live without a colon. It can't be worth all this bullshit to fight it!"

In her eyes, surgery made sense and would take the burden off her having to help me with flare-ups every few years. But I couldn't let go of how I'd been healed of countless flare-ups over seventeen years. Dr. Langdon wasn't even recommending surgery this time, unlike Dr. Jeff did the last time it got this bad. I saw that as a sign that I could beat this one more time, and then happily resume my life and all the good it held now that my marriage was fully in the rearview mirror.

After Carol walked out, Roan asked what she could get me, so I asked her to fill up my water bottle.

Aidan gave me a big, long hug and said, "I just love you so much, Mom. I wish you weren't sick."

As I lay in bed after everyone had left, I felt a profound sense of having just been dumped on the floor, as if someone were trying to carry

me, but then gave up because I was too much trouble, and dropped me. It hurt. I began to weep. I tried to hold my breath and swallow the sobs to lessen the pain in my ulcerated insides, but that just made it worse. I felt truly alone with no one to help me and my kids in the way we needed it most.

I focused on my body to shift my head away from my emotions. My body burned calories at an accelerated rate to fight the inflammation, causing the extreme weight loss and aches throughout my body. I caught my breath as a zinger ran up my spine. It was a curious and inexplicable side effect like an electrical spark triggered by a mischievous gremlin in my tailbone bent on giving me more reasons to be miserable. A vibration in my ears followed as the room began to spin, but I let it be, confident that I was nestled safely in my sheets. More tears slipped from my eyes as I felt the bed holding me. I was grateful for its quiet, consistent care.

The kids went back to school two days later. I could hear Aidan harassing Roan about something and her screeching protests as they got ready that morning. They checked in on me, but I said I didn't need anything and accepted their hugs as they headed out.

A few hours after they'd gone, I decided I needed food. It took me an hour to find the will to get up, put on my robe, get to the stairs, and slowly climb down. I hung on to doorknobs and counters to get to the cupboard for a bowl, to the refrigerator for yogurt, and then to the drawer for a spoon. I shuffled slowly back up the stairs, clinging to the handrail. I had to pause halfway up to stop the buzzing in my ears and gather my strength. I couldn't have eaten more than 400 calories over the last two days. Once I got back into bed, all I could eat were two small spoons full. I set the bowl on the nightstand and curled up in

the blankets. Five minutes later the cramps intensified because the food triggered my ulcerated bowels and I had to go to the bathroom. This time, after flushing the bloody contents of the toilet, I stepped on the scale.

I'd lost another seven pounds since I'd left the hospital five days prior. I crawled back into bed and lay in a fetal position wiping my tears. I couldn't live like this. Given the stern release from the hospital the week before, and the conversation with Dr. Langdon's nurse, I knew I'd meet serious resistance to be admitted back into the hospital. But I had no idea what else to do. I called Carol to take me, but she didn't answer, so I called my brother Craig, who left work to get me there.

As I expected, Dr. Langdon refused to give the okay to admit me back into the hospital. She was clear she had no other options for me when she released me the last time. She's a surgeon, yet she never discussed the option of surgery. This was fine by me, but I needed *something*. The only way I could get admitted was through the emergency room, but I had to argue with the ER doctor about how sick I was.

He asked me, "How are your poops?"

"Painful, frequent, urgent, and bloody," I replied, my voice weak. "It's just like last week, only I've lost seven more pounds since then."

"Right, I see you were admitted here last week. So why are you back?"

What the hell? Was this guy deaf? I looked at Craig, who shrugged.

"Because I'm *worse*," I said. I couldn't have possibly looked any more pathetic than I felt, but he eyed me doubtfully. I could see he thought I was exaggerating.

"What is your pain level? On a scale of one to ten, ten being the worst pain you've ever had, what level are you at?"

This was a question I was very familiar with, but I hated it because I could never commit to one number. "It's maybe a four or a five, but

when the cramping kicks in and I have to go to the bathroom, it jumps up to seven or eight," I said.

"I see," replied the doctor as he made notes in the chart. Maybe he thought I just wanted the narcotic pain meds and to take advantage of my insurance. Whatever his reasoning, I was held in the emergency room for three hours before he finally admitted me. My brother stayed with me the whole time. It was a comfort that he at least witnessed the poor treatment I received.

Once I was settled in my room on the same floor I'd been on the last week, one of Dr. Langdon's colleagues—a young, very tall gentleman who was freakishly even less compassionate than Dr. Langdon—came to visit me.

He spoke *of* me, rather than *to* me as if I were a made-up case for his board exam. He looked at the floor, avoiding my eyes as he said, "Medical management is the only way to handle this case. Regardless of the colon, the rest of the body is too healthy for surgery. So there is nothing more we can do than what we did last week." This meant more of the I.V. steroids, narcotic pain meds, and fluids.

There was no improvement after two days, and I was beginning to suspect that I'd lost a dangerous amount of blood. I was having episodes of light-headedness when I stood up, and my limbs felt like lead. I had the same nurse, Katie, on my second and third day, and she mentioned that I was looking more and more pale. I asked Katie if she could request a hemoglobin test which would measure my red blood cell count.

"Yeah," she said, "I was just thinking the same thing, I'm sure you're losing a lot of blood. I'll send in the request right away."

Dr. Langdon promptly refused.

The next day was Thursday. Dr. Langdon came into my room to tell me that I was fine. "You're not losing that much blood, it just looks like a lot because it's red blood in a white toilet," she said.

I thought to myself, *that's not even something she's seen or quantified in any way. How can she possibly know how much blood I am losing without doing a blood test?*

She added, "And your light-headedness is just from sitting on the toilet too long. It's called a vasovagal reflex, which has nothing to do with blood counts."

This was her reasoning for not ordering a test of my hemoglobin. But I knew what a vasovagal reflex was, and I knew that it was not what I'd been experiencing.

Why is she treating me like an idiot? But like an idiot, I said nothing, still trusting her to do right by me.

"I'm going to give you until tomorrow," she said. "If there is no change I will have no choice but to either send you home, or to Madison or Milwaukee for a highly controversial treatment with cyclosporine. Or they can decide on surgery. But I won't do it," she added. She said she agreed with her colleague who said I was "too healthy" for a colectomy.

"My surgery patients are very sick people. But you are in good shape, other than your colon."

With that brisk explanation, she then spun on her heel, taking her petit 5'4" frame out of my room, refusing to take any questions from me.

I told Katie what Dr. Langdon had said.

"Wow. You make sure you write a letter to the hospital about her," she told me. She was the fourth person to tell me that.

I assured Katie that I planned on it, but in the meantime, I needed her to please get Dr. Langdon back to explain this controversial treatment

with cyclosporine and the surgery. I Googled the cyclosporine treatment and discovered it was an infusion. Yes, it was controversial, but that was all I could find. I wanted to make an informed decision. The last I'd heard of a colectomy procedure to "cure" ulcerative colitis was over five years ago. I wanted to know exactly what was involved and if there were better procedures and success rates.

A few hours later, Dr. Langdon marched back into my room and shoved a pamphlet at me.

I asked her to tell me about the surgical procedure.

She did not sugar-coat it in the least.

"There are three surgeries," she began. "The first one is to remove the colon. Then you'll have to have a colostomy bag for six months. The second of the three painful surgeries is to create a pouch out of the small intestine, which will act as your new colon, which is surgically attached to the rectum. This is all done through a large incision in your abdomen, so there will be a big scar. After the second surgery, you'll still have the bag for another three months until the last surgery. The third and final surgery is called the 'take down'—where the colostomy bag is removed and your small intestine, now connected directly to the rectum, directs the stool out of your body from the usual outlet."

With the logistics explained, she went on to say, "You'll have control issues, and leakage will be an unending curse. Some people have repeated problems with a condition called 'pouchitis' where the pouch is painfully inflamed; and about ten percent go back to the bag permanently."

It was almost laughable how she described this surgery. She presumably had devoted her life to this field, since she was a colorectal surgeon—yet she described it as a nightmare to endure, the outcome being a lifetime of shit. Literally.

She was clearly trying to deter me from having the surgery—which was fine by me. I didn't want it anyway, and certainly not with her.

I couldn't stop thinking of my newfound love of pole dancing. Would that be impossible after this surgery? I mean, I have to exert myself to get up on that pole, so would I be able to keep it all together? Or would I mess my booty shorts every time I inverted, requiring me to wear a diaper or large pad? Could I even pole dance with the bag on my hip if the surgery was unsuccessful, and I had to have a bag full-time? And sex? What the hell would dating be like with a bag on my hip? How sexy is wearing a diaper to bed to manage the leakage? It all sounded horrifying, and not anything I wanted to have any part of. I had healed my body of this damn disease many times, and I could see no reason why I couldn't do it this time, too.

"Either you go home tomorrow, or to Madison or Milwaukee," she said. "There is nothing more I can do for you."

"I'll go home, then, but I need at least one more day to get everything arranged at home so I can be by myself and heal. The patient advocate for my health insurance tells me that I have the right to insist on an extra day."

"Fine, then, I'll prepare for your discharge on Saturday," she conceded.

I decided it was time the kids went to their dad's instead of coming back home with me. I would deal with the collateral damage they'd suffer after I was healed. Concern for my kids had previously blinded me from that option because I knew they wouldn't want to be with their dad full-time, indefinitely—especially Aidan. He had been exhibiting behaviors that indicated serious emotional turmoil, and the last place he needed to be was at his dad's.

I'd ask my friends to keep the dogs and Snickers the cat would go with the kids to their dad's. I gave a grocery list to Marty and Aidan still

had my debit card so they could stock the kitchen with a week's worth of food. I was determined to be home with no one there to stress me out, believing that alone time was the key to my recovery.

I was nervous about going home. Though I couldn't explain it, I just didn't feel well enough. Of course, I was sick and in the hospital, but something else was off. Katie mentioned again that I was even more pale, but I wouldn't let myself worry about that. I was a trooper. I was going home the next day with the ultimate self-care game plan. I'd focus on healing myself since modern medicine wasn't doing it. I chanted to myself that I'd be fine. I believed whole-heartedly in mind-over-matter and manifesting intentions. I convinced myself that I could do it, that I could tap into the meditative practices I'd learned over the years—even though I'd never felt fully successful at meditating—and I would heal from within. With the kids at their dad's, I thought it could be done. I thought I could will my colon to heal, as long as I didn't have to worry about anything else. I was determined to keep it in my body.

Around 7:00 PM that evening, every time I left the bathroom, I'd hardly be settled back in bed when the urge to go again overcame me. I'd get back up, drag the I.V. stand with me, and go again. I felt increasingly more light-headed with each trip. The nurse attending to me that evening became very concerned and turned on my bed alarm so it would sound if I got off the bed without first calling for help. She wanted me to have an escort every time I went to the bathroom in case I passed out.

I laid back in the bed again, hoping my body would give me a break for just fifteen minutes, when immediately the urge to go came on more intensely than ever. Exhausted, I sat up, hit the call button, and was immediately doubled over, holding my breath as a pain as sharp as

a dagger shot through my left side. My efforts to hold it in were futile, and the pain was worse than anything I'd ever felt. I could feel the hot thick excrement coming out of me as I sat there, despite all my efforts to keep it together until the nurse could get me to the bathroom.

I started to stand up. As the bed alarm sounded, to my horror, I lost complete control. Blood and stool gushed out of me completely unchecked as it was suddenly everywhere, the bed, the sheets, the floor—and I began to lose consciousness.

Then I saw that the nurses had ahold of me as I was slurring my apology for the mess. I sensed them half escorting, half carrying me to the toilet. The CNAs had begun to clean the mess, but their efforts were pointless, as it just kept coming out. I cried out in pain as I felt again the sharp stab in the left side of my abdomen jolt me back to consciousness. I knew then what level-ten pain felt like—the worst pain ever.

The next several hours had a twisting, dream-like quality. I floated in and out of consciousness as the nurses cleaned me up, changed me out of my blue nightgown from home, and put me in a diaper and a hospital gown. I marveled at how quickly they moved to change the bed, wipe down the side rails, and mop up the floor all while taking care of me. There was a flurry of staff in my room, asking me questions about the pain level, sticking me with a needle several times, struggling to draw a blood sample from my scarred veins—finally, the blood sample I'd been asking for them to take for the last two days—and they were taking and retaking my vital signs.

The blood test came back quickly. My hemoglobin was 4.1. I knew anything under ten calls for a blood transfusion. It had been seven the last time I was admitted for an emergency transfusion five years earlier.

I knew a 4.1 was serious.

The whole night there was a quiet murmur of activity around me. I was aware that I was a part of that activity, yet I felt oddly separate. Everything was a blur. I didn't sleep, but I wasn't always awake. Unable to get the I.V. started for the transfusion because my nearly bloodless veins had collapsed, they wheeled me in my bed down to the ER to have a pediatric anesthesiologist with an ultrasound unit get the job done.

As he injected an anesthetic to offset the pain of what he was about to do, I cringed, looked away and noticed a dark-red, nickel-sized spot on the side rail of my bed. I stared at the spot. A rush of excruciating pain shot through my hand as the surgeon worked to get the I.V. in. The anesthetic did nothing, and the agony of three attempts to get the needle in my vein dragged me out of my daze.

I continued to stare at that spot. It was clear evidence of the drama that had unfolded the evening before. It drew my attention to the heaviness of what I was experiencing. The blood—its refusal to be wiped away—demanded that I not diminish the horror of what happened. It wouldn't allow me to forget the suffering. It was like a memorial erected on a battlefield to mark the life-and-death battle that was taking place.

But as soon as I saw it and let its truth in, I slipped back into semi-consciousness. I had to let it go. It was all too much to hold.

The first unit of blood finally dripped into my veins around 6:00 AM. At some point after it started, Dr. Langdon came in to see me.

I was barely aware of her at first, but then I heard her ask, "So, you chose to bleed out on me?"

I stared into her eyes. *How absurd*, I thought, wondering how she could be a doctor at all when she had zero compassion for human beings.

My family was there—my siblings Carol, Christina, Craig, and my kids. I trembled when I saw them. Roan and Aidan came to each side

of me and held my hand. Everyone tried to be upbeat, but there was a disquieting sense of alarm surrounding me.

It was announced that I would be transferred to the University of Wisconsin–Madison teaching hospital via ambulance as soon as possible. Carol immediately said she would stop home for an overnight bag and meet me down in Madison.

After two units of blood were transfused into my veins, more blood was drawn to test my hemoglobin. They said I was going to need more blood, but they needed to get me to Madison. So the powers that be gave the necessary approval to allow the third transfusion to be given in the ambulance.

Still swimming in a surreal existence, having a vague awareness of what was happening, I found myself in the ambulance dreading the two-hour, bumpy, bouncing gurney ride to the hospital. The pain in the unmoving hospital bed was bad enough, but being jumbled around for two hours was going to be unbearable for my ulcerated insides, no matter how much Vicodin they gave me.

The driver told me with regret that unfortunately, it was going to be a rough ride, but that he and his partner would do whatever they could to make me comfortable.

As the third unit of blood dripped, I felt life begin to seep back into me. I felt stronger and more aware. I focused on the top-left hinge of the ambulance door as reality set in. I sensed the EMT sitting behind me the same moment I felt tears slide out of the corners of my eyes. For a second, I thought I should wipe them away so as not to make her uncomfortable. All at once, I decided her discomfort was not my concern. My tears were justified, and I allowed them.

I realized that I had almost died.

If I had been home as Dr. Langdon had initially intended, I would have passed out on my way to the bathroom and bled out before anyone found me. My kids would have been devastated enough to have their mother taken from them, and then they also would have been at the mercy of their selfish father.

All of which was frightening enough. But my tears were only getting started. My crying continued for the entire two-hour ride as I found myself staring at the scariest truth I'd ever faced: I didn't love myself.

I had lied to myself about relationships that were not loving, and now the fight to get love from others was literally killing me. Marty never loved me. I lied to myself that he did, and when it was clear he didn't, that reinforced my belief, which initiated another lie that I didn't deserve his love.

What was bearing down on me in that ambulance was the dawning realization of how much effort I had put into lying to myself. I had lied to myself to such an extent that I had put *my complete trust* in Marty to love me—because that was easier than loving myself.

I shuddered as I came to truly understand that I was going to have to *stop*—every lie, every action, every damn daydream and justification I had. I had to *stop* saying that he was not that bad, or that he would eventually love me enough to understand my pain if I could only explain it well enough.

I had to stop the lies—because they were killing me.

The lies I'd told myself about love, the lies I'd accepted to feel loved, and my need to be validated and understood—all that was the opposite of loving myself. I'd lost control of my body because I needed to give up trying to control everything with lies.

I sobbed loudly. I felt a pat on my shoulder from the EMT attending me as I imagined my funeral with my children and family in shock and my ex-husband crying crocodile tears for all to see as he mentally spent the money my death afforded him.

I didn't know how in the hell I was going to stop being a love liar, but I knew that my life depended on it. My kids' lives depended on it.

Discussion Questions

- What ailments do you have? What is your body trying to tell you?

- Can you quiet your mind and listen to your heart? Can you believe what it says?

CHAPTER 20

Resolution

You need chaos in your soul to give birth to a dancing star.
—Friedrich Nietzsche

I was immediately struck, even in my stupor, at the obvious compassion I saw in the doctors on my case at University of Wisconsin–Madison Hospital compared to the indifference of Dr. Langdon. I was at a teaching hospital now; I had four teams of doctors, all of whom came to see me that first day—and nearly every day after that. I had general interns who came in first; then a gastroenterologist team, then student residents; and finally the surgical team.

Everyone braced me for the surgeons. They all respected my intense desire to keep my colon, and warned me that meeting the surgeons might feel threatening. I understood their point. But it was a good idea to at least meet and get comfortable with them, just in case. I listened to the surgeons, and heard their respect for me and my challenge, but after they left, I began to cry. I wept not only with the sadness of potentially losing my colon, but also with relief because of the humanity and grace they had shown me.

Carol showed up just after I was settled into my room. My heart swelled to see her. There's nothing like standing on the brink of tragedy to help you shove aside the shit and fall in line with the unconditional love that underlies our existence. I had no hard feelings for her.

I couldn't stop thinking about my death—how my kids would have had to depend on their dad if I didn't make it. I hated to think of them living full-time with a man who had the uncanny ability never to consider anyone else's needs but his own. This man, had I died, would have gotten all the proceeds from the sale of house. And he would have been in charge of the kids' 300,000-dollar life insurance policy, because I had not yet moved it into a trust.

All of this information was brutal—it was unfair, and grievous—but as I lay in the hospital bed in Madison with my sister by my side, I knew now that I was going to survive. I was thankful to be alive, and I knew, no matter what, that everything would be okay. I knew that eventually my life and my kids would be *better* than okay.

I tried to get reports of what was going on at home. Marty had decided it was easier for him to stay there with the kids and the pets. But I didn't get much information on how it was going.

I asked Aidan on the phone how things were.

"I don't know, Mom. He's sleeping in your bed, and he's just...." He trailed off.

"He's what, sweetie?" I implored.

"Never mind, Mom. It's fine. Just get better and get home, okay?" He quickly added, "I gotta go. Love you, Mom!"

Roan was my cheerleader. She sent me a YouTube video of the song by Kesha called *Woman*. It empowered me to be strong and not take shit from anyone. *I don't need a man to be holding me too tight / I'm a*

motherfucking woman, baby, that's right. And Bishop Briggs' song *Dream* inspired me to keep my faith in love: *I wanna wake up where your love is.*

Aidan, on the other hand, fighting another battle with his life-long nemesis—his father—worked hard to keep me from knowing and worrying about his own pain, so that I could heal mine. He'd developed defiance issues that had gotten him in trouble with classmates, teachers, and even the law on occasion. I knew he was getting into trouble with drugs, too. Marijuana at least, and maybe more. I also worried about how he was doing in school. Before I got sick, he was passing all his classes with Bs and Cs, even in math. Junior year is the hardest—and he was doing better than I expected—but he didn't handle stress well. I knew I needed to concentrate on healing myself, but I couldn't help but worry.

I was two hours away from home, but I got a lot of visitors. My sister Christina came for a visit, bringing my dad along. He had insisted she bring him, although he was barely healthy enough to make the trip. He wanted desperately to see how I was really doing. He berated himself for not being available to help me as he did for me when I first flared up seventeen years ago.

My dad loved me because I was a good girl; but I also knew his love for me was real and genuine.

Michael came to visit, too. He had visited me in the Appleton hospital as well; but it was deeply heartening that he had come all the way to Madison to see me. I knew he regretted how things ended, as did I.

Everyone at the UW–Madison Hospital was on my side. They all supported my decision to fight for my colon. One of the resident doctors, Victoria, went out of her way to understand my reluctance to have my colon removed.

She sat by my side one afternoon and delicately asked about the details of my resistance to surgery. "I can't imagine the pain and suffering you're going through," she said. "You've gone through this off and on for seventeen years, yet you don't want the surgery that will essentially cure you of this plague. Why is that?"

"Oh, God," I sighed. "For one, yes, I've dealt with this off and on for seventeen years, but I've healed from it every time! I just can't let go of the hope that I could heal from it this time, too." I paused before continuing. "I was devoted to a man for twenty-seven years who never should have married me. A man who began cheating on me within the first four months of our relationship. He took nearly everything from me. He sucked out of me what little self-esteem I had. He never loved me—and he used and abused the best part of me.

"But I broke free," I went on. "I got out of that marriage two years ago and I've been living my life. Finally, at fifty, I'm finding myself and learning to love who I am. Plus, I discovered pole dancing, which I *love* and I'm good at. And I found that not only do I love dating and sex, but that I'm also pretty good at them.

"And neither of these activities seems compatible with having a bag of shit on my hip! I know the intention is to have more surgeries to remove the bag, but what if I still have problems? The doctor I had in Appleton told me I could have a lot of trouble with leakage. What if I end up in a diaper all day and I can't continue to pole dance? What if my confidence in dating is interfered with?

"I know this is overly dramatic, but if a life of shit is what I have to be resigned to, well, I feel like he would win. Like the shit-that-is-my-ex-husband will have ultimately beat me. And I'll never find happiness." I let out a sob.

I hadn't stated my fears out loud until that moment. The misery of it all came crashing down.

Victoria heard me. She didn't disrespect my pain by dismissing it because it made her uncomfortable. She let me have my pain and express it all. In so doing, she was a great comfort to me.

The next day was Sunday, Victoria's day off, but she came in to see me anyway. "I thought a lot about what you said yesterday," she started. "Your fears and concerns make a lot of sense and I appreciate you sharing them with me." She put her hand on my forearm. "I did some Googling and thought I would show you this." Victoria held her phone in front of me to show me a photo of a woman bodybuilder in a bikini with a colostomy bag displayed in full view. The woman made no attempt to hide the bag.

"Now, I realize she's not a pole dancer like you—which is very cool, by the way—but she's obviously living an active lifestyle, and very successfully. Remember, if all goes as planned, you won't even have this bag after a few months."

I looked at her to go on.

"I can imagine how daunting it is to think about dating with all this—but think of how much higher caliber of a man you will find who will understand and accept what you're dealing with. It will naturally help you weed out the assholes," she added with a laugh.

"I'm sure you're right about that. I'm sure you're right about all of it," I said. "I really appreciate your thoughts on this, Victoria, and especially coming in on your day off!"

"Ahhh!" she said immediately, "Don't even worry about it! I had to finish some reports anyway. I just thought that—even though I have no idea what you are going through—I could maybe help you see some possibilities in life after the surgery. Rather than obstacles."

No one was giving up the fight just yet, however. The gastroenterology team fought with my insurance company to cover an outrageously expensive treatment called Remicade. There were significant side-effects expected, and my body might reject it causing a possible anaphylactic response. But the specialists thought long and hard about it, and we decided it was in my best interest to give it a shot.

I was in the hospital in Madison for nearly two weeks before they were able to give me the first dose of the drug. There were a number of things happening in those two weeks before the Remicade route was taken. When I first arrived from Dr. Langdon's questionable care in Appleton, I needed yet another blood transfusion, making it four transfusions total. Losing that much blood took a serious toll. I needed time to gain some strength back for this therapy, which included a liquid diet to give my colon a break. There was also a reason to hope that continued intravenous steroids along with the liquid diet might eventually quell the inflammation in my colon and diminish my symptoms, so they allowed time for that.

In the two weeks before the looming Remicade treatment, I began to place a serious amount of hope on the drug. I prayed for it to be the holy water that would expel this demonic disease. It was finally administered on a Friday. By Saturday, I had good reasons to be optimistic. I went for over seven hours before having to go to the bathroom, and there was definitely less blood.

But that evening was another story. Everything went back to what it was, exhausting me.

Sunday wasn't much better. The disease refused to be exorcised.

On Monday, the internal medicine doctor who oversaw my case came in to see me. He had gotten updates throughout the weekend

about my progress. He had championed my recovery without surgery and seemed to place as much hope as I had on the Remicade treatment.

But when he entered the room, I was aware of his surrender.

I was in awe of his diplomacy as he gently broke it to me—not enough to smack me with it in case I wasn't ready.

I didn't know this man outside of this setting, but I could feel his love and compassion for me as his patient. I knew the jig was up and surgery was inevitable, but he and I both recognized the need to give me time to process that fact. It was a giant shift for me to surrender my hopes for the Remicade treatment and contemplate the surgery—not as a thing to be avoided, but to be embraced.

I always process decisions better with writing, so at 3:00 AM that Tuesday morning, with Facebook as my platform, I wrote out my decision:

I believe in the power of positive thinking. I believe in mind over matter. I believe "where there is a will there is a way," and I believe in prayers—all of your prayers that you've sent my way. In essence, I have faith, as those religiously inclined would say.

I've done a great deal of soul-searching these last few days to make the decision to have surgery. I'll admit, I was tempted for about a minute and seventeen seconds to think that I had lost the fight. To give up my faith and succumb to self-pity. But where does that get me? That gets me bitterness, resentment, and more pain—which will only show up in some other form.

This decision to have surgery feels amazingly right. Despite my tears, I know that this surgery will bring me a life that I have no idea of, but I embrace it with full gusto. And I believe I will be living the second half of my life in much more peace than I have the first.

I've been in the habit my whole life of fighting for my will. Of deciding something should be a certain way and controlling everything toward that

ideal. But that is my will, not my heart telling me what to do. This time I'm following my heart. Yes, I suppose I needed to come dangerously close to losing my life in order to realize this. But my will is strong and stubborn and ultimately, not serving what is best for me, for my heart, for my soul.

The day after the two-year anniversary of my divorce—on Thursday, April 26th, 2018—the surgery to remove my entire colon and most of my rectum took place. My surgeon was a very sweet, very pregnant and dedicated surgeon whom I'd met on my first day at the UW–Madison Hospital. When I first met her, I refrained from paying too much attention to her because I was devoted to not needing her services. However, as I got to know her over those weeks in limbo, while she patiently awaited my decision for surgery, I grew to feel very confident in her and her abilities. After the surgery, she assured me that my decision to have my colon taken out was undeniably the right one.

"Seriously, it looked like dog food," she said, shaking her head.

Recovery was tough. I couldn't imagine the pain could be worse, but it was, and I had nausea and vomiting for several days. I was still very weak. My hemoglobin level was under ten, causing the medical team to debate over whether to give me another transfusion. The doctors assigned me to the task of walking the halls three to four times a day to help me gain some physical strength. I knew it had to be done, but the gumption I needed to collect in order to push me out of the bed was immense. I was grateful to the nurses for enforcing the directive.

I also listened to music on my headphones and lost myself in the fantasy of dancing, and spinning and inverting on the pole. In my mind I had the strength, coordination, and grace to do all the steps and tricks. I engaged in this for hours in my mind as I lay in the hospital bed too weak to read or even watch TV—and it always made me feel better.

My team of doctors decided that despite the low hemoglobin level, they would send me home without another risky transfusion. They gave me a prescription for iron and discharged me on the 2nd of May.

I had pushed for the decision to be sent home. Roan had signed up to be in the school talent show on May 3rd, which was also Aidan's seventeenth birthday. I badly wanted to be home for both. I was in the hospital for a total of thirty-five days, including those days in the Appleton hospital. That was enough. It was time to go home.

The colostomy bag was a new adventure. I was grateful not to have to keep running to the bathroom, but the bag freaked me out. Twice a week for the first two weeks I was home, a nurse came by to help change it and acclimate me to my new life without a colon.

My challenges were not yet over. I still had to sell my house, find a new house to rent, contend with my ex-husband, raise my children, and heal my very fragile body and heart—but at least I was home. No more uncomfortable hospital bed and 6:00 AM blood draws. Although I did miss having my meals brought to me three times a day.

One day out from the hospital, I was determined to see Roan's performance in the school talent show. Sitting in the passenger seat while Aidan drove us to the school where Roan had already arrived with her dad, I felt feverish and weak, but excited to see my daughter on stage. When we got to the auditorium steps, Aidan offered me his arm for support as we walked up the stairs. The room began to spin slightly once we got in the building. We found seats quickly so I could sit down. I closed my eyes to settle my head and wondered how I was going to make it through to Roan's performance, which was scheduled toward the end. When I opened my eyes, I saw my sister Carol and my brother Craig waving at us from several rows

down. I smiled, motioning that I would relocate to where they were since they were closer to the stage.

Roan had been preparing for this show since before I went into the hospital. She was very secretive about it, but I knew it was a solo dance piece. She had done a similar performance the year before to Beyonce's *Pretty Hurts*. I was so damn proud of her ability to put herself out there and be who she is without apology, and this performance was no exception. My niece helped her order her outfit for the show, a black leotard with a long, flowing, made-to-be-tattered skirt. The song she danced to was Lady Gaga's *'Til it Happens to You*. She hadn't had any formal dance lessons since the ballet class I'd signed her up for when she was five, but that didn't stop her from dancing on an auditorium stage with her own choreography and putting all her heart and soul into expressing what she needed to express to this haunting song. *'Til it happens to you, you won't know / It won't be real (how could you know?).*

The song itself was a very purposeful choice, although I didn't press her on her reasons. I appreciated that she had her own drama, which undoubtedly classmates were judging her for. I knew she'd been bullied by the boys in her class for her early breast development and the inevitable weight gain associated with puberty. She got that from them at school, and then at home her brother who taunted and bullied her. I lost myself in the song's message as I contemplated its meaning. Despite all my efforts to be a good mother, I couldn't protect her from all that bitterness.

Tears rolled down my cheeks as I watched my daughter. I watched her enviable hourglass figure passionately displaying her anguish— through spins, fist punches, and head drops—collapsing to the floor and then triumphantly raising back up to declare herself a fierce survivor

of others' judgements. *You tell me it gets better, it gets better in time. . . . 'Til it happens to you, you don't know / How it feels.*

Roan had worked through the bullying I was unable to prevent. She had grown into one of the strongest people I know. My daughter learned at thirteen what I had nearly killed myself to learn at fifty: You can't love yourself when you're so desperate for love and validation from others.

The message was clear: Give yourself validation. Give yourself the love and respect you need. And distance yourself from those who can't or won't.

Discussion Questions

- What are you afraid to do? Can you let go of the fear long enough to step back and question why you are afraid to do it? Once you can break down why you're afraid and get a better perspective of it, the fear will no longer have power over you and you can make decisions from a place of clarity. Once you dismiss the fear, you are free to move forward.

- What can your fears teach you about yourself? When will you know that you're ready to dismiss the fear and finally do the thing that you were afraid to do?

CHAPTER 21

Seeing the Light

Open your mind and clear it of all thoughts that would deceive.
—A Course in Miracles

I had a second surgery in September of 2018. I still had the colostomy bag after that surgery. The new internal connection needed eight weeks to heal until the third surgery. That surgery, called the "take down" was where they removed the colostomy bag on my hip and allowed my digestive system to eliminate from the usual outlet. It was supposed to be the last surgery, but I continued to have problems. In spring 2019, I needed the bag back temporarily as I underwent two more surgeries.

Healing my mind wasn't going to happen overnight either. My old habits of thinking and coping were going to take diligence and persistence to change, but I was determined to do it. I began to read books to learn more about codependency as well as narcissistic personality disorder.

I knew that the epiphany I'd had in the ambulance—about the lies I'd told myself while seeking the love, compassion, and approval of others—was immense. But now I needed to put what I'd learned into daily practice, to create a lifetime habit of self-love. I needed to

do serious work to understand why I'd lied about love so consistently. I needed to know how to break the habit of lying to myself, and how to ultimately give myself nothing but genuine love. If I could give such love, compassion, and approval to my kids, then I could do this for *myself.*

The first book I read was called *Why Does He Do That? Inside the Minds of Angry and Controlling Men* by Lundy Bancroft, a counselor who worked extensively with abusive men and their victims. I recognized my ex-husband in this book as surely as if his picture were in it. I'd identified him as a "Water Torturer" style of abuser. "If you are involved with a Water Torturer, you may struggle for years trying to figure out what is happening. You may feel that you overreact to his behavior and that he isn't really so bad. But the effects of his control and contempt have crept up on you over the years. If you finally leave him, you may experience intense periods of delayed rage, as you become conscious of how quietly oppressive he was."

This book also detailed for me the notions of "victim shaming" and the devastating support that well-meaning loved ones of the victim will give the abuser by adopting the abuser's perspective. This reminded me of a comment from Jenna that had cut me so deeply when I'd visited her after the divorce.

"You know, Carin," she had said, "it takes two to make a marriage work, so I think both partners should take responsibility when it doesn't." She was empathizing with Marty in that instance. But how could she forget that she'd said to me often, "I don't know anyone who has worked harder on their relationship than you"? She had been with me through everything from the beginning with Marty, but she still gave him the benefit of the doubt despite the infidelities.

I knew I couldn't blame her for not understanding the codependent–narcissistic dynamic we were engaged in—because not even I understood it then, but she did judge me harshly with no regard for my heart. In the spirit of my codependence, I gave her the title of "best friend"—ignoring every comment and action she delivered over the years to contradict that title—because once again, I was fooling myself into believing that I needed her love no matter the cost.

I read in Lundy Bancroft's book about a statement that someone sympathizing with the abuser might say: "You should show him some compassion even if he has done bad things. Don't forget that he's a human being, too." This reflected Jenna's opinion. The author went on to say that he had "almost never worked with an abused woman who overlooked her partner's humanity. The problem is the reverse: He forgets her humanity. Acknowledging his abusiveness and speaking forcefully and honestly about how he has hurt her is indispensable to her recovery. It is the abuser's perspective that she is being mean to him by speaking bluntly about the damage he has done. To suggest to her that his need for compassion should come before her right to live free from abuse is consistent with the abuser's outlook."

After reading in Lundy Bancroft's book, I knew then without a doubt that the most loving thing to do with regard to Jenna was to stop explaining myself to her and simply to release her and her judgement from my life. And so I did. She confirmed my decision by calling my accusations "bizarre," refused to discuss it with me, and unfriended me on Facebook. The more I read, the more I came to see her true colors as vividly as I was seeing Marty's. I saw how devastating my codependent needs were in our friendship. Learning that fact broke my heart, but it gave me the salve to mend it at the same time. My clarity showed me

that although truth can obliterate a facade, it also gives you the building blocks to construct the real thing.

The Lundy Bancroft book blew away the fog of lies I'd lived in for years. Now I needed to read much more to keep the fog away. So I also read *Becoming the Narcissist's Nightmare: How to Devalue and Discard the Narcissist While Supplying Yourself* by Shahida Arabi; *The Journey: A Roadmap for Self-Healing After Narcissistic Abuse* by Meredith Miller; *The Covert Passive Aggressive Narcissist* by Debbie Mirza; *Out of the Fog: Moving from Confusion to Clarity After Narcissistic Abuse* by Dana Morningstar; and *Complex PTSD: From Surviving to Thriving* by Pete Walker.

I also signed up on the notable question-and-answer website, Quora, to read countless accounts of victims of narcissistic abuse who were, I discovered, much like myself. I read of women and men who were in decades-long marriages suffering all kinds of auto-immune illnesses, severe depression, anxiety, and pain of all varieties—which couldn't be directly blamed on their partners.

That is the rub of covert abuse: a direct correlation between how a victim is suffering and what the abuser is doing is maddeningly difficult to nail down. I was so often told by others that my husband was the "nicest person." This was typical of what I found in countless Quora posts from victims. Their abusers usually had a large social media following, people who bought their bullshit posts demonstrating how caring and doting they were to their family and loved ones. I was reminded of how Marty had everyone fooled into believing he was caring for me when I was sick, when in fact—where no one could see—he was doing everything possible to do the opposite.

Of everything I read on people with narcissistic personality disorder (NPD), the most painful truth—which freed me from my own lies of

believing otherwise—is their inability to have empathy, compassion, or genuine unconditional love. That is the piece I never fully grasped until I read all the books I'd found on the condition. That was what I was literally killing myself for: Marty's non-existent empathy. There is a study published in the *Journal of Psychiatric Research* that details how the area associated with empathy in the outer layer of the brain's cortex is measurably thinner in those afflicted with NPD.

This is how Marty's lack of empathy devastated me. It was very subtle, and much like a slow-acting poison. It got into my system and started to methodically break down the functions I needed to thrive. Marty's gaslighting and manipulations, and his complete lack of regard for how much it would hurt me, eroded my emotional foundation until I consistently beat myself up over my husband's unhappiness. I took full responsibility for his unhappiness and gave him everything I could while never considering what it was that *I* wanted. It was as if I were hitting myself over and over again.

There is a great deal of literature out there—as well as contributions on Quora and on the website Medium—where narcissists are vilified. I certainly understand the instinct to do that. However, beyond the initial validation of the problem I had seen in Marty, the anger and blame I adopted from those writings actually became a deterrent to my healing. Once I educated myself so that I had an understanding of narcissism, and I accepted the fact that I had actually been abused, then I was able to embrace my own diagnosis of codependency.

On Quora I discovered a psychologist by the name of Dr. Elinor Greenberg who specializes in the treatment of personality disorders. She is the author of *Borderline, Narcissistic, and Schizoid Adaptations: The Pursuit of Love, Admiration, and Safety.* She has contributed countless

answers to questions on Quora about narcissism. Her counsel through those answers was a huge factor in my healing because she helped me to see Marty in a different light. She helped me to see just how tortured someone's soul truly is when that individual shows an insufficient capacity for empathy. Not only can narcissists not have empathy for others, they also cannot have empathy for themselves. I know now more than ever how horribly tormented that must be for a narcissist.

Empathy can often be the codependent's kryptonite in an abusive relationship. My empathy for Marty was dysfunctional—in that I'd sacrificed love for myself as I gave it to him. I found that once I turned that empathy and love onto myself, then I could also find a *healthy* compassion for Marty's struggles. I learned how to turn my empathy—my ability to love myself and others—into my super power rather than my kryptonite.

In this process I also came to know better than to attempt to explain to Marty that I empathized with his problem. That is the difference between the empathy I gave to him before and what I did after I became enlightened. Before, I gave it to him and he took it without returning it—and I accepted that; afterwards, I could give it to him from afar and thus protect myself from his dysfunction and heal my own heart.

As I understand it, the psychiatric community is still debating and striving to define narcissism and other personality disorders, and treatment of these afflictions is still controversial. I often read that the general opinion is that they cannot be treated. However, Dr. Greenberg does not let this belief deter her; she works with her patients and their significant others with a healing compassionate attitude—with the conviction that every soul needs compassion to thrive. I'm confident that her work and the work of others in the field will bring us all to a better understanding of this menace, and to better ways to manage it.

In all my research, what became increasingly evident to me was that my personal diagnosis—that Marty has a narcissistic personality disorder—doesn't matter one way or the other. I'm not a psychiatrist so I can't officially diagnose him. What matters is that I have relinquished the blame, and that I understand my role in the relationship. I take responsibility for the lies I told to perpetuate the cognitive dissonance our marriage created. That step—of holding myself accountable—has become a great source of peace for my mind and reinforced the love I have for myself. I've made the changes necessary so that I will never again be a victim.

While I've done that work for myself, I believe Marty has found some peace as well. He's attempted many times in the past year to gather Aidan and me together to apologize. He has finally come to realize just how shitty a husband and father he had been and he wanted to make amends. His awareness emerged after Aidan cut off all contact with him, and his girlfriend finally broke up with him for the last time.

I've told Marty that I won't listen to his apologies—and neither will Aidan—because it's too traumatizing given all the heartless apologies we'd received from him over the years. However, I respect his assertion that he has changed—or at least that he is genuinely trying to change—because he's finally recognized that his old pattern of being isn't working for him.

I've suggested to him that instead of apologizing, he ought to simply move forward to build a relationship with Aidan. I frankly don't need his apology; I just need him to be as much of a father as he can be to our children. If he can let go of who he was and be who he's trying to be for both his children, I believe we can all blossom into forming healthy relationships. We can free ourselves from the legacy of a perpetually dysfunctional family dynamic.

It seems to be working. His relationship with Aidan has resumed and I know Aidan has grown from it. And that's all that matters to me.

Between each of the surgeries, I never allowed my pole classes to lapse. The minute my surgeon said it was okay, I was back on the pole gaining back my strength and advancing my skills. I knew I'd have to stop again for another six weeks with each surgery, but I was not giving up on pole because for me it was a very important form of self-love.

When I still had the colostomy bag I had my instructor take a photo of me on the pole. The bag was invisible, tucked in the waistband of my booty shorts as I was upside-down in a pose called "the bat" where my legs were wrapped around the pole holding me on as my arms were flayed out like bat wings. I put that photo into a 5x7 frame and gave it to my surgeon. I told her she could use it to show anyone else who was as scared as I was about having a colostomy bag so that they could see just how exciting life can be with a bag of shit on their hip.

In June, the house finally sold. With my childhood home and all its painful memories now in the hands of a new family, I moved—with the kids, the poodles, and the cat—to a rented house in Appleton. It was a perfect spot for my recuperation. Severing the ties of home ownership and renting the new house allowed me to realistically, finally, look to a future outside of Wisconsin. Our new place had a screened-in back porch with a lovely landscaped yard on which I spent every warm day I had, while dreaming of a permanently warmer climate.

It was great place for recuperating from what turned out to be a total of five surgeries over fourteen months. I no longer had the ghosts of my childhood and my marriage accosting me around every corner.

The house gave me a whole new perspective on life as I kept my mind open to new adventures.

My kids had their own healing to do. They believed their Aunt Carol blamed them for my illness and ultimately for my near death. They'd suffered many harsh realities of their own when I was sick while no one paid attention—which played out in Aidan's failing grades, his attempts to self-medicate with marijuana, and his scrapes with law enforcement. I also watched Roan's self-esteem issues drive suicide ideations to such a frightening degree that I had her see a local therapist who was able to work with her face to face, unlike her sessions with Ruth.

As a family, we still had a long road ahead of us. But we would survive. The lessons I'd learned from my childhood and marriage bolstered my commitment to making sure my children worked with a therapist, so that they could learn how to avoid the years of heartache I had endured.

After my dad suffered a stroke in March of 2017, my siblings and I moved him to a senior care facility. One day I visited him there after I'd gotten my strength back from my first surgery. I mentioned the latest anecdote of my ex-husband's callous behavior and explained how much better I was getting at not letting it affect me. He sat in his blue Lazy-Boy recliner and listened, then motioned for me to sit in the chair next to him so he could hold my hand.

He paused to collect his words. Then he said, "He's done a lot to you. Anyone would be jaded, but you're better than that." As he squeezed my hand for emphasis, he added, "Damn proud of you!"

Tears welled up in my eyes. I suspect he knew he'd made serious mistakes as a parent. I was one of the "good" kids, so I never doubted

his love. But it always pained me how conditional his love was and how so many of his kids didn't receive it because in his eyes they didn't earn it. However, this wise observance from him showed me that with age, he may have developed a deeper understanding of how to love without conditions.

Even if bad things happen to you, or if people do awful things to you, you can choose not to allow it to kill all the love in your heart. Dad inadvertently taught me the difference between conditional and unconditional love; and perhaps in the end, part of him learned the difference from me, too.

Dad passed away on Cinco de Mayo, 2020—with never a deeper conversation about love. But every time I saw him he was adamant to let me know how very much he loved me. I like to think he was pouring onto me the love that he hadn't been able to give to those children of his whom he'd deprived of love (the ones who had understandably refused to see him anymore). In spirit, I passed that love on, even knowing I would never convince my brothers and sisters who'd suffered his contempt that in the end he had at least tried to give his love.

I will hang on to that as I maintain nothing but unconditional love for myself and others. I credit my father as one of my best teachers of that lesson.

Discussion Questions

- Knowing you're abused is imperative to breaking free and healing; yet wasting your energy trying to make sure that your abuser takes responsibility for the abuse will keep you stuck—and nowhere near healed. Can you commit to your heart—commit to yourself—and let go of your need to explain to others how much you've been hurt? Can you let go of blame and take control of your healing?

- What lessons have you learned from those people in your life who have caused you grief? Can you be grateful for them even if they've passed on? Or even if for some other reason you can't tell them directly? Even if you know they won't receive your gratitude, can you forgive them?

- Have you identified the love liar in you, and given it the compassion and space to speak the truth you need to hear?

EPILOGUE

The only good soul is a lost soul, and only a lost soul
can find its way home.
—Trebor Healey, *A Horse Named Sorrow*

When my dad passed away I was free to let go of Wisconsin in pursuit of new adventures. I had been his power of attorney—in charge of him and all his finances—so when he passed, I had nothing more to keep me from living my future unknown life.

I'd decided against California. As many Californians were doing, I followed their trail to the live music capital of the world: Austin, Texas.

Sunny had passed away a month after my last surgery eighteen months prior. That sweet, curly, black poodle broke my heart when he died. I'd never had a dog more attentive and connected to me. Whenever I had to get up in the night to use the bathroom he'd get up with me and watch me from the bathroom door. When I was home recuperating, I was never out of his sight. I believed he was in my life during the most challenging years for a reason. When he passed on it was as if to say, "You've got this now, Mama. You'll be more than okay."

I felt the support of his and my dad's spirits with us in January 2021 when in the midst of a pandemic, my babies and I loaded up two cars all the way to the dome lights—with all we'd need in our rented house in Texas before the moving van arrived with our furniture. Roan and her boyfriend Caleb were in her sedan; Aidan, Dixie, and Snickers were

with me in the SUV. I also had my pole packed in my car. No way was I going to leave that to the movers. Nine-foot ceilings were awaiting me in the new house I'd rented in Texas. Not quite high enough, but better than what I'd had in my basement in Wisconsin. There would be plenty of room to spin, invert, and continue practicing my tricks.

The first night of our journey to Austin we stayed just outside Chicago. We'd been to Chicago several times, so the excitement didn't quite set in until we got out of Illinois and into Missouri. As Aidan and I searched for our Airbnb in Memphis, with Roan and Caleb on our heels, the warm climate washed over us—an electric feeling that we were finally making a move out of our lives in Wisconsin. I felt in the mood to celebrate. I think Aidan felt it, too. He played a song off Spotify he thought I'd like.

They just dreams, turn 'em to reality. . . . Let me get a one-way ticket, haven't picked a destination. . . . Mac Miller's *Thoughts From a Balcony* gave me goosebumps as the music had me slowly swaying to the beat. *What the fuck is time?. . . Go 'head, judge me, hate cost money, but this love free.*

So much time was gone after my marriage and the years of healing that followed, but *what the fuck is time?*

People judged me. People still do. But now I had a one-way ticket to move past them to wherever I wanted to go. I now had a new standard from which to make friends and enrich my life—with relationships free of lies.

I'd made the decision to move across the country and, my kids wholeheartedly supported me.

I told them, "I'm doing this for me, but I can't do it without you."

They said they knew that. Roan wasn't sure Texas was for her, but

she understood the trip was necessary for her, so that she would develop the courage to find her own adventure one day.

It was us against the world, and we were ready to take it on with the understanding that time didn't matter. It didn't matter that I was fifty-three and they were sixteen and nineteen. *What the fuck is time?*

It would take time to feel at home in a new state, and it would take time for Aidan to find his path—which he did by learning to manage his anxiety without drugs and by applying himself. It would take time for Roan to graduate high school—which she did early—and to set her sights on college.

It would take time for me to find the end to this book. But what the fuck is time when we had each other—when we had unconditional love for one another?

We'd been blessed with the hard lesson that to love ourselves was the greatest gift of all.

I put myself to task to wholly inhabit the version of me who years ago had triumphantly declared to Marty, "I deserve to be happy. I deserve to be loved, and I believe I will have happiness, but not with you. I believe I will be loved, but not by you."

That strong and confident woman I sought for so long was now standing solidly within me. Although sometimes she still felt like an apparition, I knew for sure that I'd brought her to life.

ACKNOWLEDGMENTS

I would never have had the courage to write this book without my writing coach, Samantha Wallen. Without her relentlessly pushing me to craft the story a little better, pull out all the gerunds (still not sure I know what those are), "unpack that a little further," and stop being so didactic (another word I had to look up), I'm certain this book would have taken up much more real estate in the landfills of our world.

I've always been vulnerable and transparent—or an over-sharer, if you'd rather—because of a sense that my life isn't just mine to have, but to be shared for the sake of enriching others' journeys so that we can all grow together. It was Sam who taught me how to dig into the depths of my heart and extract the most effective insights and pearls that my experiences precipitated. My gratitude for her role in my writing, and in my life, can never be properly expressed no matter how many creative writing classes I take.

My kids' willingness to have their own vulnerabilities and private lives displayed in these pages couldn't possibly have me loving them any more than I already do. Their support inspires me to always strive to do better as their mom. The best way I know to do that is to continually identify when I didn't do my best, and to do better. Writing this book allowed me to do just that. It's given me the insight to see my flaws and the means to fess up to them in a way that honors my children and allows me to genuinely experience the love I say I have for them. To love my children "like heaven"—meaning without judgment, without

fear, and without expectation—is not always easy, but I continually strive to do so. It is the only way I know how to give them a chance to live their best lives.

I have so many to thank who have supported me in my book-writing journey, all of whom I could write pages about, but the book is long enough. I'll start with my friends, Greta Cotnoir, Jane Manning, Lisa Welsh, Tanisha Martin (may we all be blessed to see your book on the shelves soon, too), and Joe Sharp who's lovingly built my website just because I needed one. Also Loretta Stevens, my dear friend and owner of Competitive Edge Branding, who not only supplied much emotional support, but was also a giant help with ideas in marketing this book, and my virtual assistant Janet McIntosh, who's also been a friend who's supported me though my journey while I've tried to figure out its purpose. I will also always dearly remember the staff members at the many Shopko Opticals where I worked, who gave me space to write my story between patients. Also my thanks go to C.J. Curtis, my massage therapist and fellow spiritual explorer; Bill Ritcey and Cindi Ritcey Fox, whose family values I am forever striving to emulate; Rob Fleishauer, my biggest cheerleader; and Mark Porteous, an infinite fount of resources that took this book to completion.

The support I've gotten from my family members—my brothers and sisters—through my divorce and illness has been far more important than their support for this book. I suspect they are in shock that I've actually gone through with my intention to publish and they have likely questioned why on earth I would do such a thing. Perhaps now that they can see what I've gone through from my perspective, they will know why I had to tell this story.

I must also mention the two therapists who were with me at different times in my journey. Ruth Airey-Vidal and Elizabeth Kimbrough, M.D. became almost like surrogate parents for my children as I sputtered through my role as mother while overcoming the physical and emotional pain that cursed so many of my days. I made many mistakes, but my therapists were there to help me avoid repeating some of them and to find forgiveness and redemption for the ones I couldn't. Through their guidance, they both made it easier for me to parent my kids when I struggled to do the right thing. They also helped me to see the value in my role as parent to my babies, which ultimately allowed me find the love and grace for myself that I'd been so challenged to appreciate.

This book would not exist without Christine Kloser and her team at Capucia Publishing. The decision to write this book required that I stay devoted to my journey, but finding the faith in myself to send it out into the world required a whole other discipline. I researched many options and publishers, but I connected immediately with Christine. Like selecting a midwife to birth my baby, it was of the utmost importance that the publisher I chose to birth my book be someone I could trust with my most precious creation. I talked to many whom I know would have done a great job on getting my book published, but the reverence for my story that I sensed from Christine was what I needed to choose her. I knew in my heart that Christine and her team at Capucia would help it become the book of my dreams.

Carrie Jareed is Christine's right hand and my go-to for all things logistical in the process of publishing. She always made me feel like I was her only client and went out of her way to get my many questions answered. She has made this daunting little project of mine much easier than I think it could have gone.

I was blown away by the many beautiful options that Jean Merrill and the design team presented to me for the cover. It turned out far better than I could have hoped. I gave them very little direction and I couldn't be happier with the result.

The marketing guidance I received from Penny Legg and Karen Everitt, as well as Josie Robinson and Roseanne Cheng of Evergreen Authors made my most feared task—selling this book—a little less scary and a lot more informed.

And then there is my editor. Janis Hunt Johnson gave me the confidence in my writing. I hadn't realized I was so desperate to have that reassurance. Other than my coach, Samantha, Janis was the only other person to comb through this entire manuscript several times, and she not once suggested I toss it in the trash and get on with my life. Quite the contrary, beyond fixing typos, adjusting my grammar, guiding me toward what needs to go and what can stay (and what might need more elaboration), she helped deepen my respect for my own work. Her support in that manner couldn't have been more important, nor could I have been more clueless as to how much I needed it. And I must say, I was very impressed with her following my many music references and helping me get the spelling of names, song titles, and grammatical mechanics right.

I am forever grateful to all of you for believing in me, to all the many Facebook, Medium, and Quora followers for championing my process, and to my heart for never letting me quit.

RESOURCES

TheLoveLiar.com

Arabi, Shahida. *Becoming the Narcissist's Nightmare: How to Devalue and Discard the Narcissist While Supplying Yourself.* New York: SCW Archer Publishing, 2016.
shahidaarabi.com

Bancroft, Lundy. *Why Does He Do That? Inside the Minds of Angry and Controlling Men.* New York: Berkley Books, 2003.
lundybancroft.com

Brown, Brené. *The Gifts of Imperfection: Let Go of Who You Think You're Supposed to Be and Embrace Who You Are.* Center City, Minn.: Hazelden Publishing, 2010.
brenebrown.com

Greenberg, Elinor. *Borderline, Narcissistic, and Schizoid Adaptations: The Pursuit of Love, Admiration and Safety.* New York: Greenbrooke Press, 2016.
elinorgreenberg.com

Miller, Meredith. *The Journey: A Roadmap for Self-healing After Narcissistic Abuse.* Scotts Valley, Calif.: Createspace, 2017.
innerintegration.com

Mirza, Debbie. *The Covert Passive Aggressive Narcissist: Recognizing the Traits and Finding Healing After Hidden Emotional and Psychological Abuse.* Ashland, Ore.: Safe Place Publishing, 2017. debbiemirza.com

Morningstar, Dana. *Out of the Fog: Moving From Confusion to Clarity After Narcissistic Abuse.* Mason, Mich.: Morningstar Media, 2017. danamorningstar.com

Neff, Kristin. *Self-Compassion: The Proven Power of Being Kind to Yourself.* New York: William Morrow/HarperCollins, 2011. centerformsc.org

ABOUT THE AUTHOR

Dr. Carin LaCount has a doctorate in optometry and a passion for helping others see within and beyond themselves. With a penchant for vulnerability and transparency in life and in writing, her first book, *The Love Liar: A Memoir of Codependency, Narcissism, and the Pursuit of Self-Love*, illustrates her devotion to finding the best version of herself and loving her unconditionally. She writes frequently for Medium.com and is available for select speaking engagements. She currently lives in Austin, Texas with her two children and their cats. Learn more at TheLoveLiar.com.

Made in the USA
Monee, IL
07 October 2022